IMAGES
of America

POWERHOUSES OF
THE SIERRA NEVADA

IMAGES
of America

POWERHOUSES OF
THE SIERRA NEVADA

Steve Hubbard

ARCADIA
PUBLISHING

Published by Arcadia Publishing
Charleston SC, Chicago IL, Portsmouth NH, San Francisco CA

Printed in the United States of America

Library of Congress Catalog Card Number: 2007921315

For all general information contact Arcadia Publishing at:
Telephone 843-853-2070
Fax 843-853-0044
E-mail sales@arcadiapublishing.com
For customer service and orders:
Toll-Free 1-888-313-2665

Visit us on the Internet at www.arcadiapublishing.com

To the forgotten, nameless pioneers of California who made the future possible.

CONTENTS

ACKNOWLEDGMENTS

I would like to thank Lisa Randle, Janet Walther, and Annette Perazzo of Pacific Gas and Electric Company for assistance in researching PG&E history. Dave Barrett and Chad Mulock of PG&E were also very helpful in providing technical information.

Pat Johnson, director of the Sacramento Archives and Museum Collection Center, was of great assistance, as were Carson Hendricks and Dylan McDonald.

I also appreciate the efforts of Bill Santos, enginologist, in sharing his collection of exquisitely restored historic engines and machines from the Gold Rush era, as well as his expert knowledge of how they work.

The Placer County Water Association and Steve Kedinger were most helpful in providing details about the operation of canals.

For more information on historic images of the American West, or to contact me, please visit my web site at www.goldcountryimages.com.

The photographs are from a number of sources. Unless noted below, they are from the PG&E corporate archives in San Francisco. Some are from the Sacramento Archives and Museum Collection Center. They include the picture of the transformers on page 90. The photograph on page 157 of the diversion canal is from the SAMCC PG&E Collection. Other photographs from the SAMCC include the image on page 91 of the diversion dam, which is from their William Sommers Collection. The second image on page 91 is from their Eugene Hepting Collection. The image on page 58 of the wagon going to the Wise Powerhouse is from the James Howell Collection. The following images were taken by the author: the two images on page 20; the Pelton wheel images on pages 21 and 22; the Folsom Plant on page 90; both images on page 92; the generator images on 93 and 96; the oil cups on 98; the Wise plant photographs on pages 102, 103, and 104; the Drum photograph on 107; both images on page 110; the Spaulding images on 111 and 114; the Drum image on 115; the Spaulding image on 116; and the contemporary photographs on pages 126 and 127.

INTRODUCTION

In the late 19th century, the making of electricity, which had been a parlor trick only a few decades before, became an urgent need as the necessities of urban life—lights, streetcars, industrial motors—converted from gas, coal, and steam power to electrical power.

While electricity could be generated at coal or gas plants, California had mountains, canyons, and rivers that made hydroelectric generation of power possible on a larger scale than in the eastern United States.

In addition to the terrain and the water, the early developers of hydroelectric power in California found an existing infrastructure in the Sierra Nevada that dammed, stored, and conveyed water for mining and irrigation. Those facilities were adapted to generate electricity. Beginning in 1895, with the original powerhouse in Folsom, dozens of powerhouses in the Pit, Sacramento, Feather, American, and Yuba watersheds came on line in an intense period of development that ended only in the 1960s, when all the feasible sites had been utilized.

Most of the plants are still in operation in 2006. They can be viewed from public roads. The Folsom Powerhouse, now a state park, allows the public access into the interior of a restored plant.

The story of their construction is illustrated in the photographs that follow.

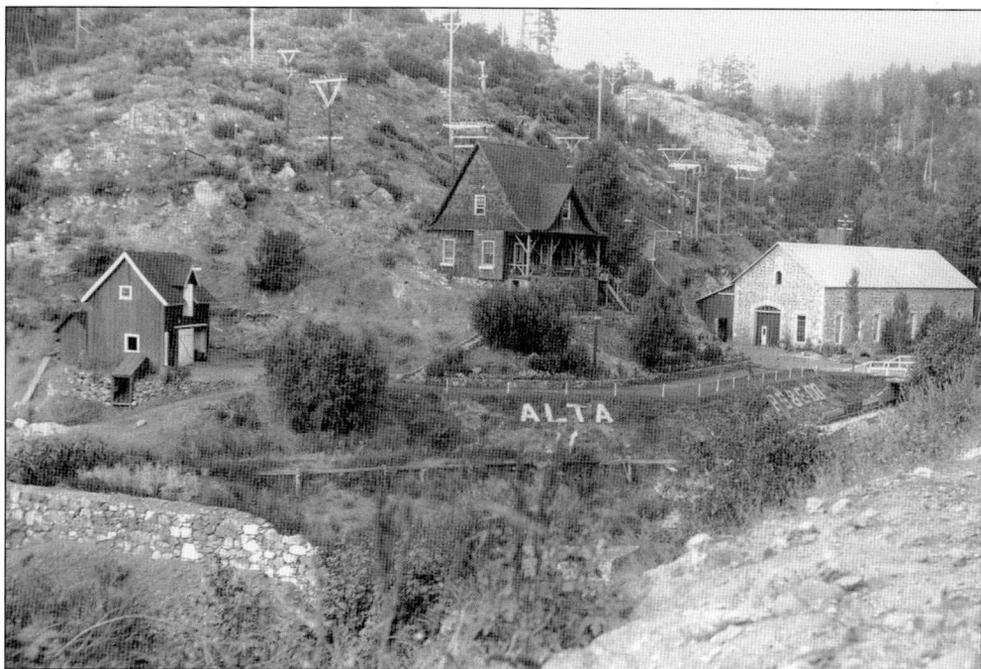

In an era when things were simpler, the chief operator's bungalow stood next to his workplace at the Alta Powerhouse in 1912.

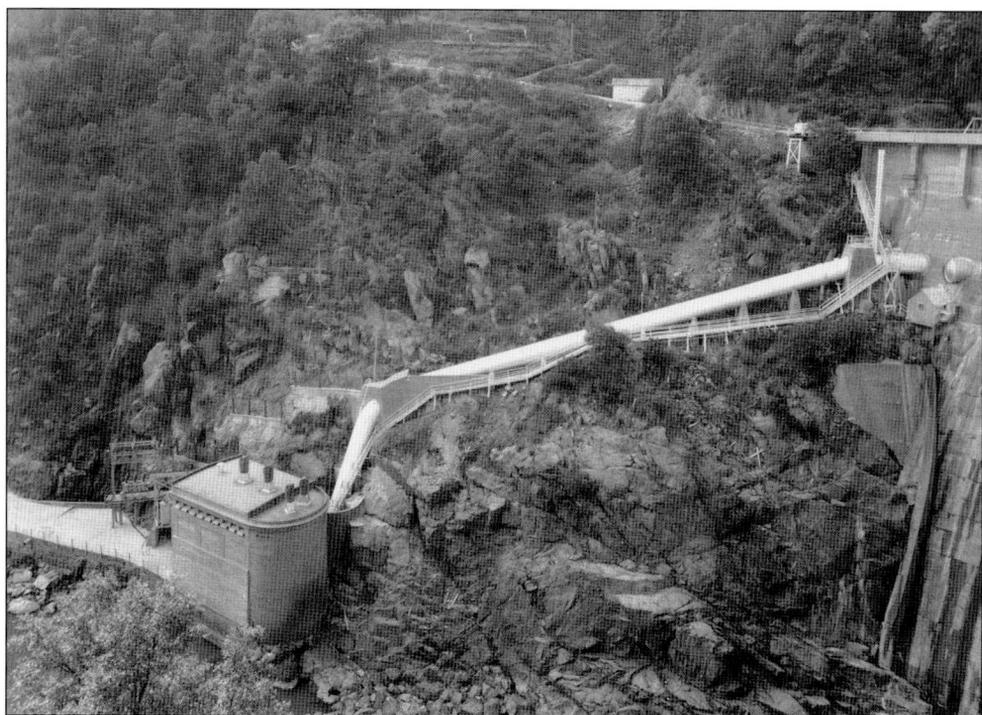

Three decades later, the advance in technology is obvious. The Bullard's Bar facility is larger and vastly more complicated.

One

VISIONARIES AND THEIR NEWFANGLED APPARATUS

The early powerhouses were good examples of adaptive technology. The demand for electricity at the end of the 19th century was constant and increasing but was frustrating to fulfill because generating and transmitting power on a commercial scale had never been done before.

Critical components, such as generators, needed to be imported from the East Coast, while the list of supporting equipment that needed to be fabricated (and sometimes invented) locally was long and complicated.

Local craftsmen skilled in woodworking constructed early flumes, and even pressurized pipes, of timber harvested from the west slope of the Sierra Nevada. Pipe fitters used their experience with steam engines to build shafts, pulleys, and speed regulators. Harness makers crafted leather belts for power transmission between machines.

A critical tool in converting the energy of moving water into electrical energy was the ability of a waterwheel, or turbine, to spin a generator at high speed. Various designs had been used for thousands of years to rotate shafts at slow speeds in mills and factories, but electrical generators required a high-speed drive system of unprecedented precision and efficiency.

A mining camp "tinkerer" in Camptonville, California, came up with a solution. Lester Pelton devised a new type of waterwheel cup that split the jet of water that was aimed at it in two directions, centering the energy and deflecting the rebounding water away from the wheel. His invention greatly increased the efficiency of the waterwheel. The design was subsequently improved by inventors such as Doble, who added a notch in the cup to increase the efficiency even more. One hundred and fifty years later, it remains in use in its basic form in hydroelectric turbines around the world.

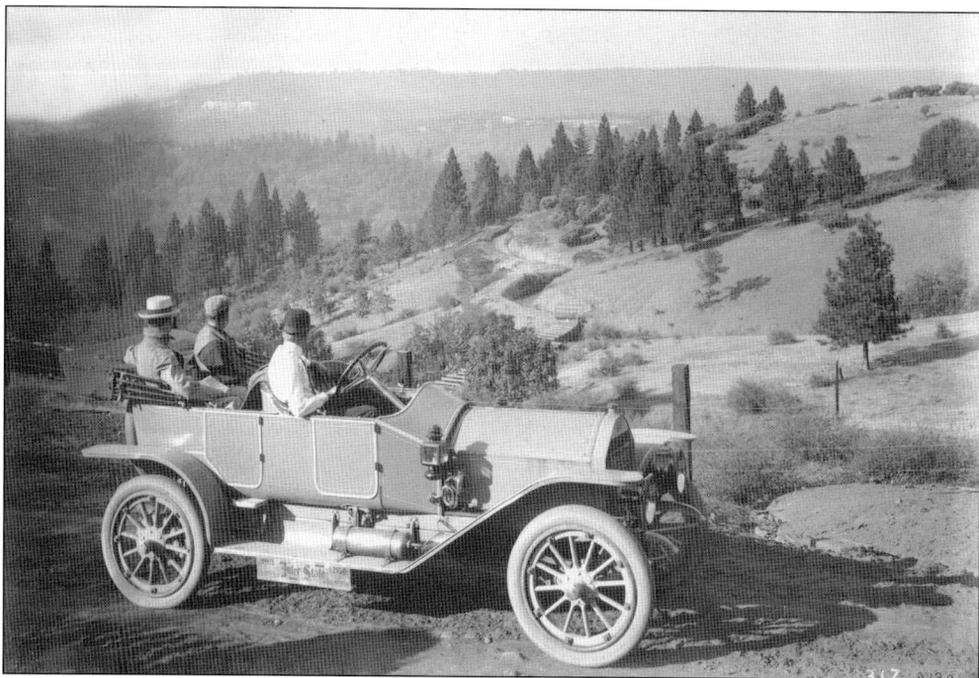

Three gentlemen in a 1911 InterState motorcar—the "Torpedo" model—survey a foothills water canal as they begin their tour of PG&E's hydroelectric facilities in the central Sierra Nevada. Many images in this book were captured on that trip.

Early explorers sought out prospective dam sites for irrigation, and pioneers then erected wooden dams, such as this one in Bear Valley. Hydroelectric developers followed with larger structures to impound more water.

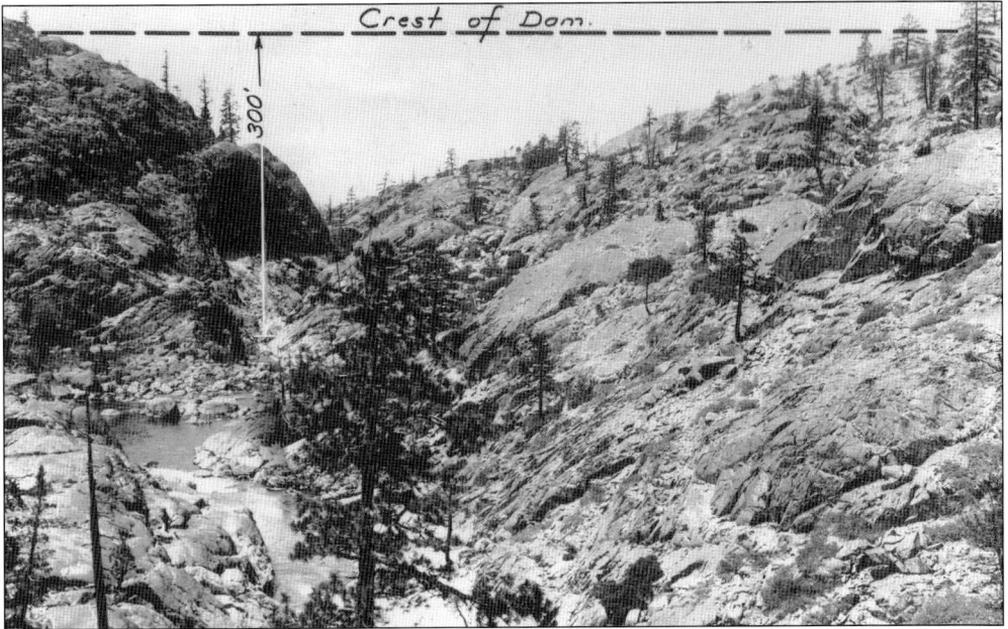

Crest of Dam.

300'

A dam at Spaulding, with a height of 300 feet and crest of a quarter mile, is proposed in this pre-engineering photograph.

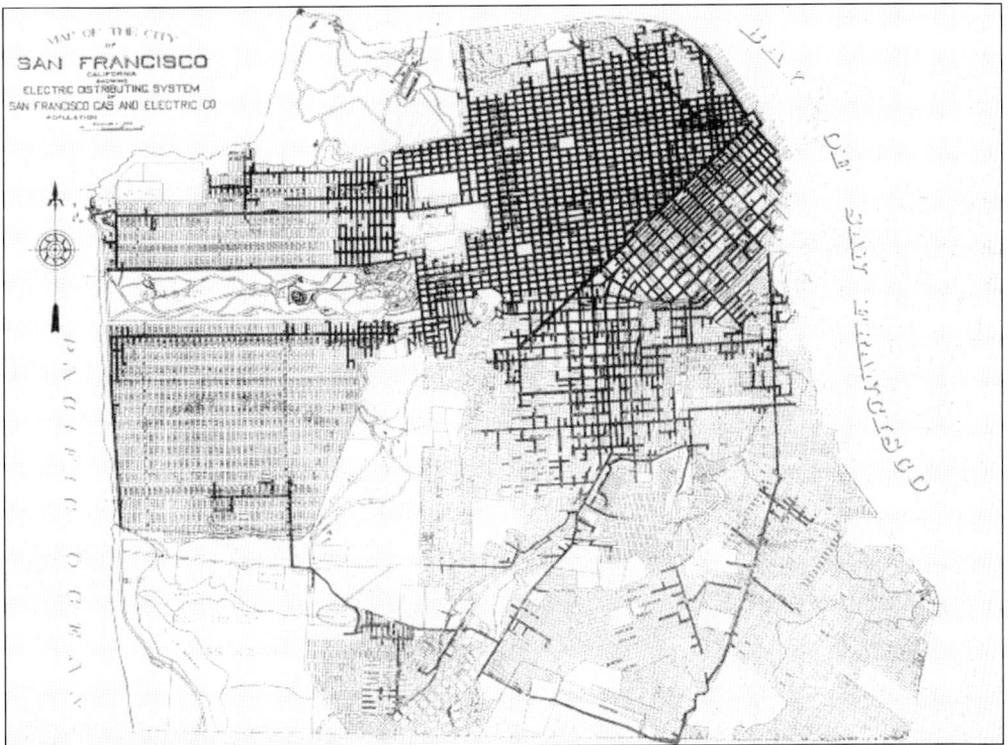

MAP OF THE CITY
OF
SAN FRANCISCO
CALIFORNIA
SHOWING
ELECTRIC DISTRIBUTING SYSTEM
SAN FRANCISCO GAS AND ELECTRIC CO

This is what drove the development of hydroelectric power: by 1900, San Francisco had an electrical grid that covered much of the city, and electricity provided the energy for everything from streetcars to residential lighting.

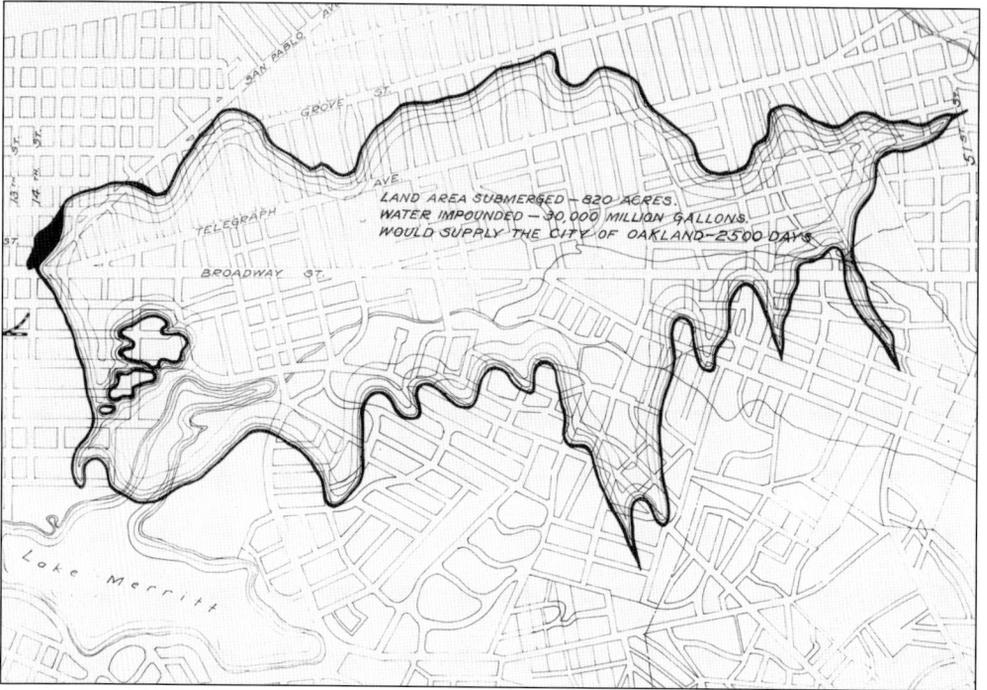

In a drawing related to the one on page 11, the power company shows that the new Spaulding reservoir would cover an area equal to most of Oakland, from Lake Merritt to Fifty-first Street.

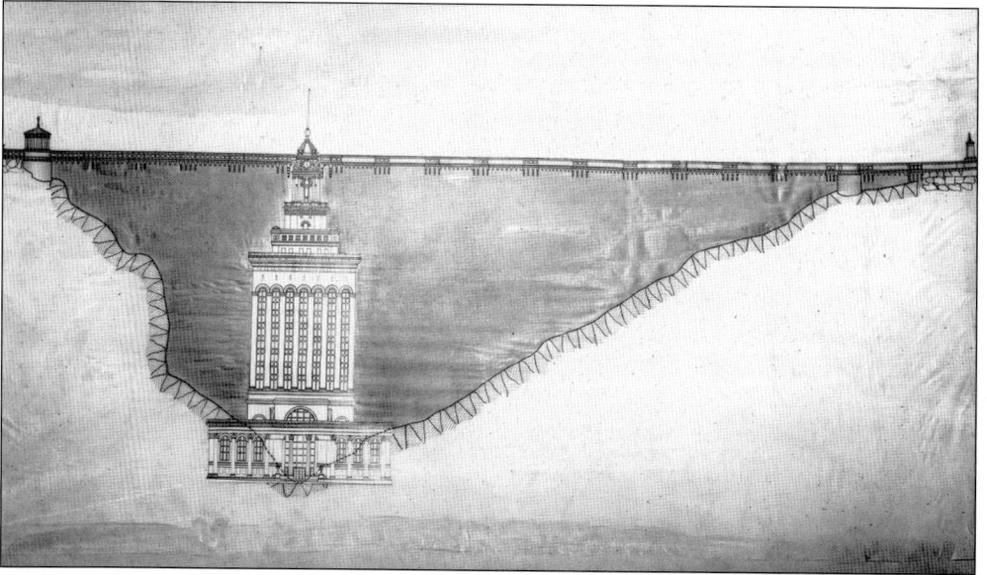

And exactly how deep would this new lake be? If Oakland City Hall was dropped into the middle of the lake, only the top of the tower would be seen.

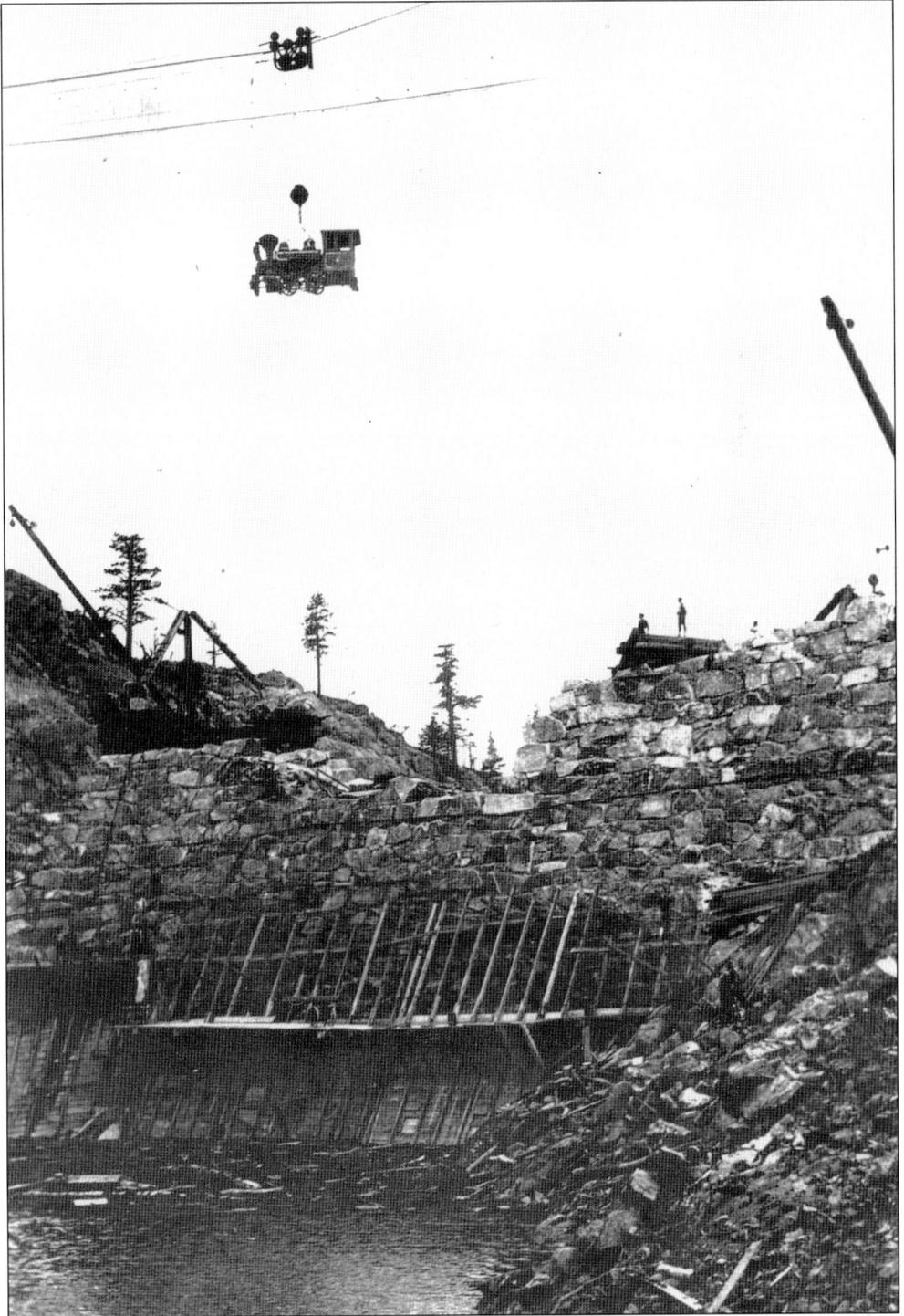

One had to be a visionary engineer to figure out how to get a 10-ton locomotive over a canyon with no roads or rails. Whoever owned the locomotive probably had several tense moments before it landed safely on the other side.

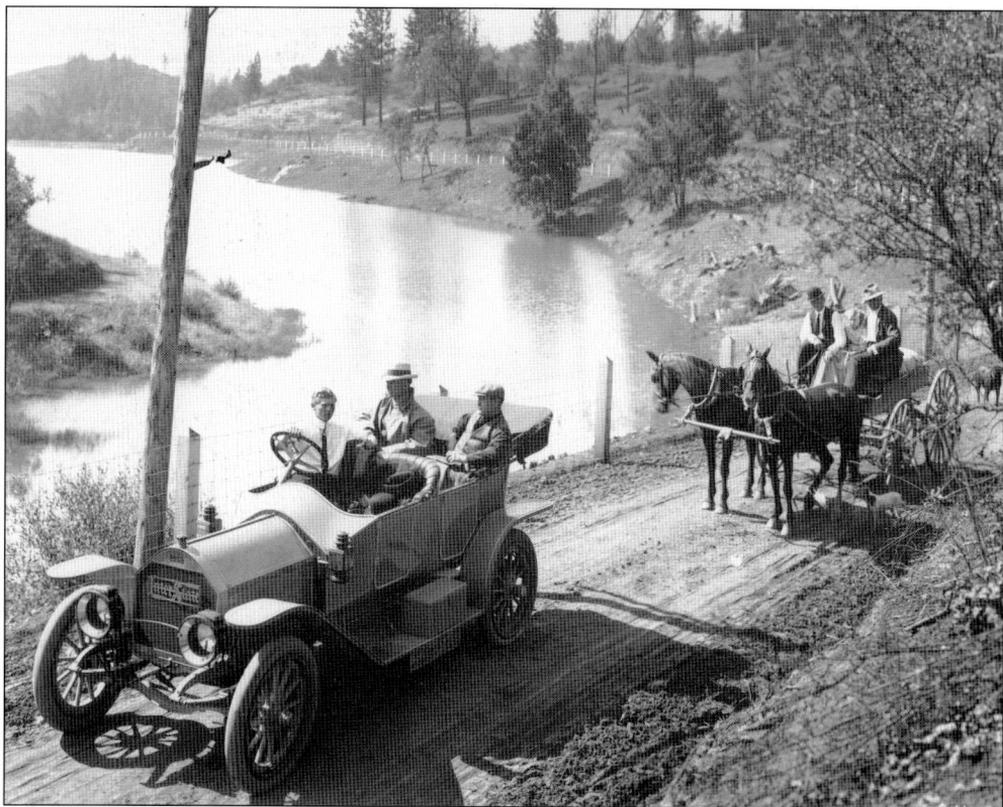

It was a time of overlapping technology. The party in the InterState automobile pauses for a photograph opportunity, and a mule-drawn wagon pulls up behind them. The automobile driver's bowler hat sits on the seat beside him.

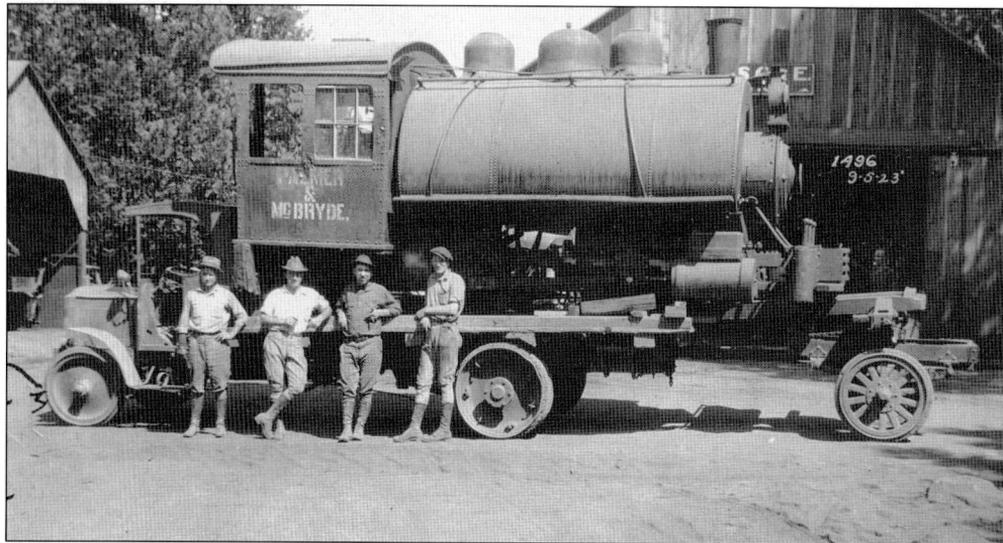

Here is another way to move a locomotive when there are no rails—remove the wheels and drop it on the back of a truck. However, the teamsters had to modify the truck by adding a makeshift second set of wheels in the rear to carry the weight.

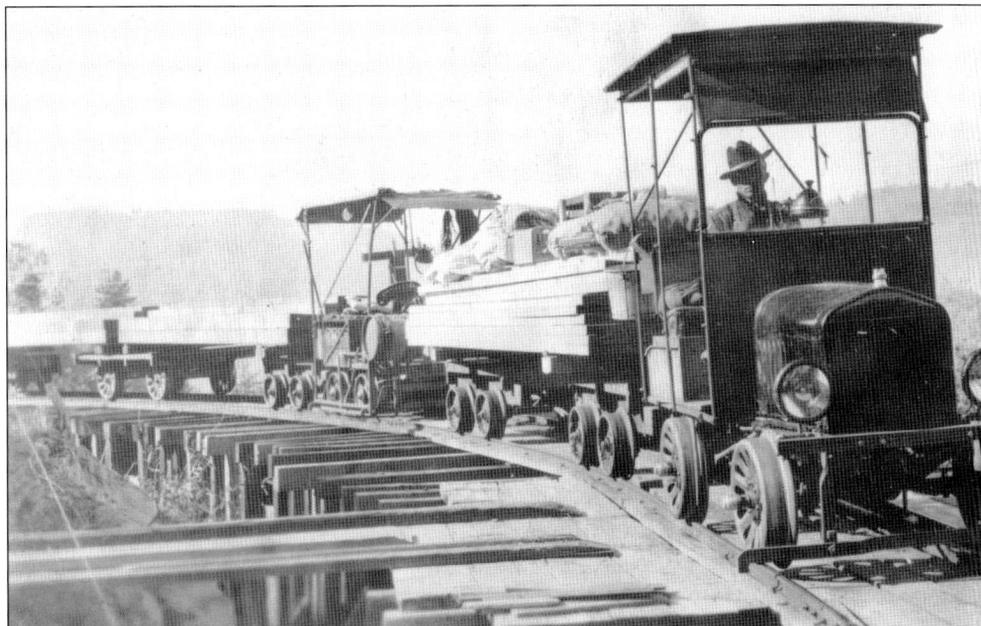

If one did not have a spare locomotive, how about building a "speeder car," which is a Model T adapted to pull carts along a narrow-gauge railroad?

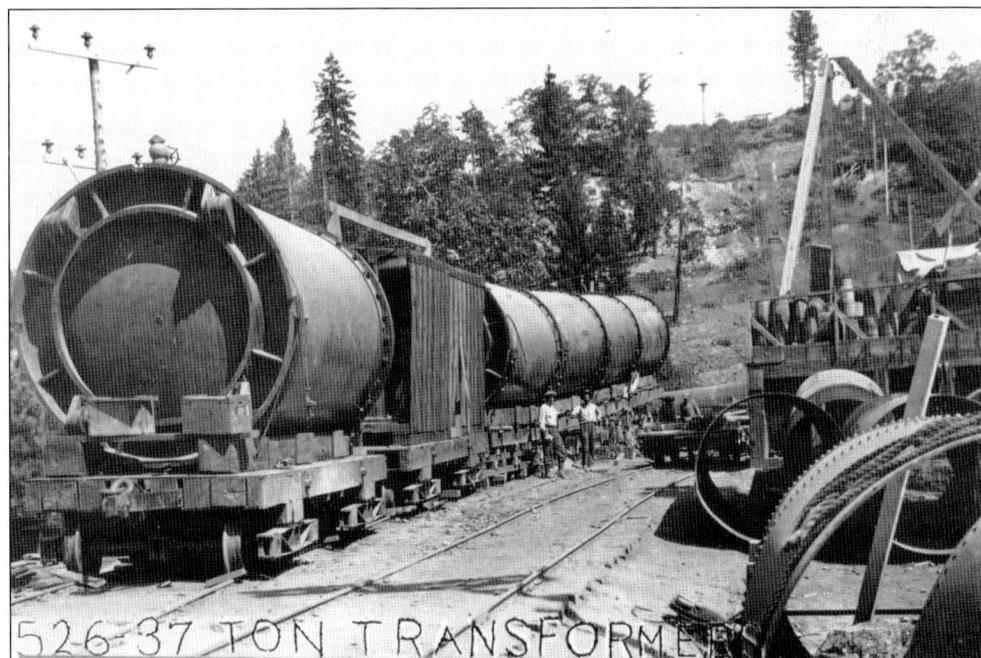

526-37 TON TRANSFORMERS

Some loads could only be moved by rail, as was the case with these 37-ton transformers being hauled to the Drum Powerhouse. Note the wheels on the base of the transformer in the foreground. Tipped on end at the powerhouse, they could be moved into place on their wheels.

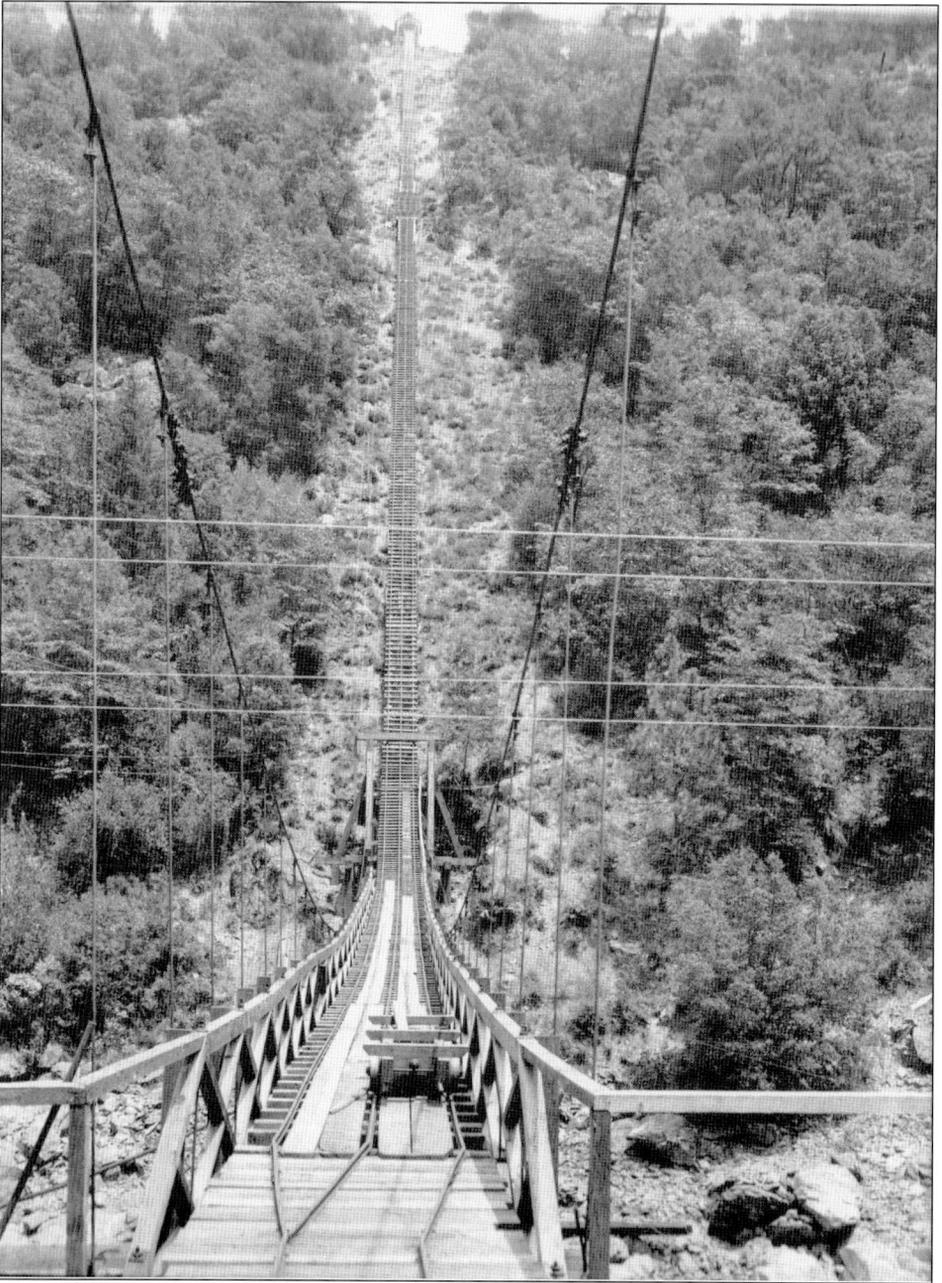

A good set of brakes must have been a prerequisite for speeders on this narrow-gauge bridge over the North Fork of the Yuba River.

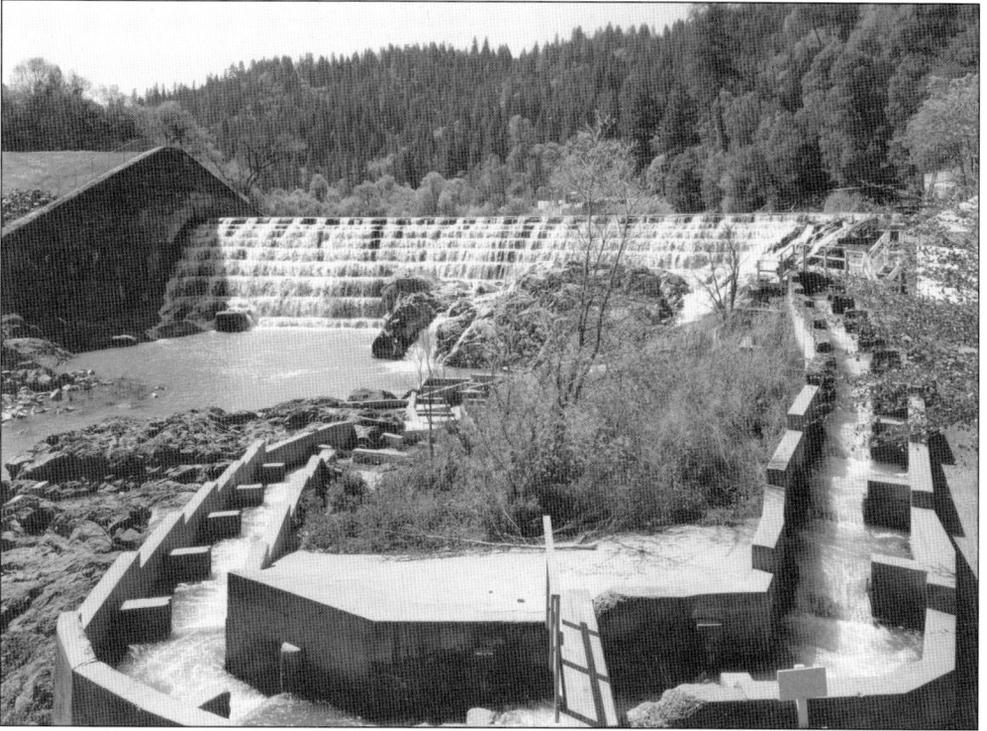

Here is another invention of the time—fish ladders. These allowed anadromous fish such as salmon and steelhead to swim around the dams and continue upstream to spawn. This fish ladder has only a short dam to navigate; taller dams were problematic.

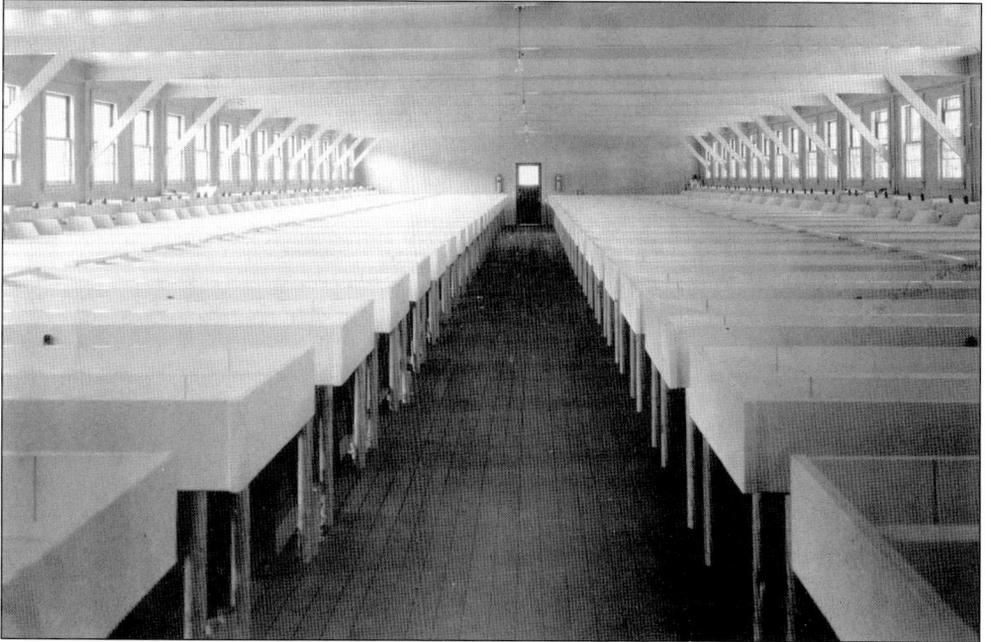

If a fish ladder was not feasible, the power company might build a fish hatchery, as seen in this 1912 view, to reintroduce trout to the stream after construction.

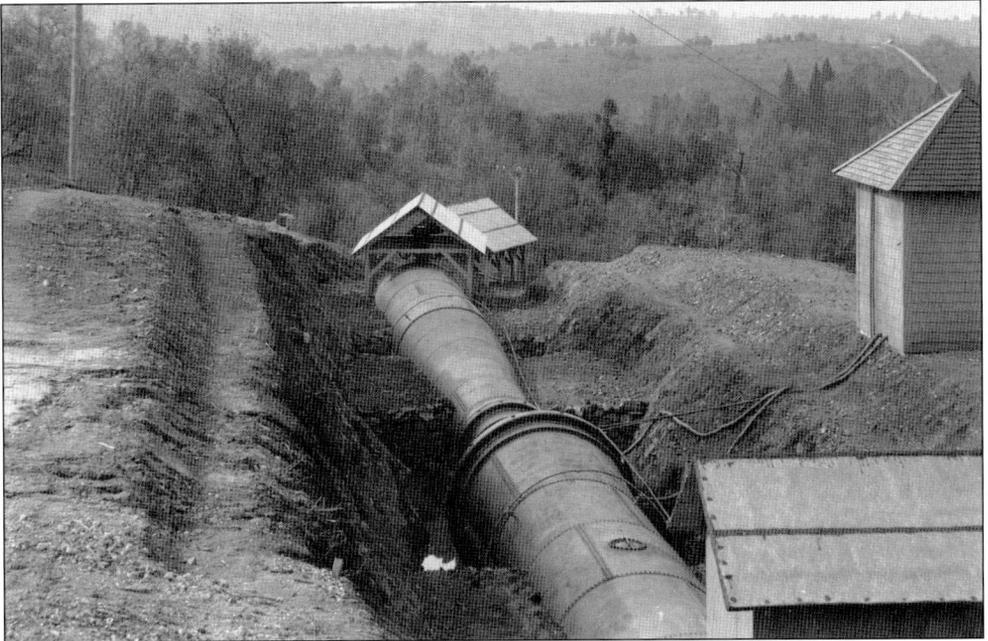

This curious structure on the Wise penstock was important enough that the photographer documented it, but its function remains a mystery. Although the penstock is still in use in 2006 and accessible for viewing in Auburn, the structure has been removed. Whatever the exact purpose, it is described in the photographer's notes as a "venturi meter."

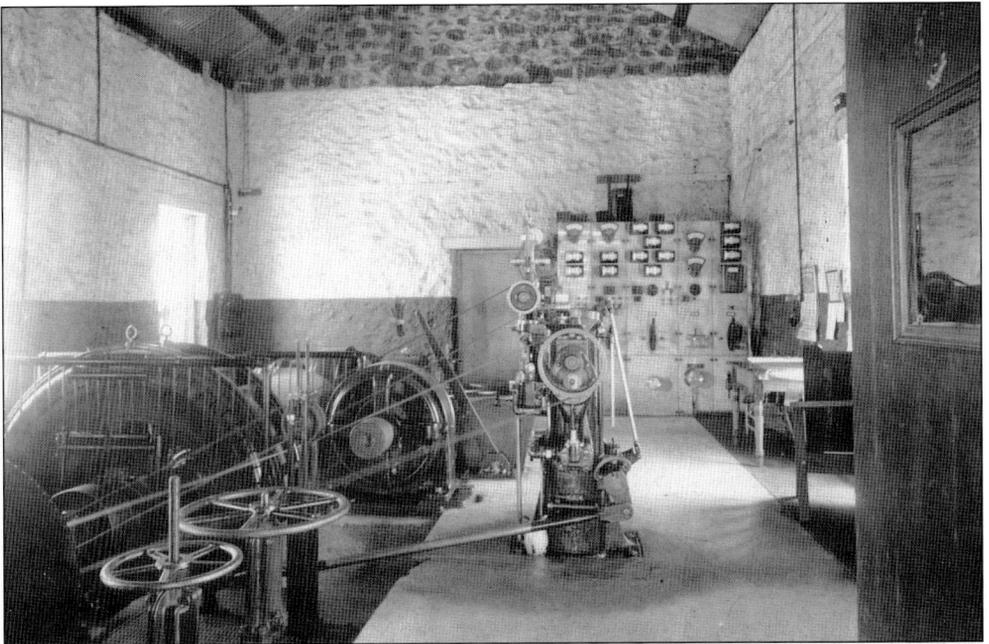

Electric dials and meters, common today, had only existed for a few years when this photograph of the Coal Canyon Powerhouse was taken in 1917. The belt-driven device at the center is a mechanical governor, which controlled the speed of the waterwheel to maintain a stable frequency of 60 hertz.

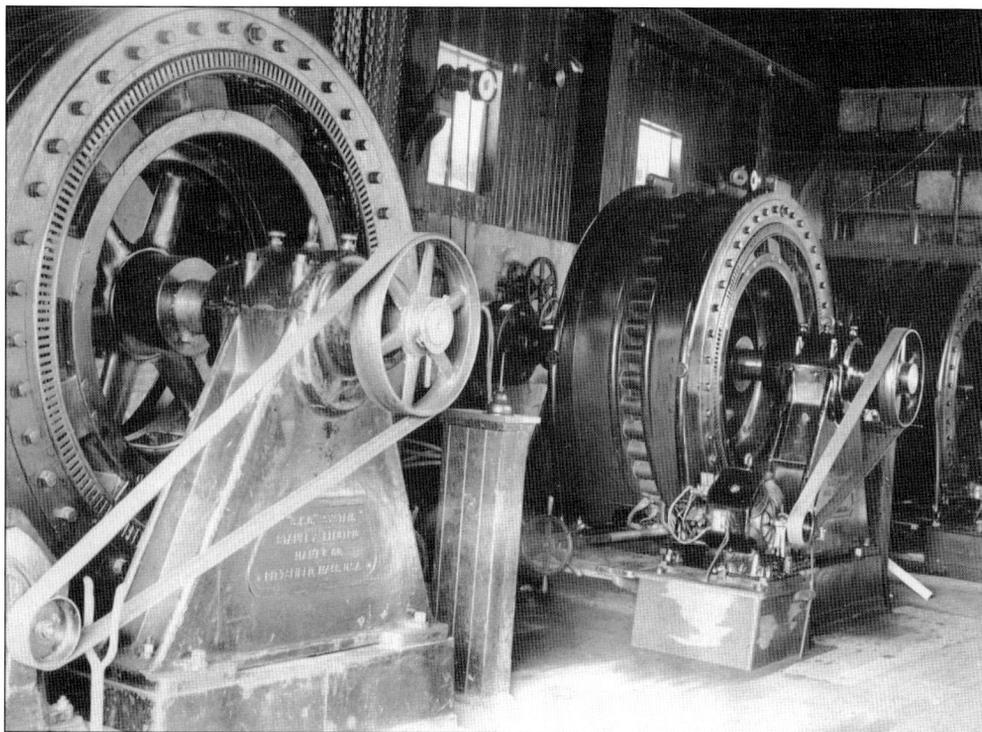

In this photograph, probably of the Folsom Plant, a belt powers what is either an exciter motor or hydraulic pump for the governor system.

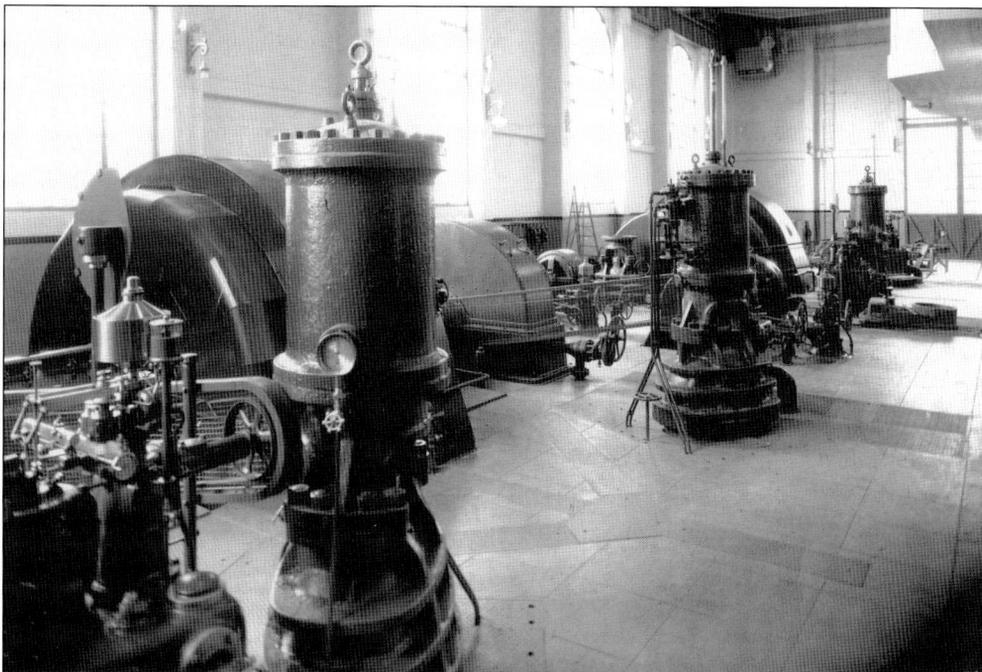

The plants were a curious amalgamation of steam, water, and electrical components, cobbled together by practical craftsmen who learned their skills in the field.

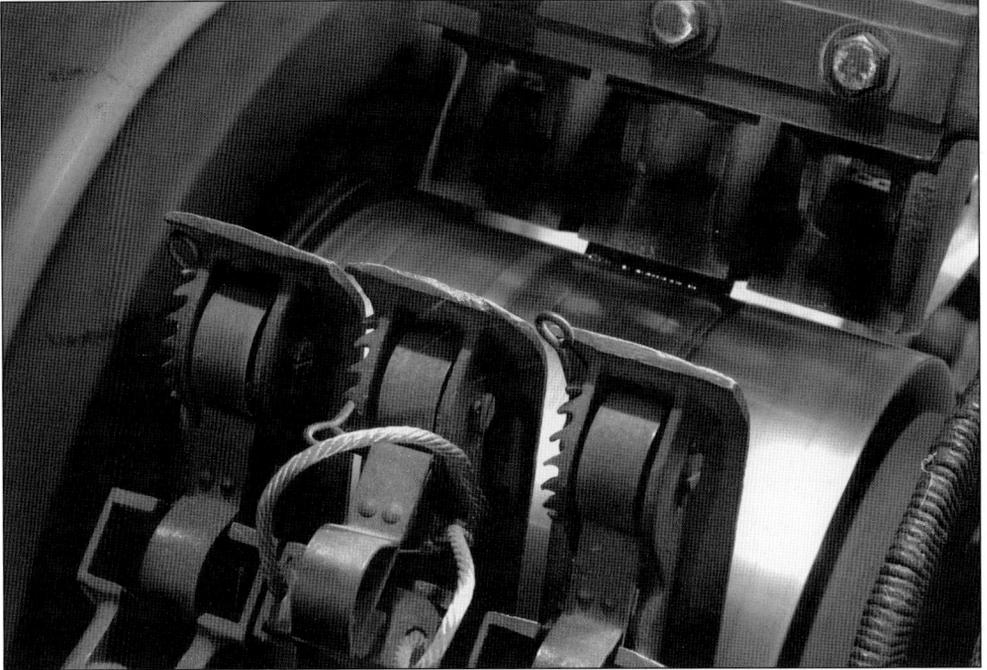

A close-up contemporary view reveals brushes at the Alta Plant. Note the tensioning hooks and springs, worn from a hundred years of use.

There were several different designs of waterwheels, or turbines, in the late 19th century. This is probably a Knight wheel, which had serrations at the bottom of the cup to focus the energy of the water jet.

Pelton divided the cup into two hemispheres, which center the jet's energy while dispersing the water away from other cups. The basic design remains in use today.

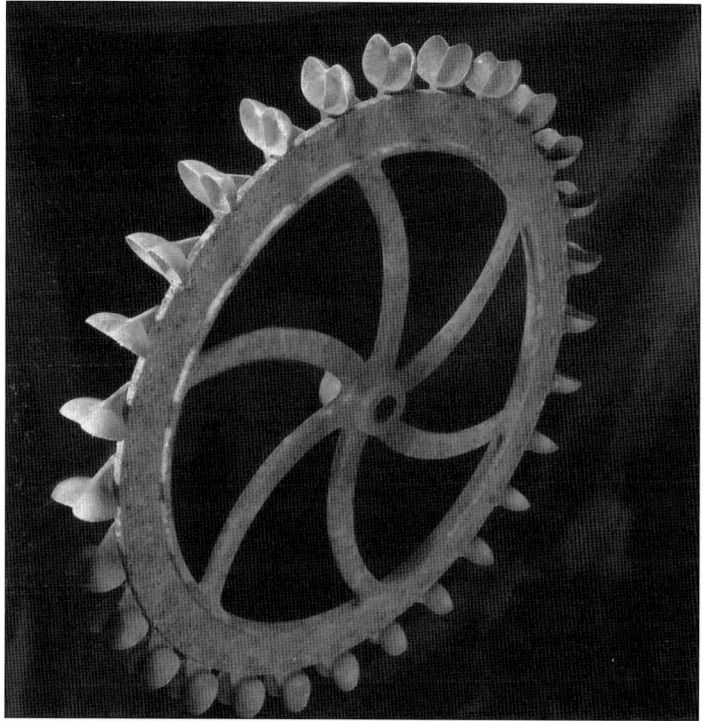

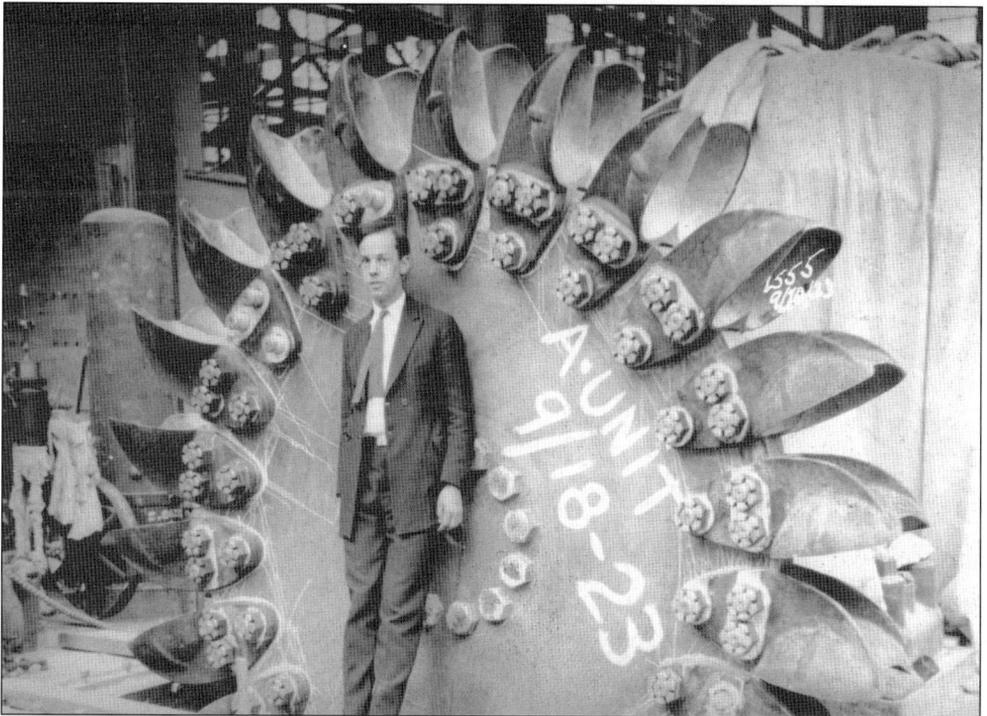

This cast-iron Pelton wheel is ready for installation at the Drum Powerhouse. Note the massive mounting assembly that holds each cup to the wheel. The pressure of the water jet that struck the cups could exceed 600 pounds per square inch.

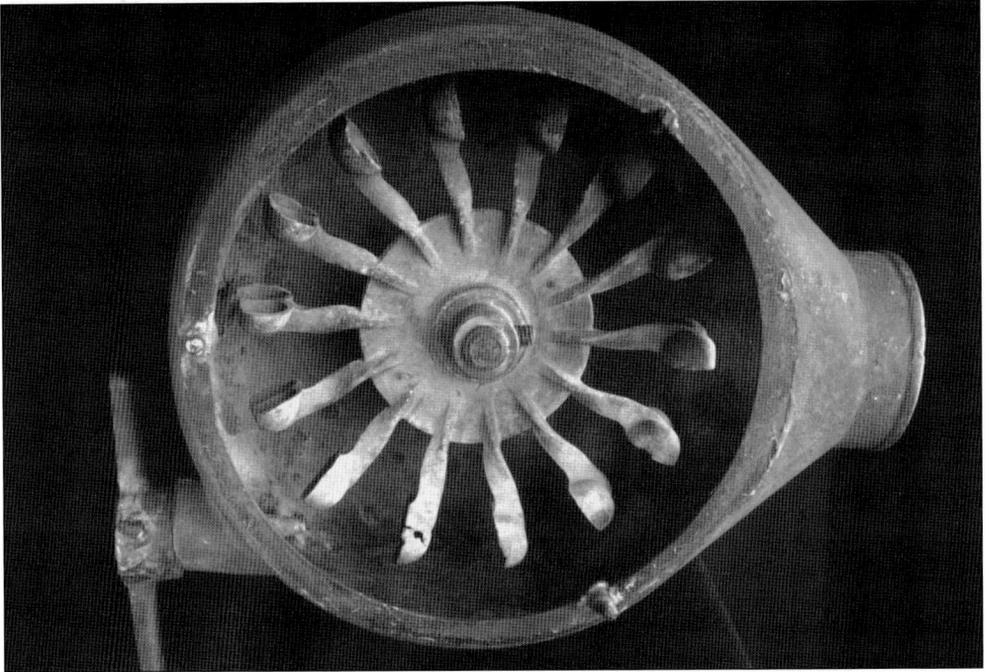

The Pelton wheel was highly adaptable and could be used for both small and large applications. This wheel, less than a foot in diameter, could be driven by a garden hose. The spinning shaft could power a sewing machine or a water pump.

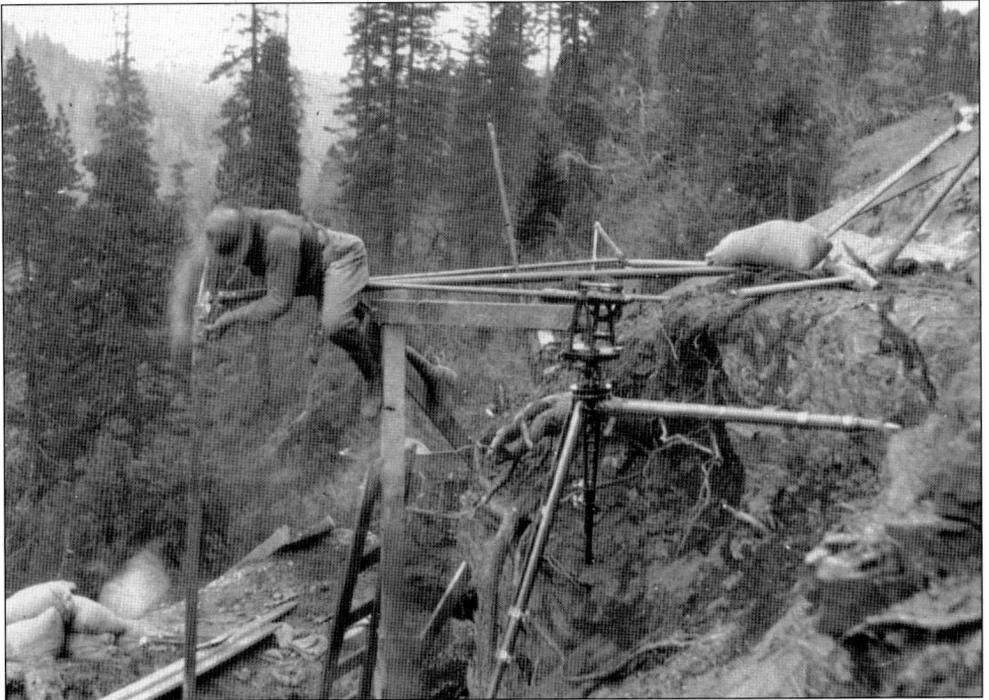

This surveyor, a one-man team, must construct his own observation platform. Presumably, the next step would be to move his tripod onto the platform.

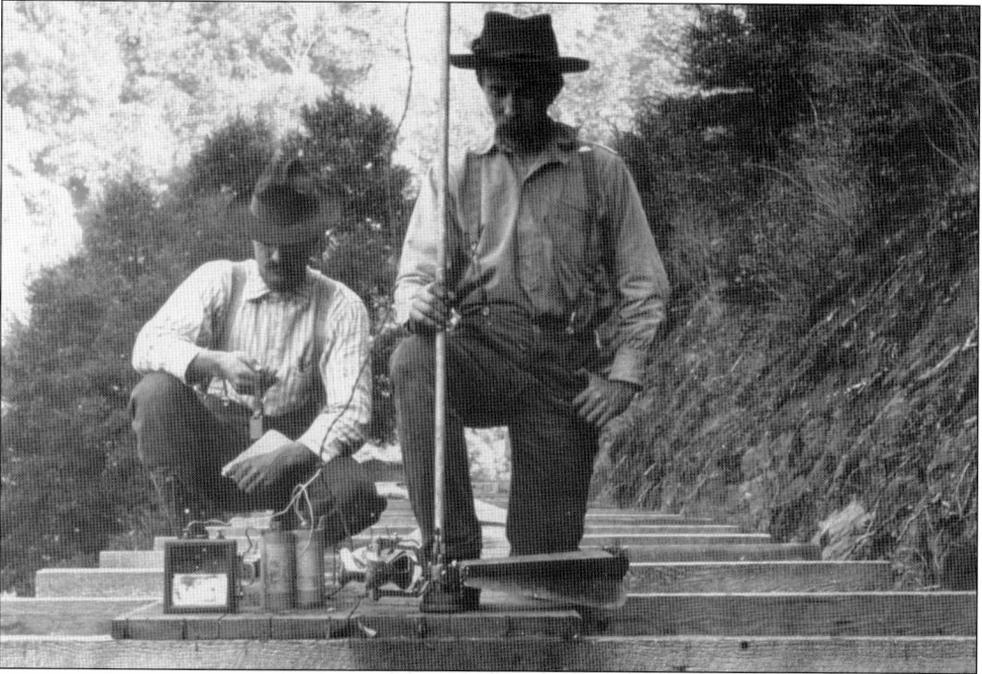

One man holds a stopwatch, while another prepares to drop a water vane into the Bear River Canal to measure the velocity of flow in 1916. The basic method of measuring water volume is still used today.

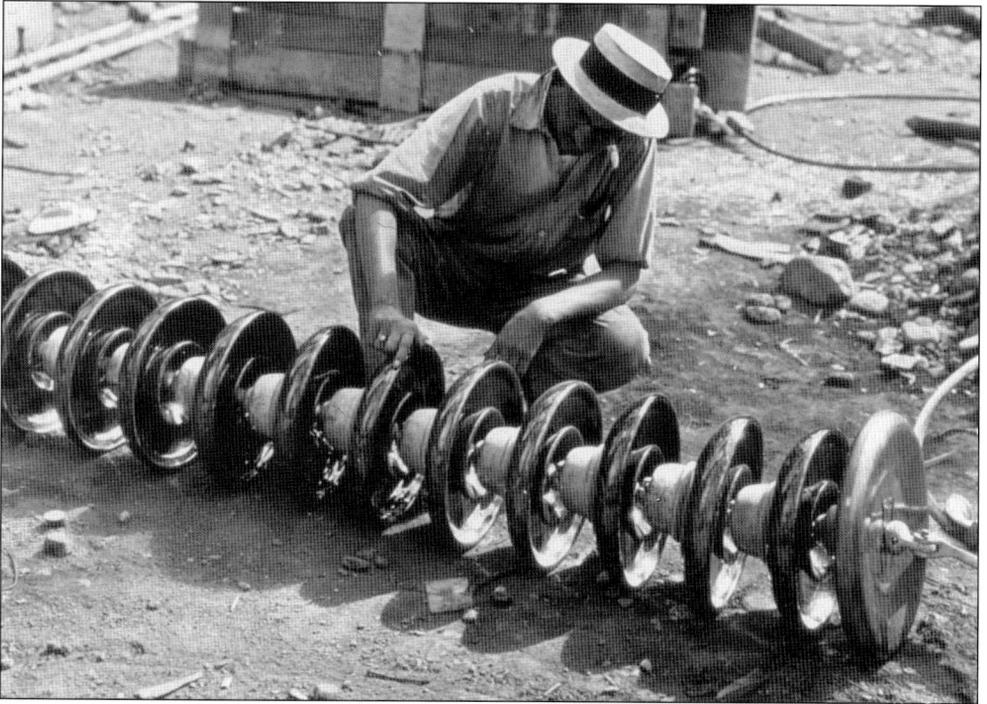

In 1926, a worker inspects a ceramic insulator to be installed on a transmission line. For the first time, the new electrical plants brought humans into close proximity with lethal voltages.

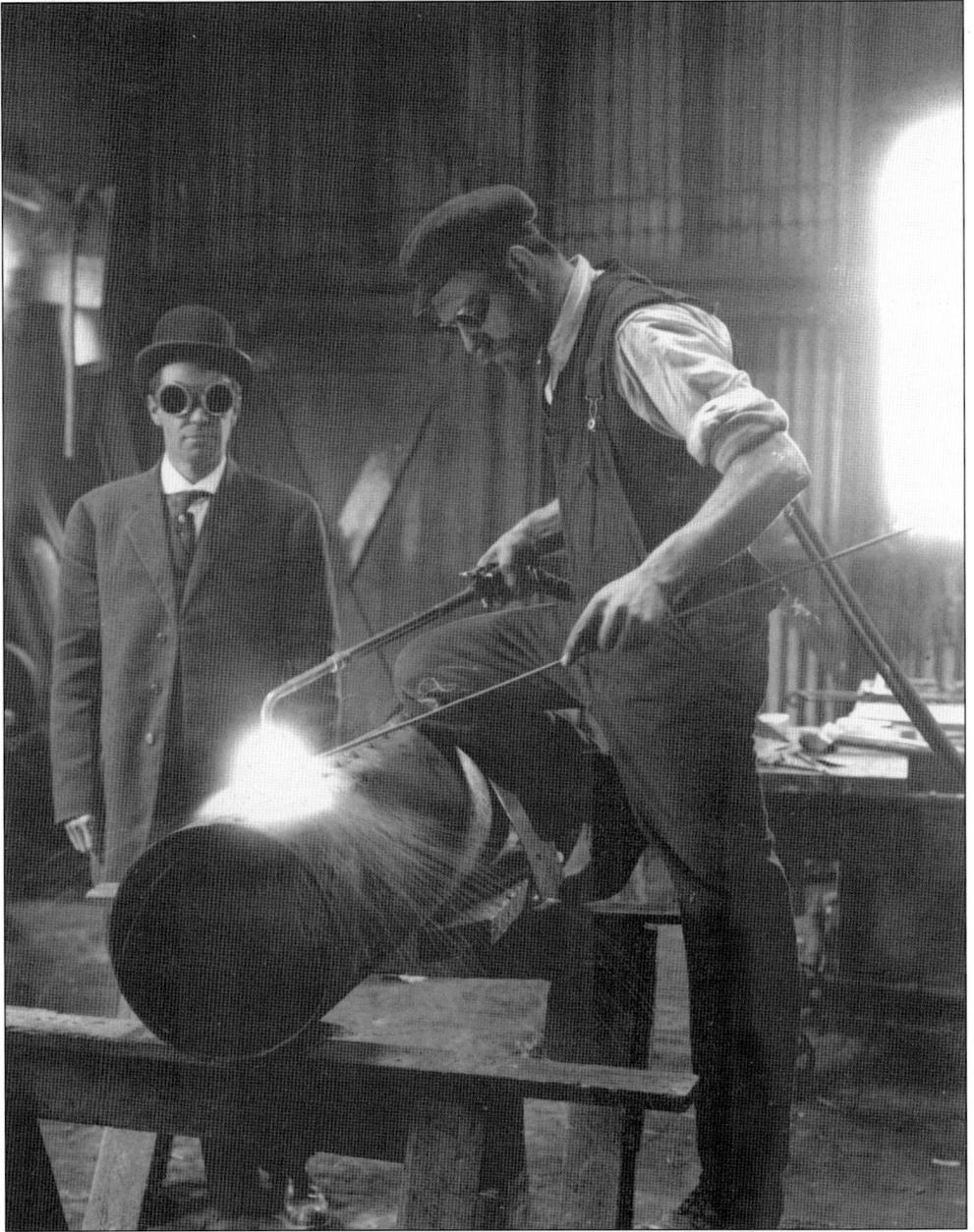

An early practitioner of acetylene welding demonstrates his skills in the shop. Although available for use in the late 19th century, arc and acetylene welding could not provide strong enough bonds for high-pressure penstocks. They were riveted together.

Two

ANATOMY OF
A POWERHOUSE

A hydroelectric powerhouse converts mechanical power to electrical energy by spinning a generator. The mechanical power originates as water pressure, which is converted to kinetic energy by applying it to a waterwheel, or turbine, and spinning it at high speed. The waterwheel is connected by a shaft or belt system to the generator.

Early developers understood that the water pressure needed to be several hundred pounds per square inch to effectively drive the waterwheel. Such pressure was usually achieved by building an open flume or pipeline and inserting it in a river some distance upstream of the hydroelectric site. The flume ran along the side of the canyon ridge until it was several hundred feet higher than the stream below. At that point, a penstock was constructed. A penstock is a reinforced metal pipe, usually three feet or greater in diameter, which drops the water from the ridge to the powerhouse and in the process develops the required pressure, or head, of water.

A spigot, or jet, aimed the water flow at a Pelton wheel, which was connected to the generator by a shaft. The electrical energy thus generated was applied to large transformers, which increased it to several thousand volts, the high voltage being required for efficient transmission of the power. A high-voltage power line, built initially on wooden power poles and later on metal towers, transmitted the power to cities like San Francisco, where hundreds of thousands of users increasingly depended on electricity to go about their daily lives.

Variations to the system included a forebay, which is a pond of water at the top of the penstock whose capacity was regulated to provide a steady supply of water. An afterbay might be built below the powerhouse, where the discharged water could be stored until it was needed at the next powerhouse in the system.

Most dams built in the Sierra Nevada were tall enough to develop sufficient water pressure at the base to run a power plant. If not, the dam could serve as a head dam, where a flume could be originated to feed a powerhouse downstream. As a result, some power plants are located at the bottom of isolated canyons, miles from the nearest dam.

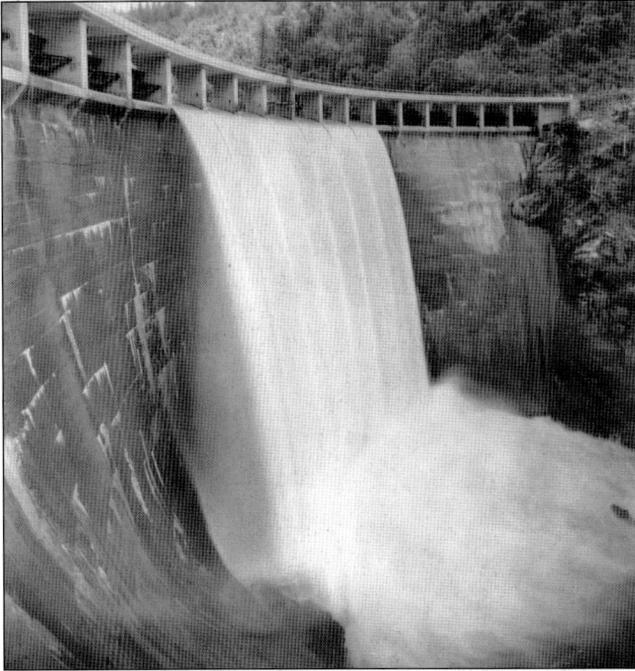

In many cases, the first element in a powerhouse system is a dam, which provides a head of pressurized water to drive the turbine. Water is pictured here pouring over the top of Bullard's Bar dam at a rate of 2,020 cubic feet per second in 1932.

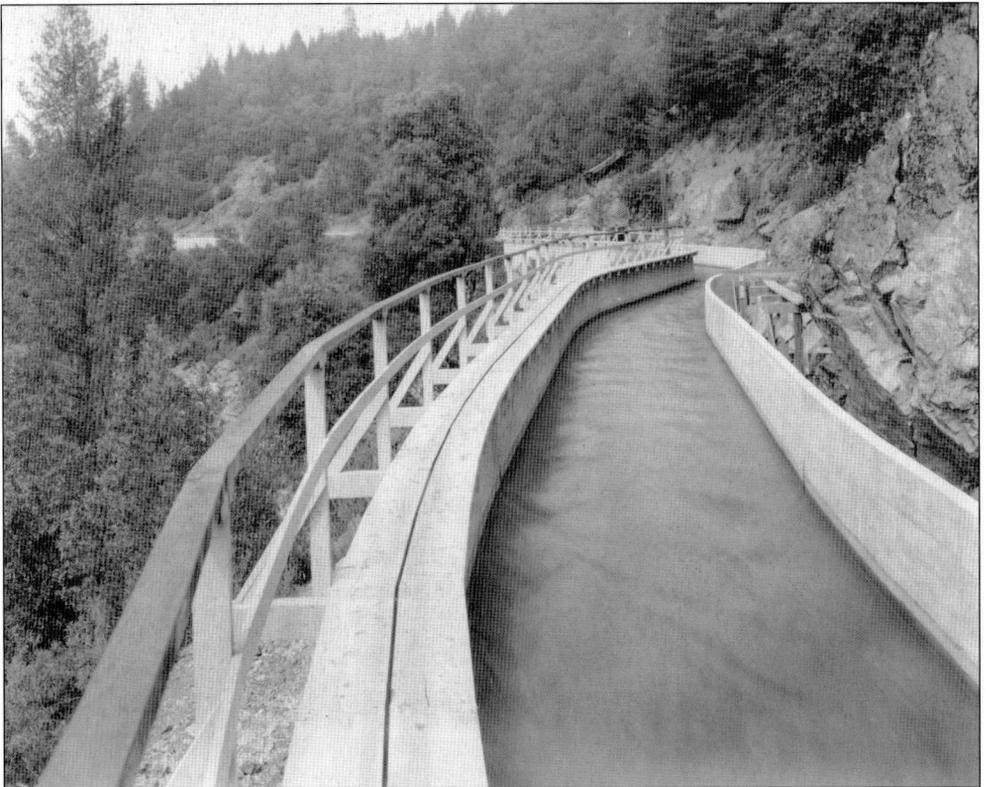

Earlier flumes were built of wood, but by the date of this 1931 photograph, concrete had proved to be a more durable material. This is a downstream view of the Bear River Canal.

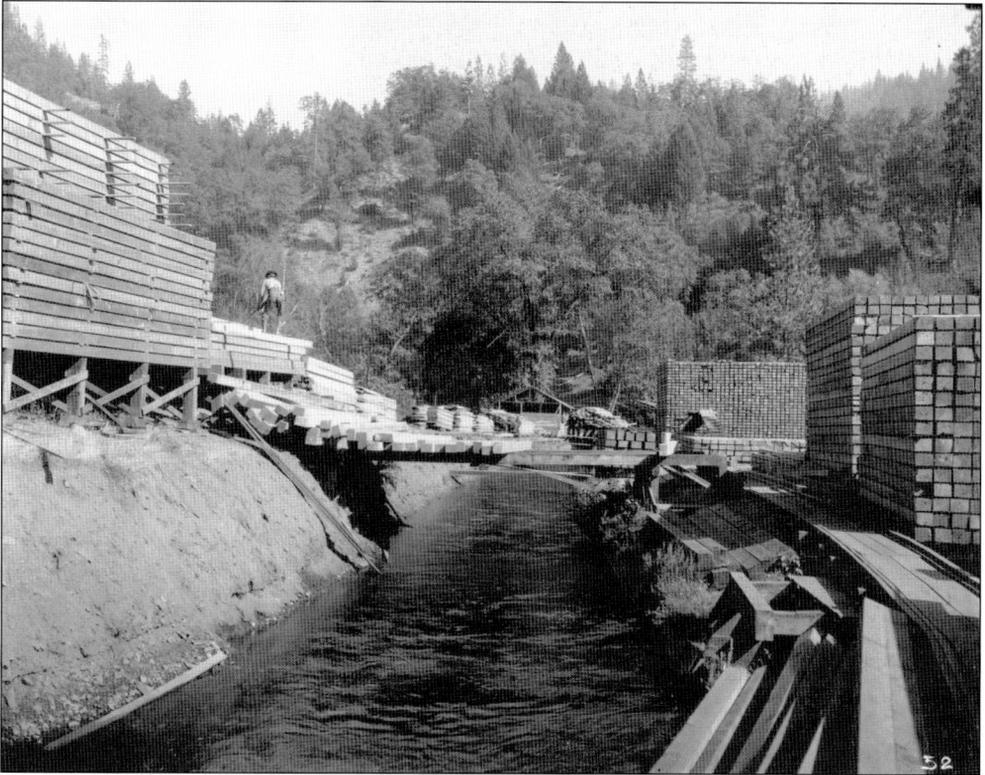

Flumes could provide more service than just transporting water. This view of the Electra Camp shows that the flume could be used to move timber as well.

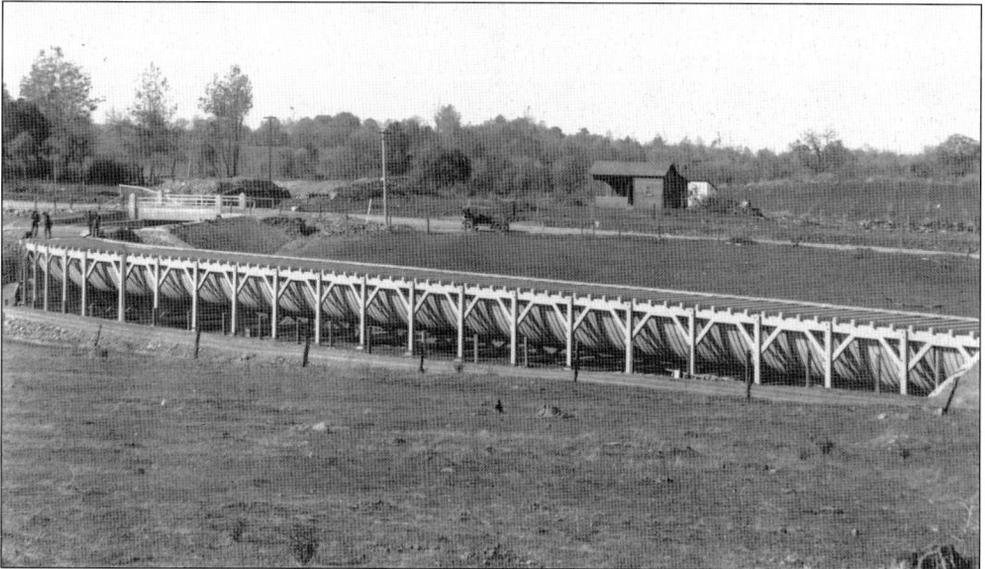

Why this elevated flume was built, at great expense and effort, instead of just backfilling the meadow with dirt and digging a ditch to move the water, is hard to say; however, it remains an impressive structure. Located between Rock Creek Dam and the Wise forebay, it is still visible today in Auburn.

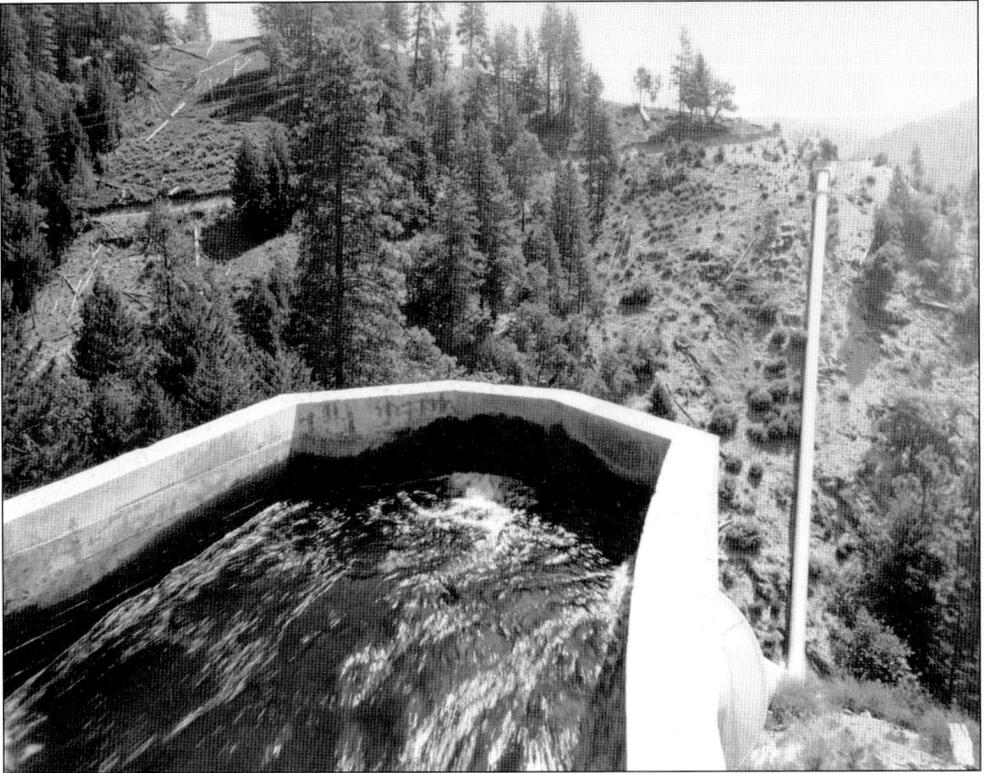

When a penstock had to descend a ridge and ascend the other side, an inverted siphon was employed. This is a 1936 view of the flume on the way to the Salt Springs Powerhouse.

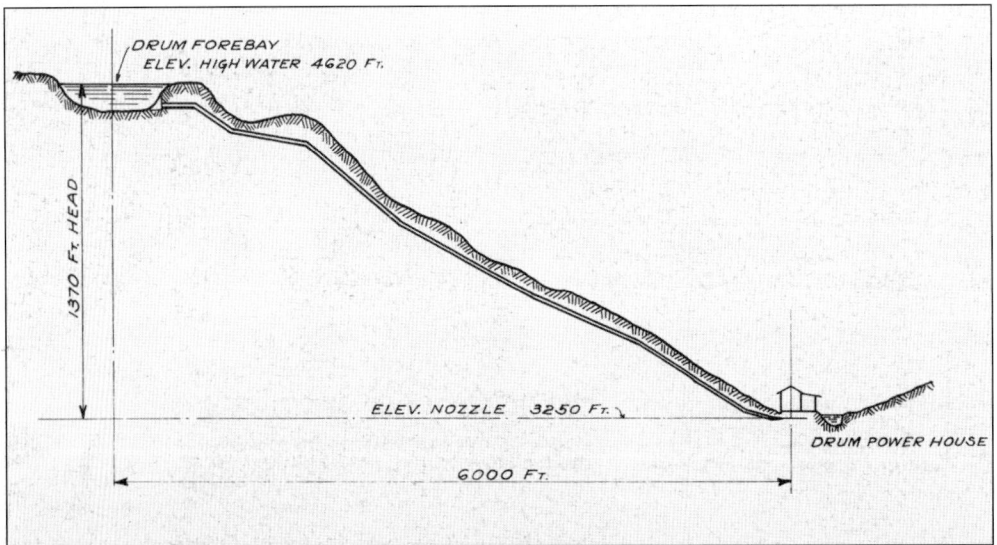

An engineering drawing of the Drum penstock is pictured here. Note that the elevation difference between the forebay and the powerhouse is 1,370 feet, enough to develop a head of pressure equaling 650 pounds per square inch at the powerhouse. Such water pressure was unprecedented in 1900 and required massively reinforced iron pipes at the bottom of the penstock to keep from bursting.

The penstock at Bucks Creek Powerhouse on the Feather River was one of the most impressive in the system, dropping nearly 2,000 feet from the ridgeline above.

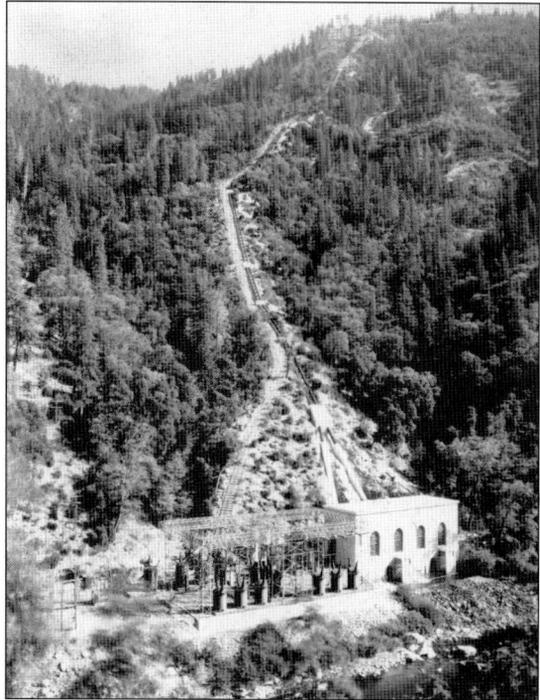

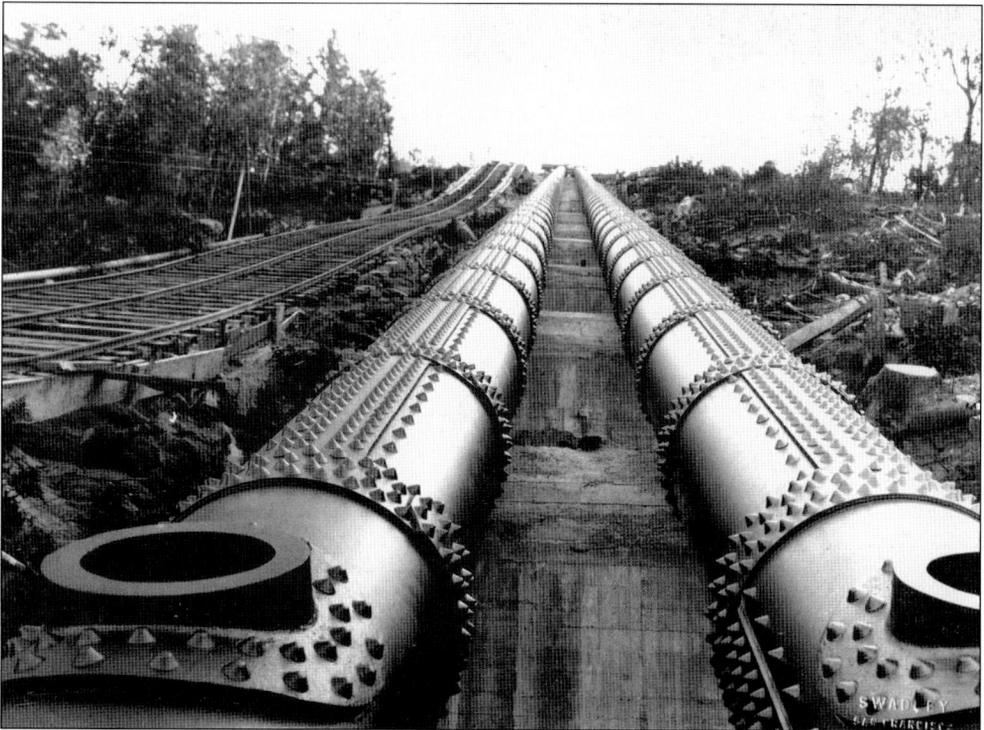

This view shows the robust construction of the Bucks Creek penstock. Temporary rail tracks were built adjacent to the penstock to move pipe sections up and down the grade. Note the quantity of rivets necessary to contain the high-pressure water column.

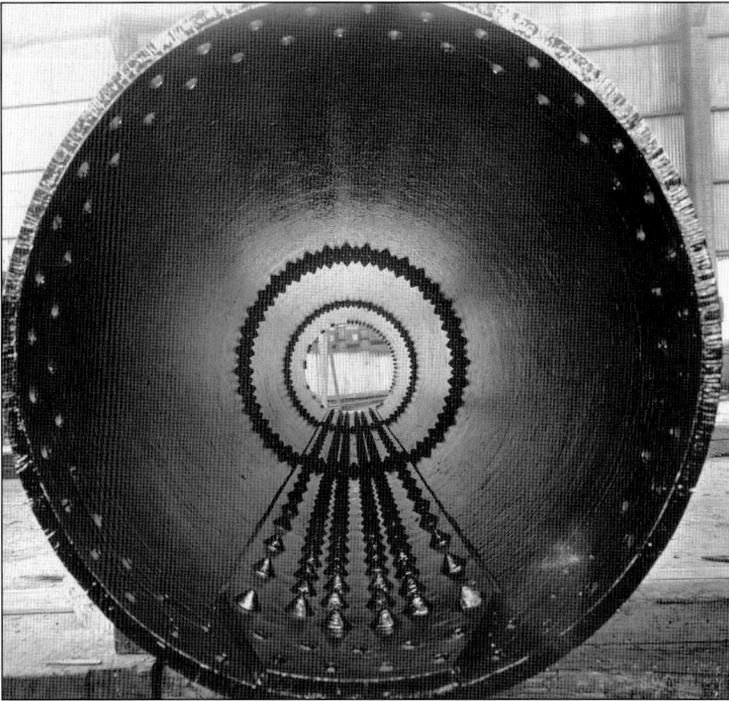

This section of penstock sits on the foundry floor ready to be delivered to the Bucks Creek project on the Feather River. The iron is an inch and a quarter thick.

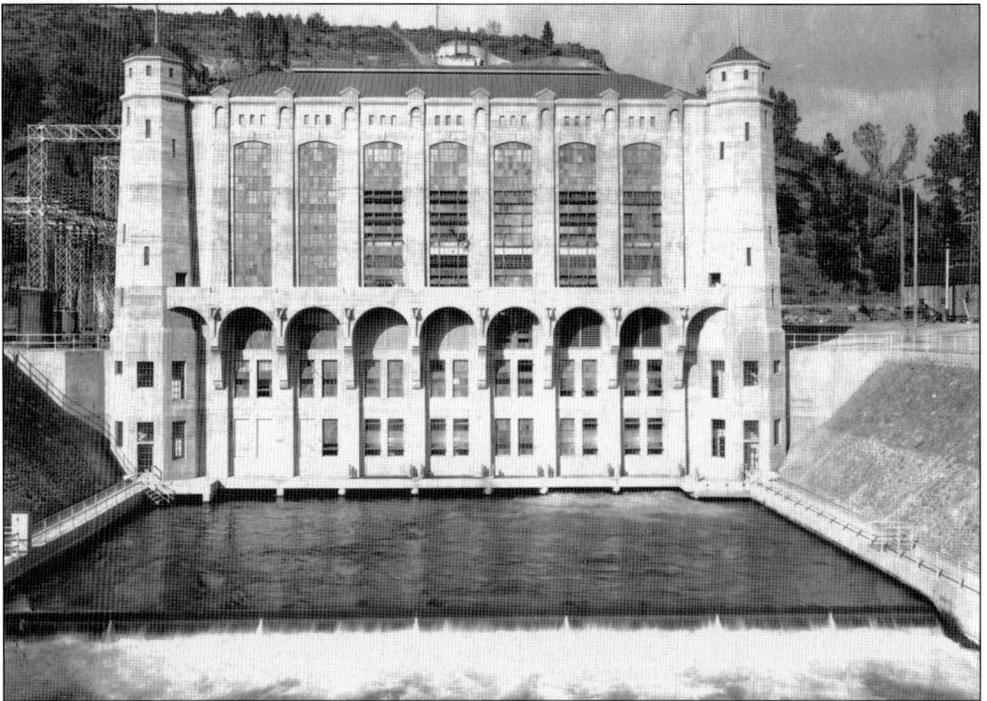

The Pit River Powerhouse No. 1 is often cited as a premiere example of engineering and design combined in an attractive building. The forebay is on the horizon behind the plant. This plant can be accessed from Highway 299, about five miles east of the Highway 89 junction and adjacent to the campground.

This photograph shows where the water meets the wheel. In this cavity, normally sealed from view, the water jet is directed at the Pelton wheel. Note the adjustment arm that aims the water jet at the wheel.

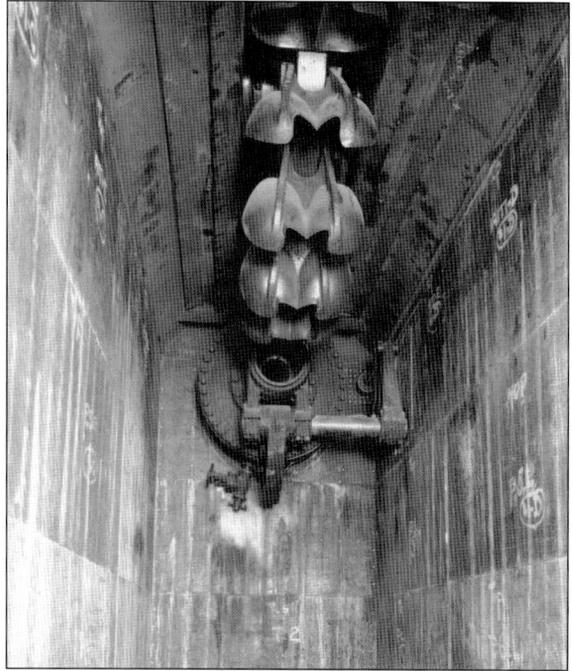

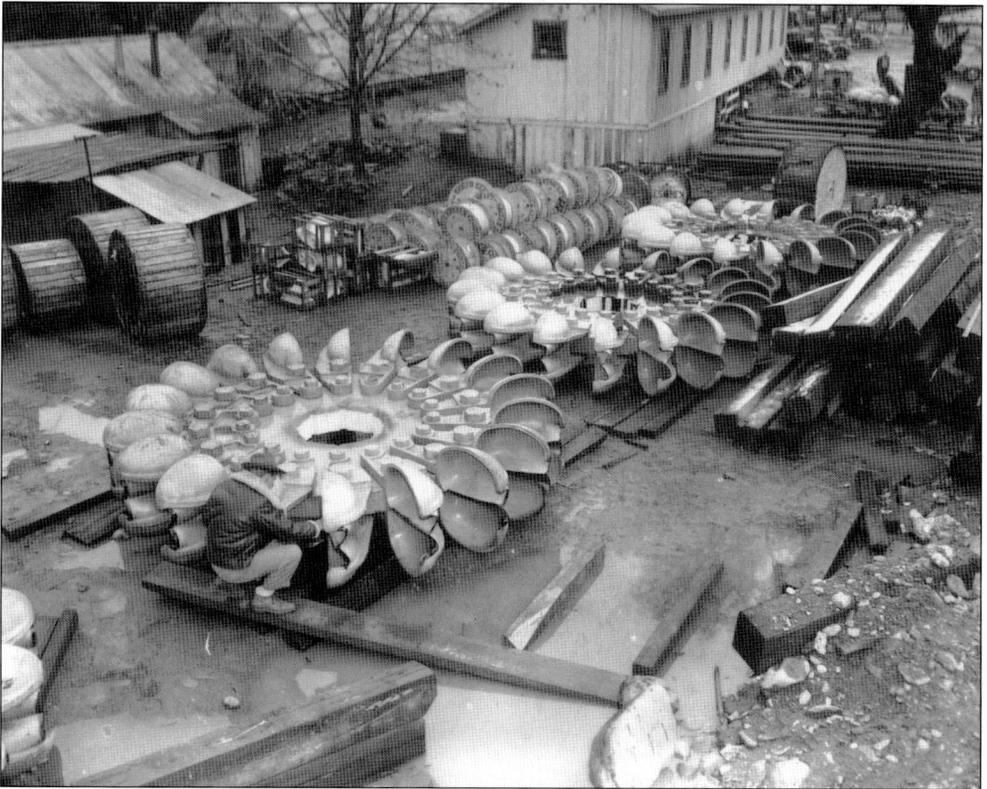

These Pelton wheels have been assembled on-site and are ready for installation at the Electra Powerhouse. The worker in the foreground provides scale for how large the wheels were.

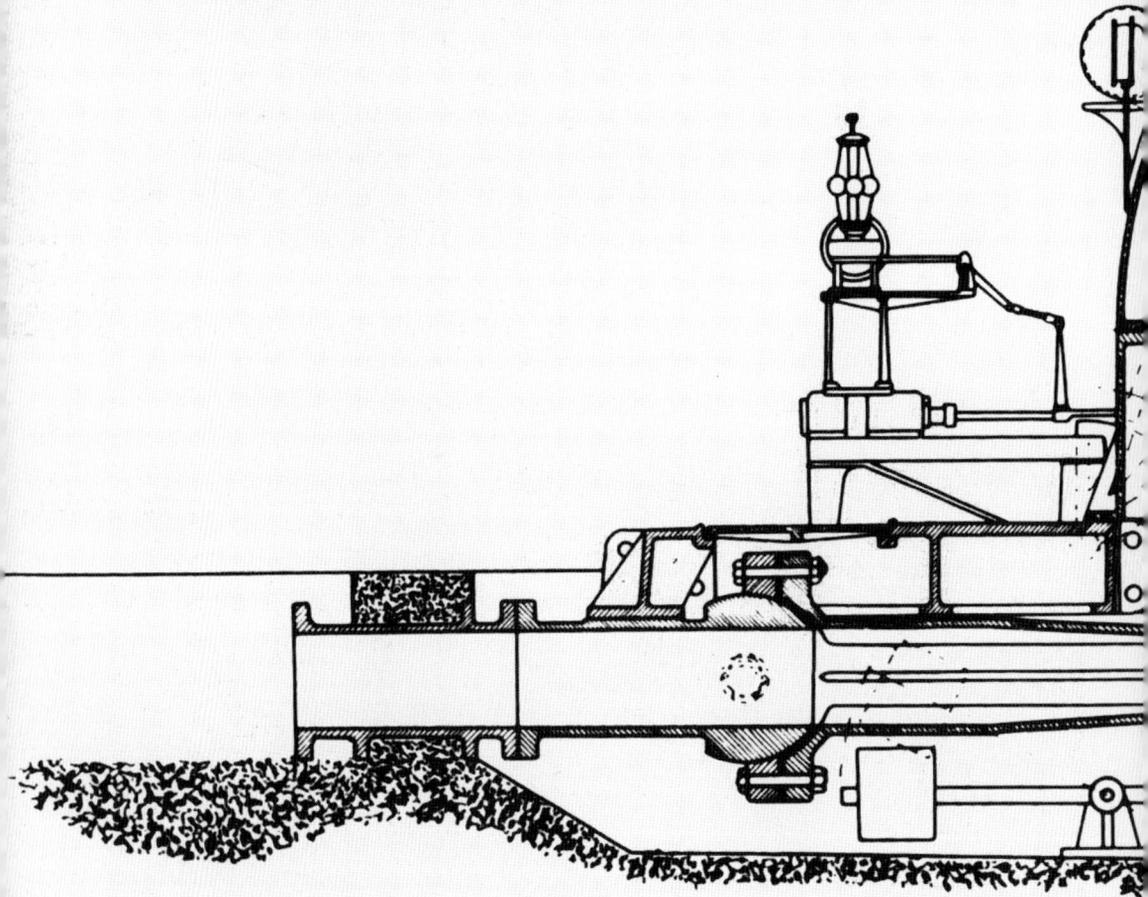

THE 3000-HORSEPOWER RISDON WHEEL AT COLGATE.---VERTICAL SECTIO

This photograph illustrates the function of a waterwheel (in this case a Risdon wheel, similar to a Pelton). They are typically operated in an undershot mode—the water jet impacts the bottom

RISDON PATENT WATER WHEEL

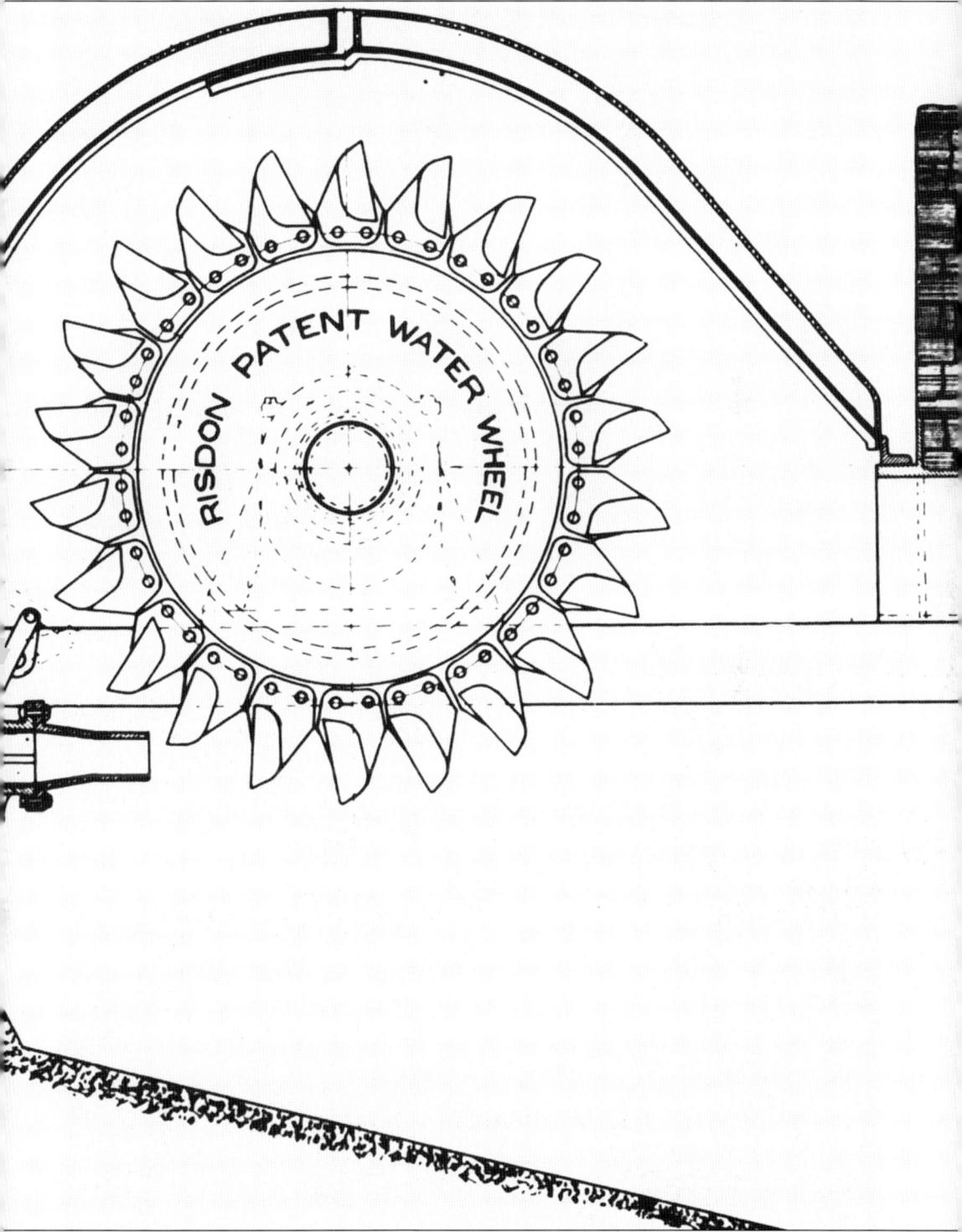

buckets on the wheel, as opposed to an overshot wheel that might be used in a slower-rotating waterwheel. The jet is adjustable in a number of ways to control speed and efficiency.

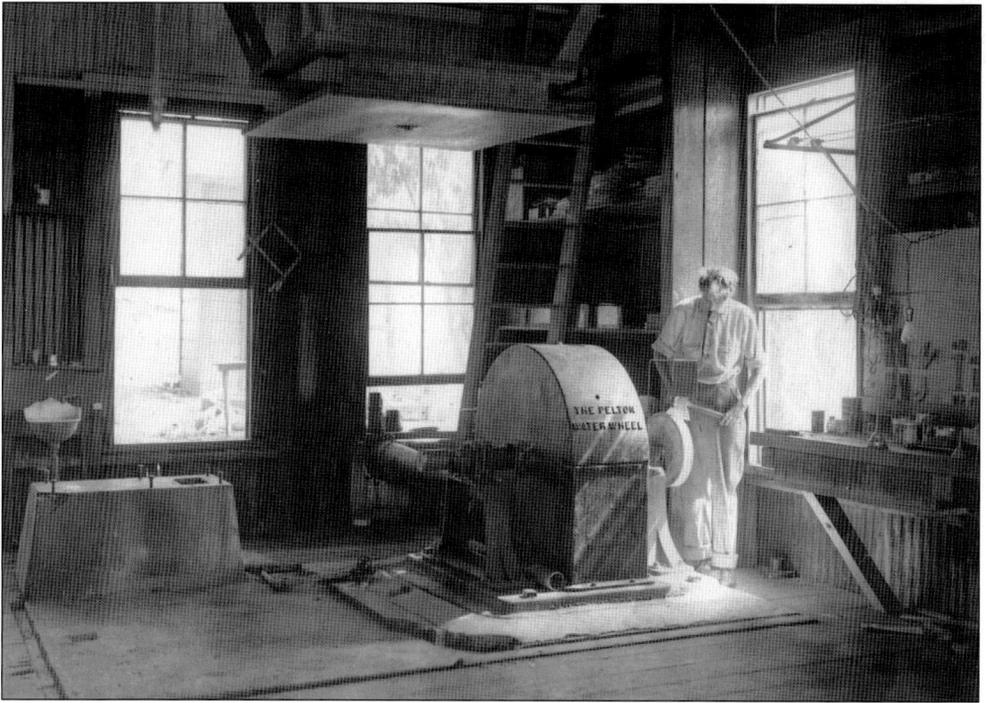

While a Pelton wheel might be used to power a large generator, it could also be used effectively for tasks requiring less force, such as turning a grindstone at the Newcastle Powerhouse.

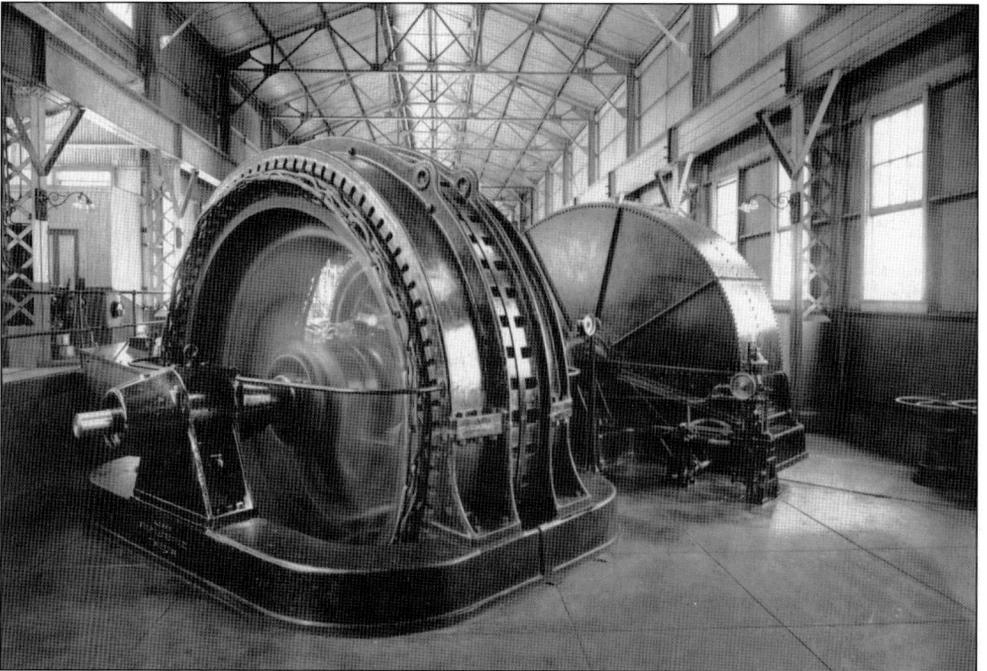

This photograph illustrates the mechanical connection between the waterwheel, in the background, and the generator it drives, in the foreground. Here, at the Electra Powerhouse, a Pelton wheel is driving a 200-kilowatt generator, one of five at the site.

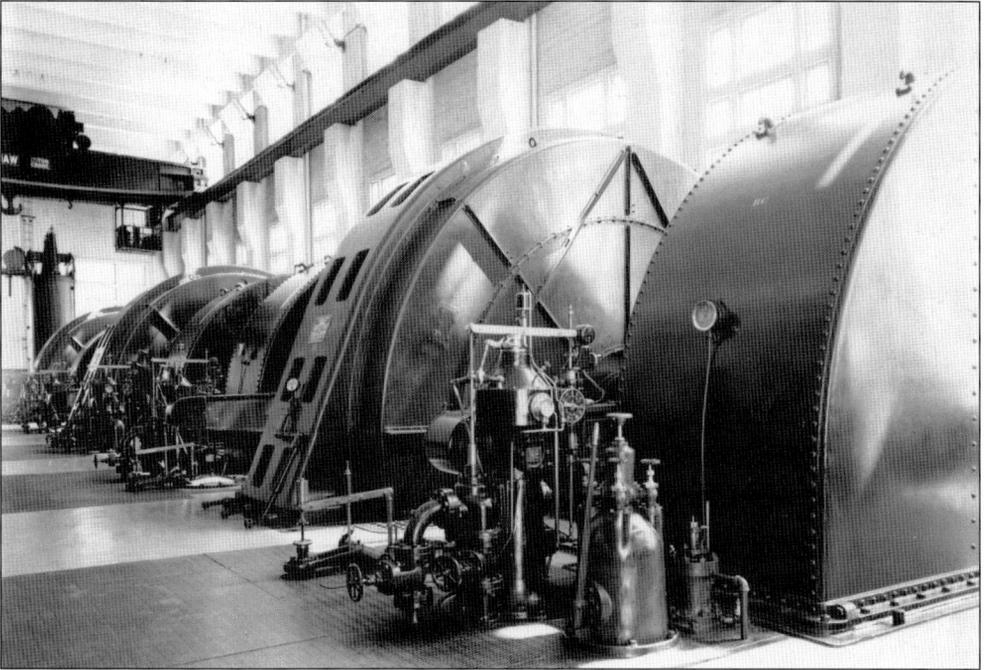

This view of a waterwheel and a generator at the Caribou Powerhouse in 1936 provides detail of the speed-regulating and aiming mechanism of the water jet. The speed of the wheel had to be precise to generate an alternating current voltage of the right frequency.

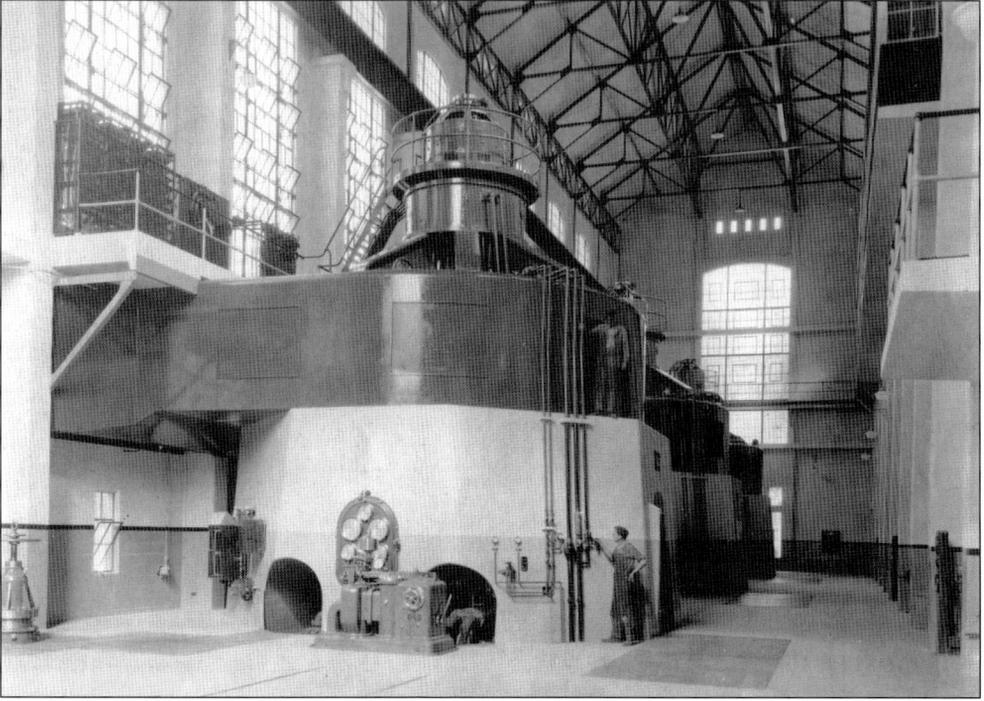

Installations could be small, as at Caribou, or much larger, as pictured in this 1925 photograph of the interior of Pit River Powerhouse No. 3.

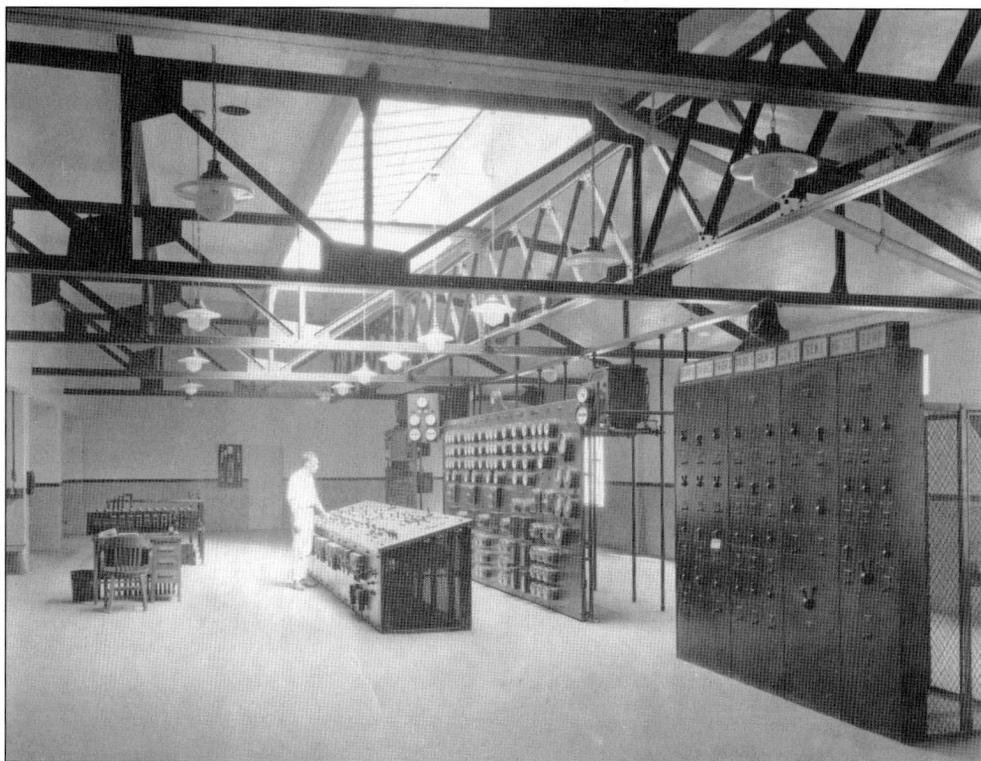

Pit No. 3 was the largest project on the Pit River. This September 1925 view of the switchboard and operating floor shows a functional and efficient control system.

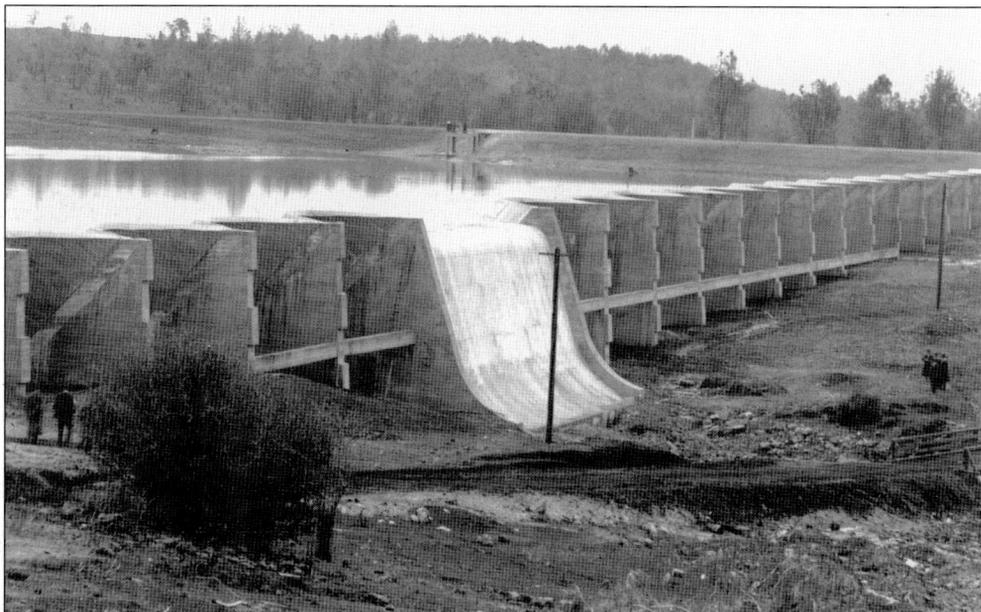

This is a photograph of a "regulating forebay," a body of water held in reserve to power a downstream generator. Today it is named the Rock Creek Reservoir and can be seen from Highway 49 in Auburn.

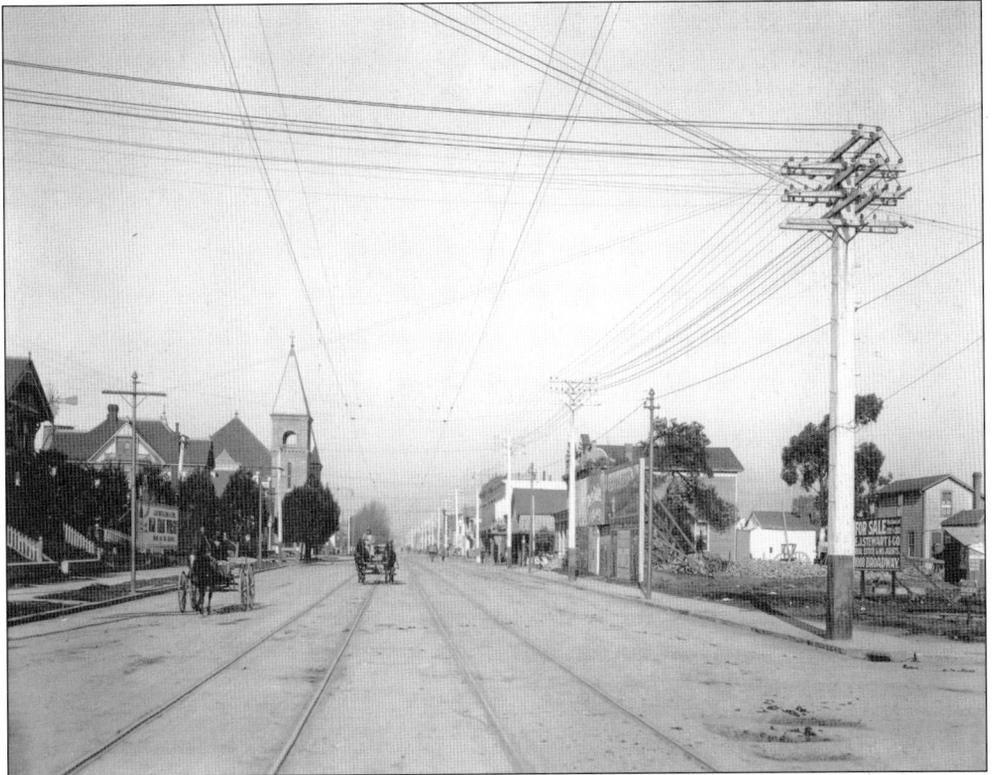

This was where all the electrical grid of the cities went. By 1900, aerial electrical lines covered most major cities.

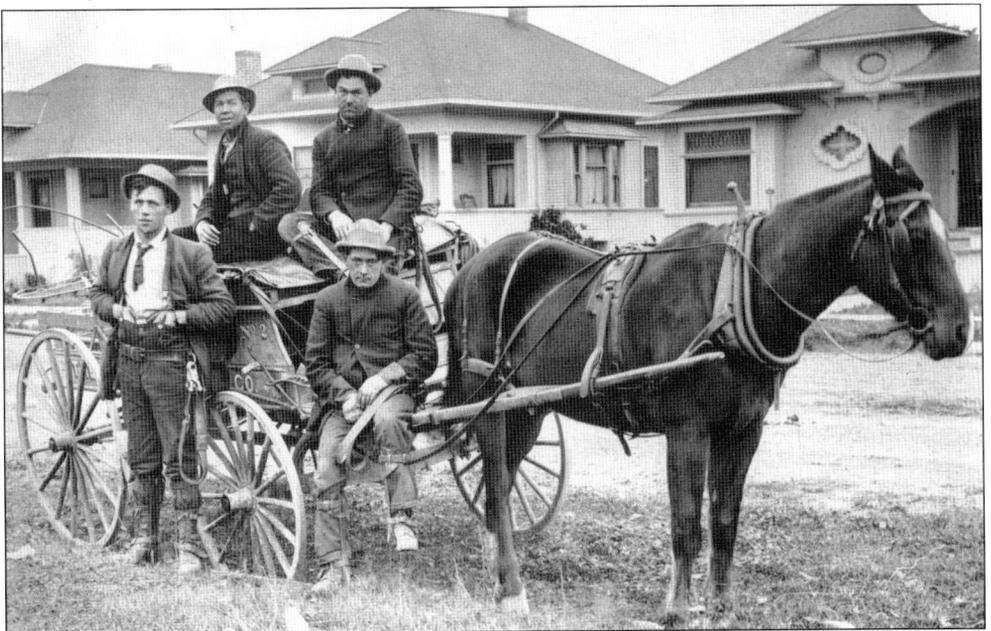

This photograph features early linemen. Note the pole-climbing hooks on their legs and their safety belts. This was a tough job, especially without hard hats.

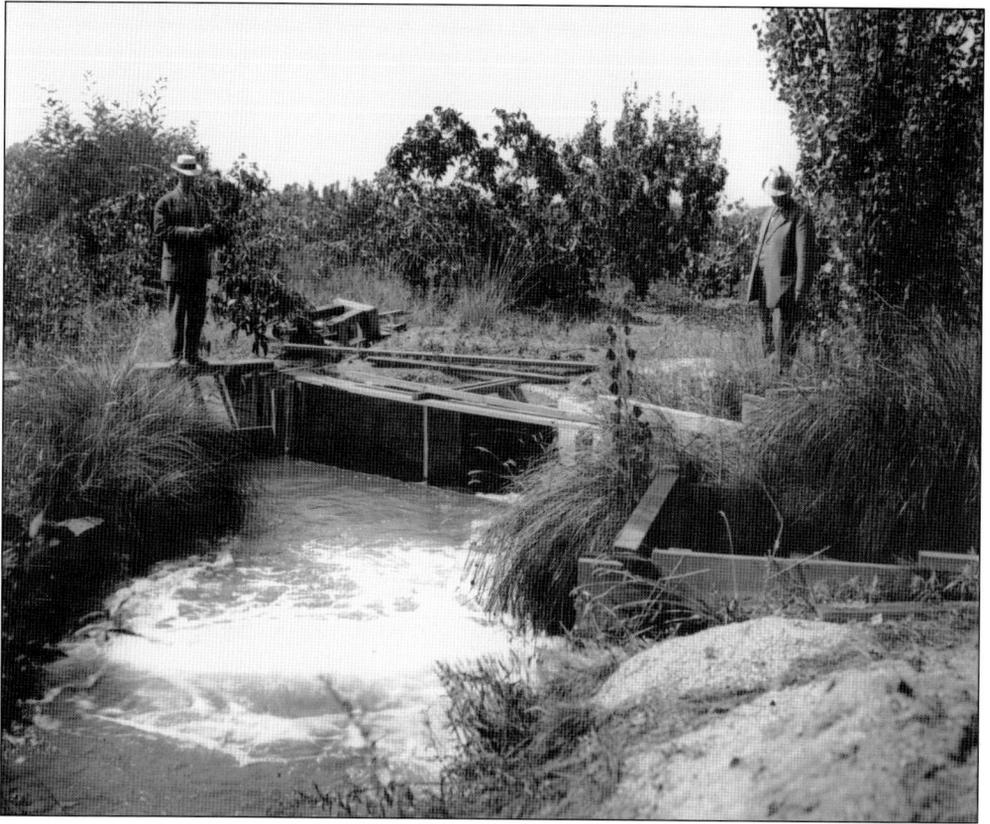

By the time the water finally descended to the Sacramento Valley floor, every watt of electricity had been squeezed from it. However, it had another, final use that was as valuable to the farmers of the valley as the electricity was to the city. Here the water from one of the flumes is channeled into an irrigation ditch.

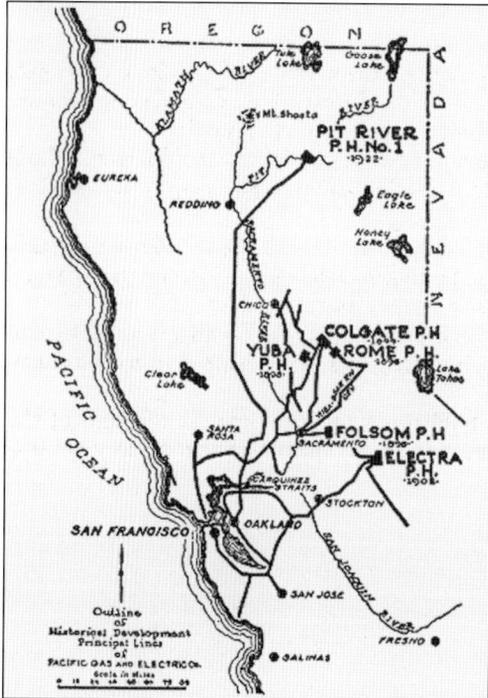

By 1929, power companies operated an extensive series of powerhouses in Northern California. This map shows major installations on the Pit, Yuba, American, and Mokelumne Rivers.

Three

CAMP LIFE
IN THE MOUNTAINS

A project to build a dam and an associated hydroelectric plant employed hundreds of people, sometimes for several years. Construction camps developed into self-contained communities, complete with cabins for living quarters, eating facilities, stables, and hospitals.

While mining camp life in California is well documented in journals and books, there is little source material to document daily life in dam construction camps. Photographs from various archives present the best detail.

Judging from the attention early photographers focused on camp kitchens, food was a primary concern of the workers. A 1912 photograph of the Drum/Spaulding camp kitchen shows a staff of 10 preparing meals in a well-equipped, but clearly temporary, tent facility.

Photographs of the same camp show the camp doctor in his lab. Although the room is clean and electrically lit, it also is temporary. Another photograph shows a worker recovering from an arm injury.

Dam builders appreciated the value of good publicity. Depression-era photographs of the dedication of the Salt Springs Dam show a small army of "motion picture operators" documenting the grand event for the public.

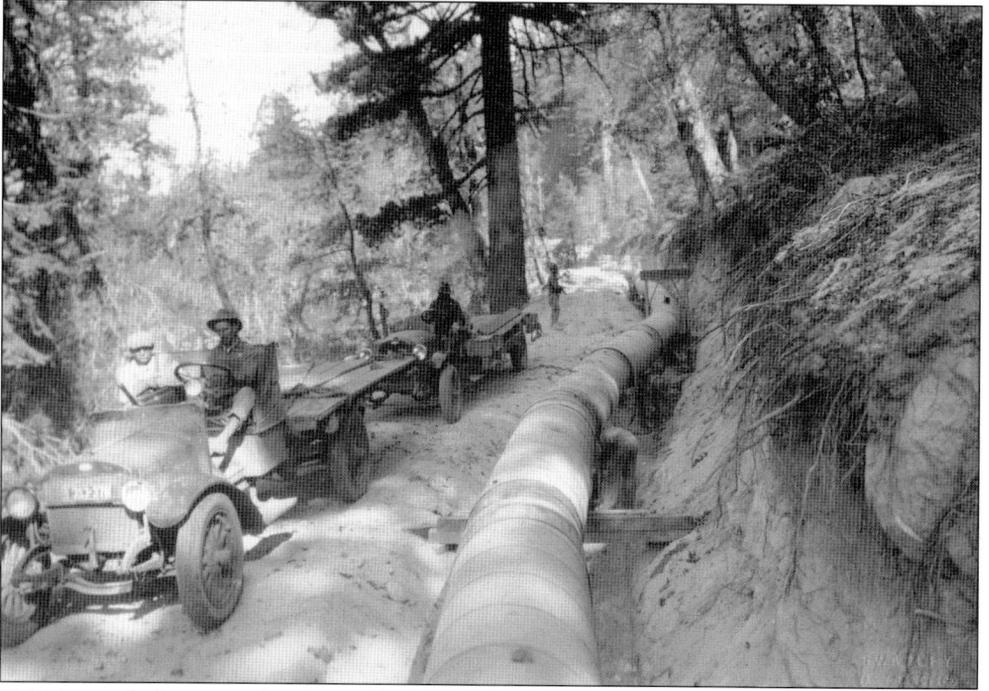

Vehicles work their way along a winding penstock laid crudely on the forest floor. While some penstocks were buried in ditches, others remained partially exposed. The Wise penstock is visible from several Auburn neighborhoods.

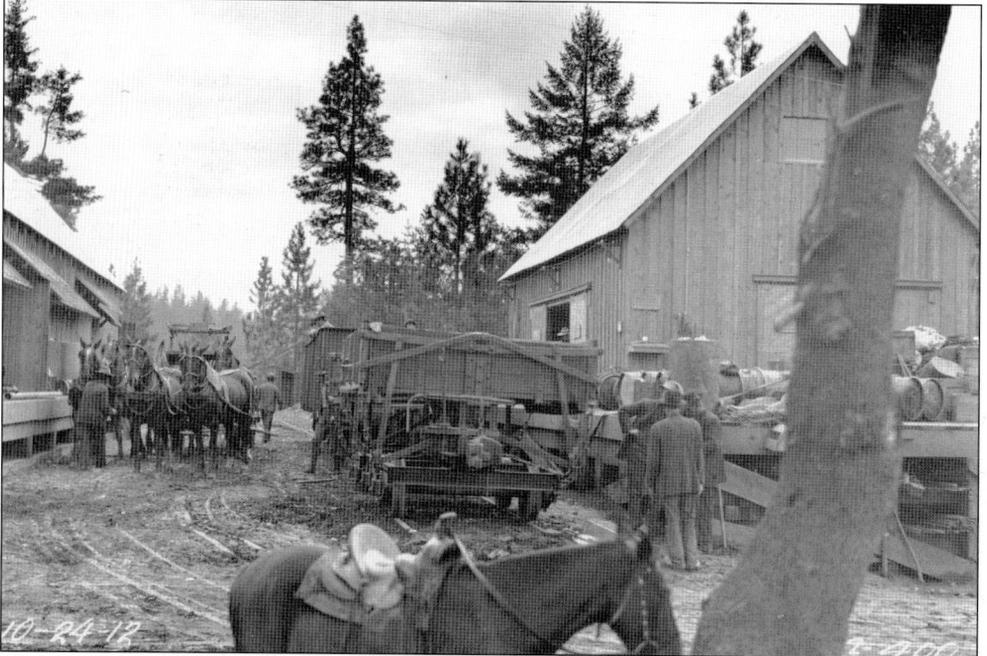

This 1912 photograph of the Spaulding Camp shows three modes of transportation in use—a wagon pulled by mules, a railcar, and a horse. Maybe a Model T motorcar is just around the corner, ready to drive into view.

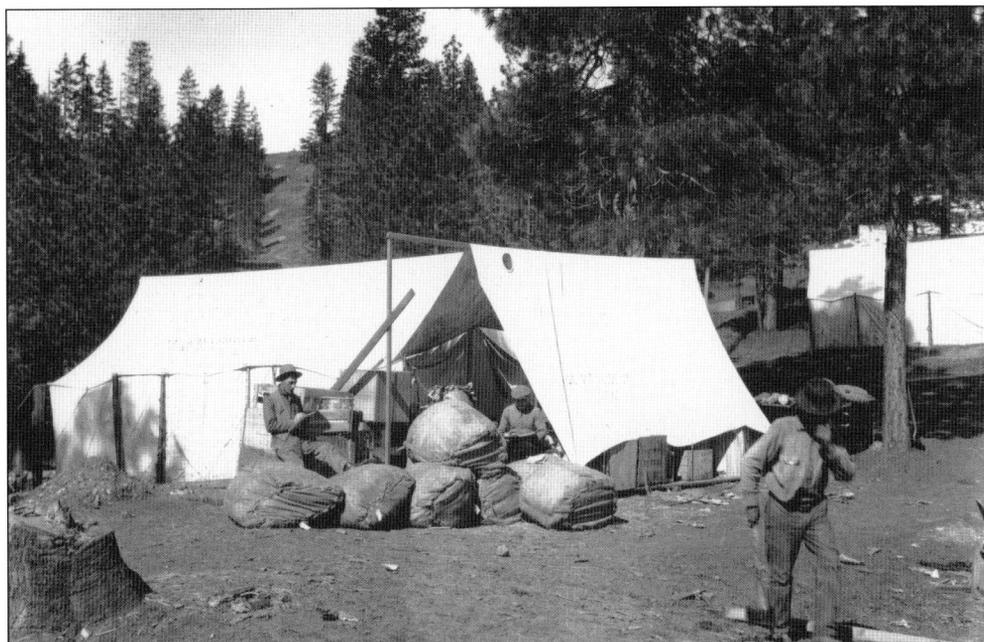

Supplies are unloaded and stored at the Spaulding Camp. The fellow with the clipboard is, as always, in charge of the process.

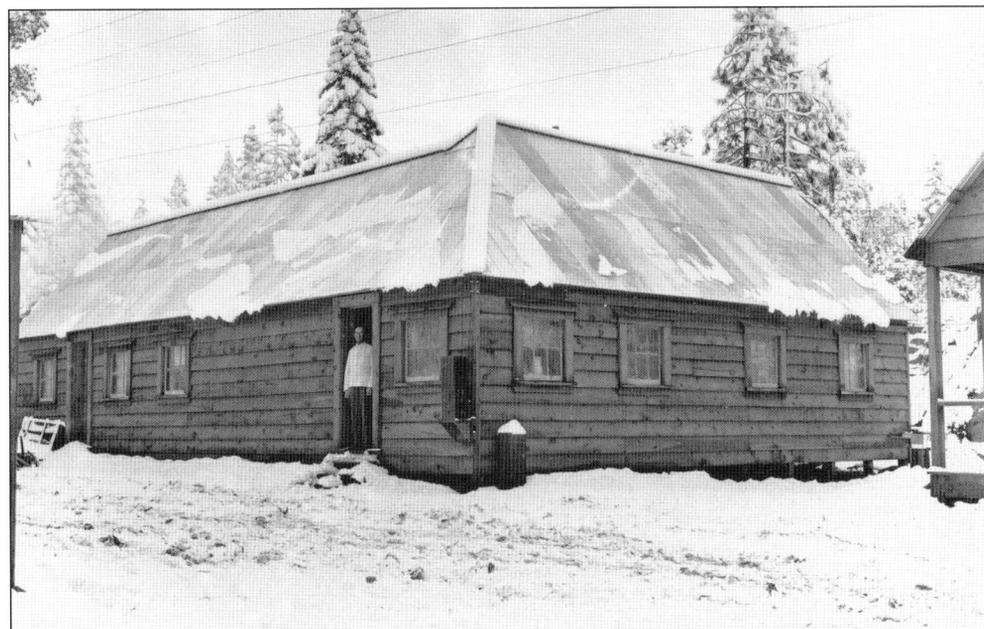

The camp doctor stands at the door of his infirmary at Spaulding. Note the steepness of the roof pitch and the condition of the road. Little detail survives on the status of work during the winter, which would have been difficult in the heavy snow at 5,000 or 6,000 feet in elevation.

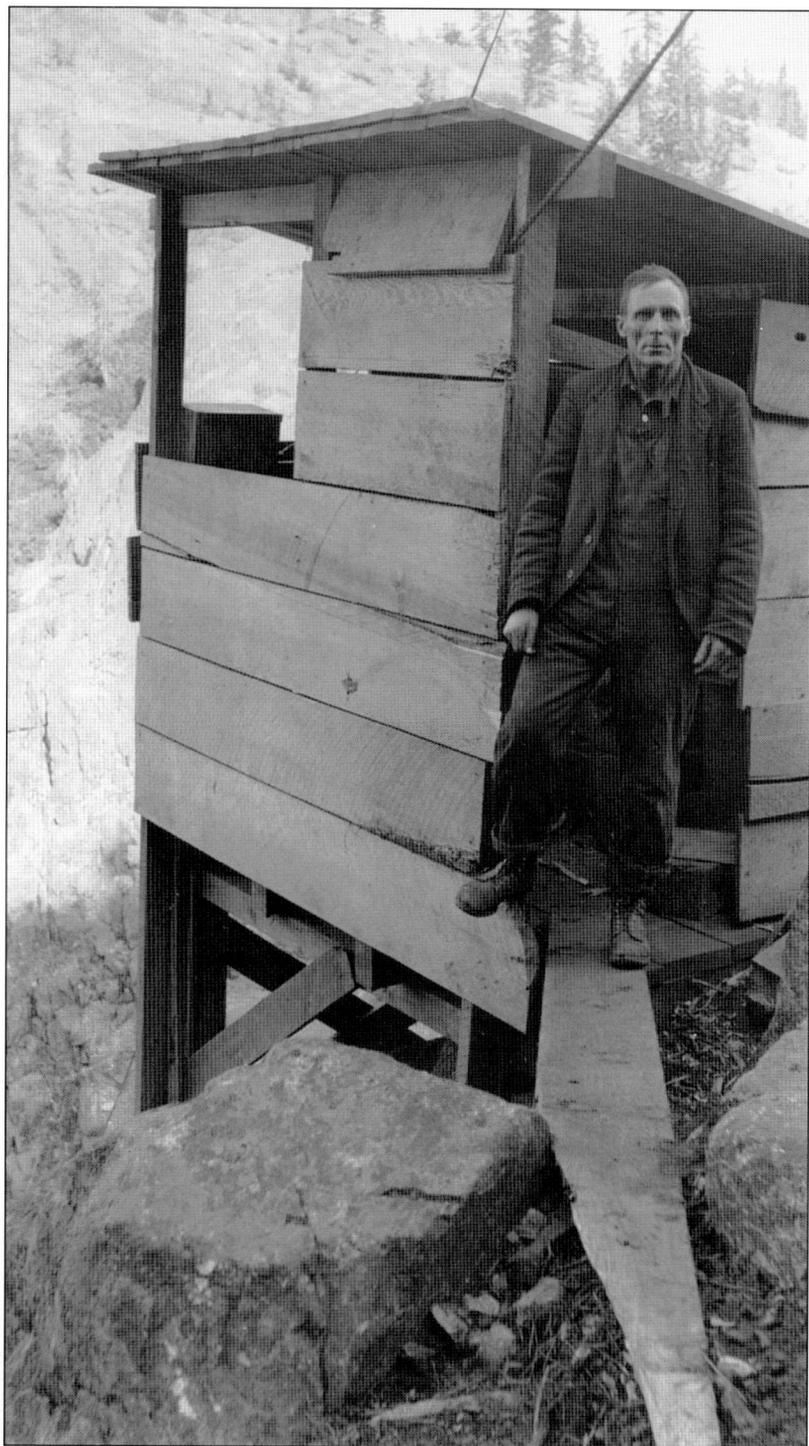

This earnest gentleman gazes at the camera from his workplace, which appears to be a signal shack at Spaulding. Several projects, including Spaulding and Drum, were inaccessible by road, and all material and personnel traveled to the work site via trams, which ran down the canyon wall.

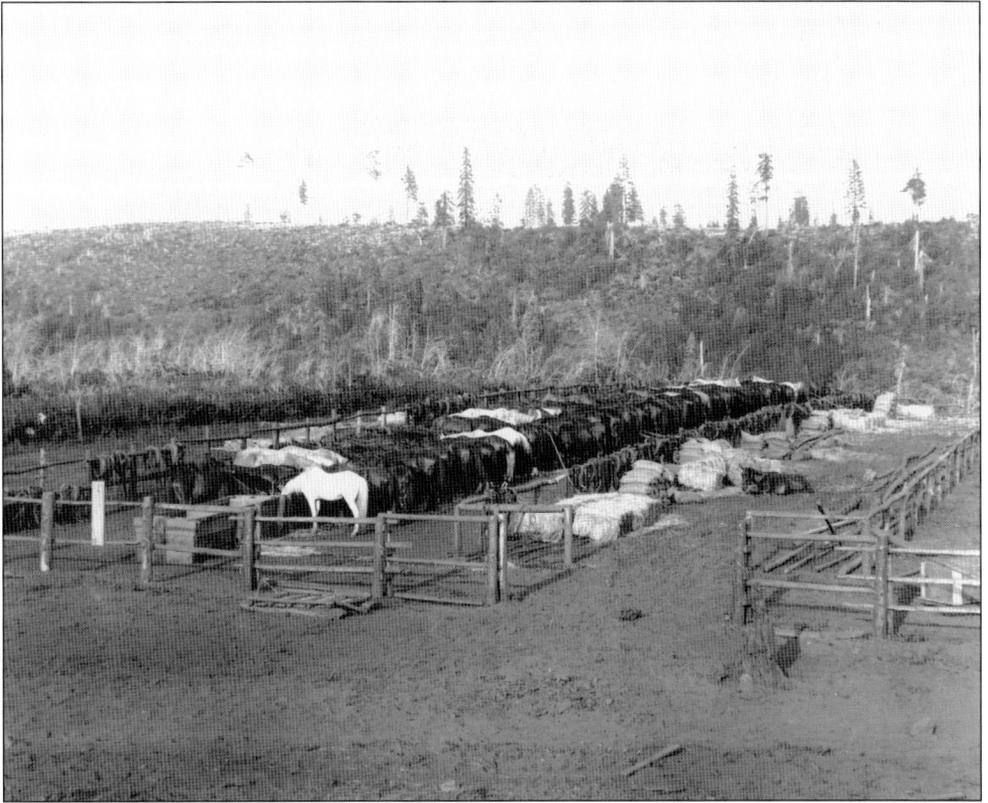

Horses and mules provided most of the motive force for the Spaulding project. Constant hard work meant they needed feed brought to them on the project. No days off to graze in the lush mountain meadows.

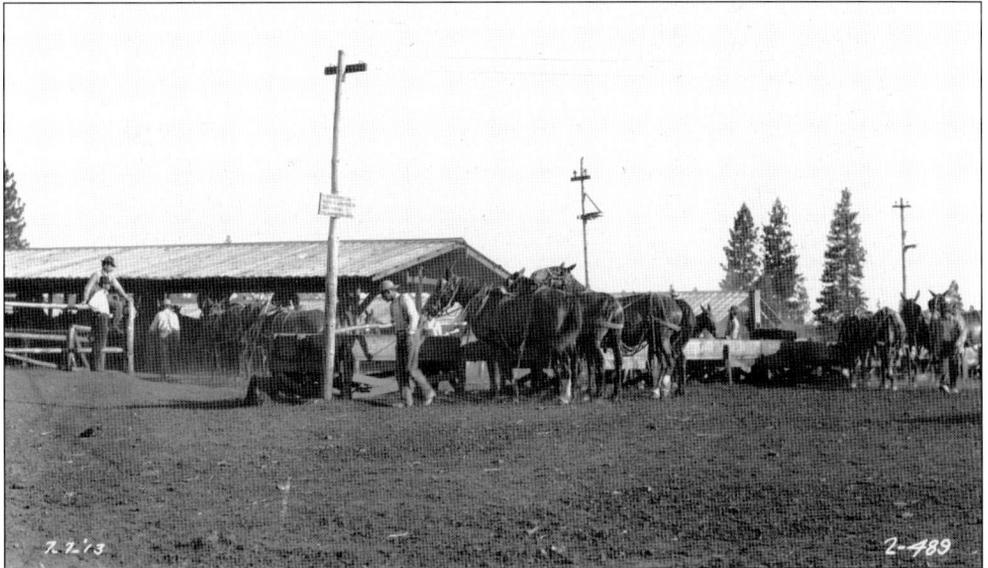

The sign attached to the post at this 1913 work camp notifies workers that smoking is forbidden around the stables.

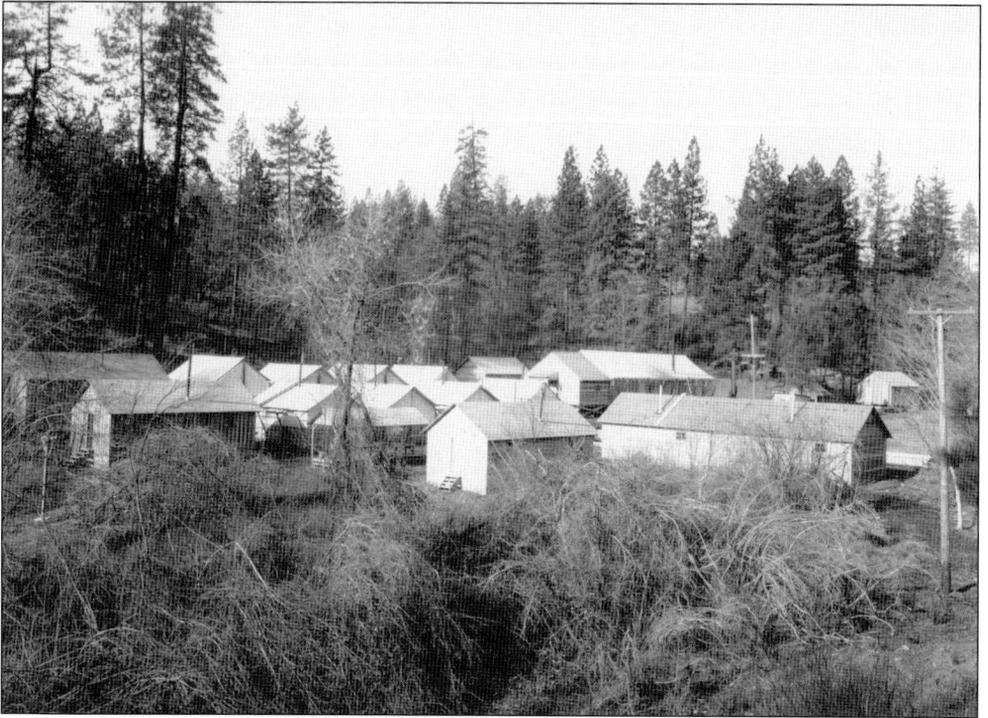

Pictured here in 1930 is a wintertime camp, located near the Bear River Canal. Despite the date of January 2, the ground is free of snow.

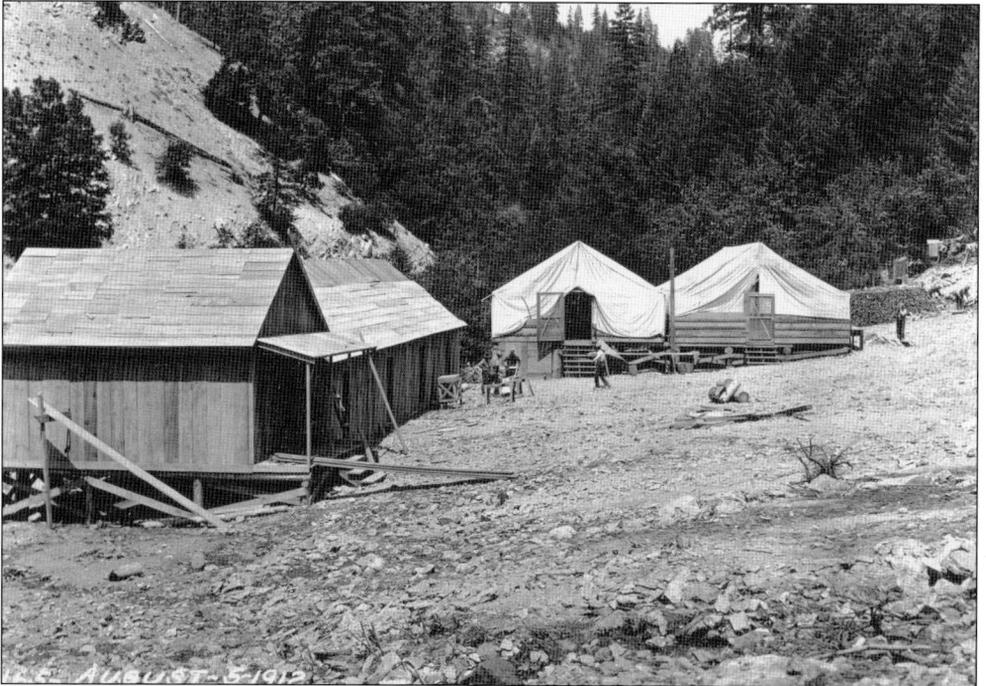

In the summer of 1912, Spaulding workers lived in a combination of temporary buildings covered with canvas tent and permanent buildings built of wood, complete with front porches.

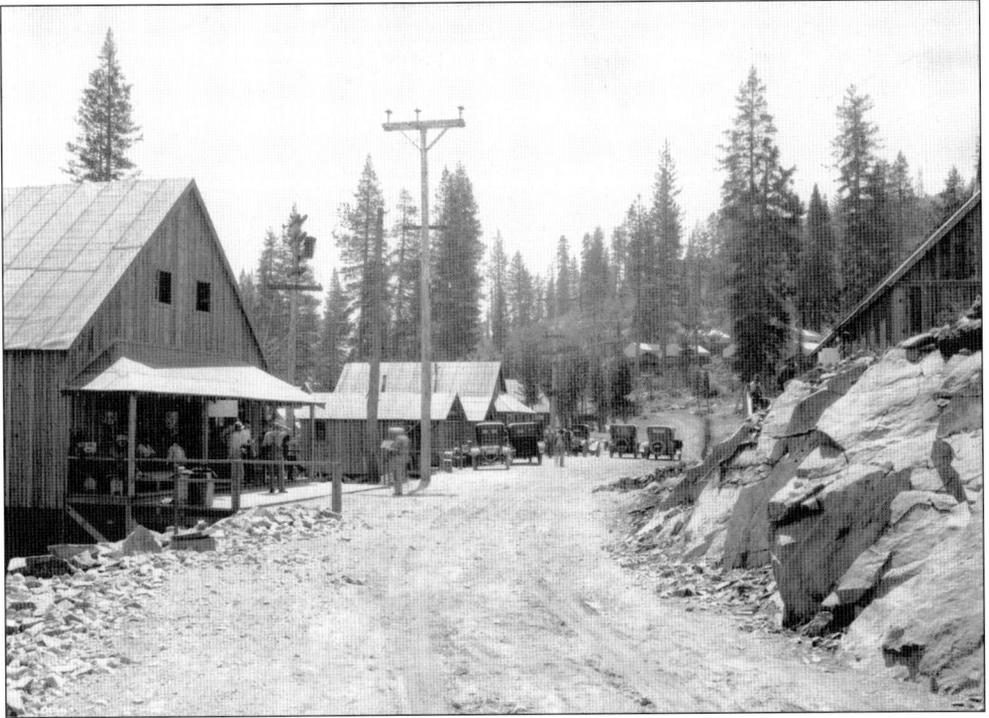

Electricity and automobiles had replaced steam power and mules by the time this photograph was taken at the Fordyce Camp in 1924, just 12 years after Spaulding was built with animal power and steam.

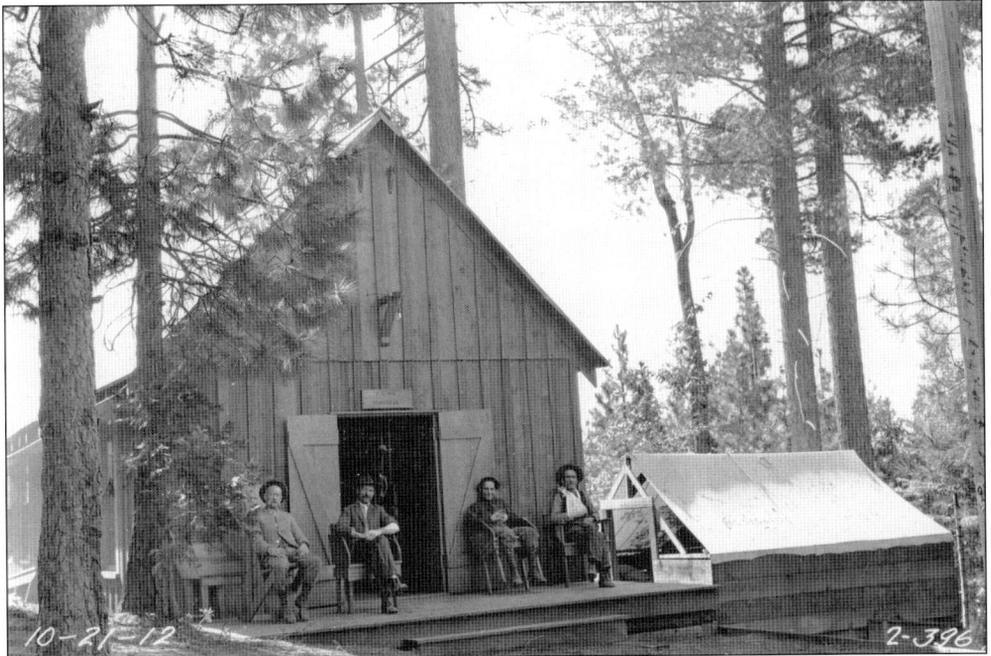

10-21-12 2-396

Here a worker recovers from an injured arm in 1912. The sign on the building identifies it as PG&E Hospital.

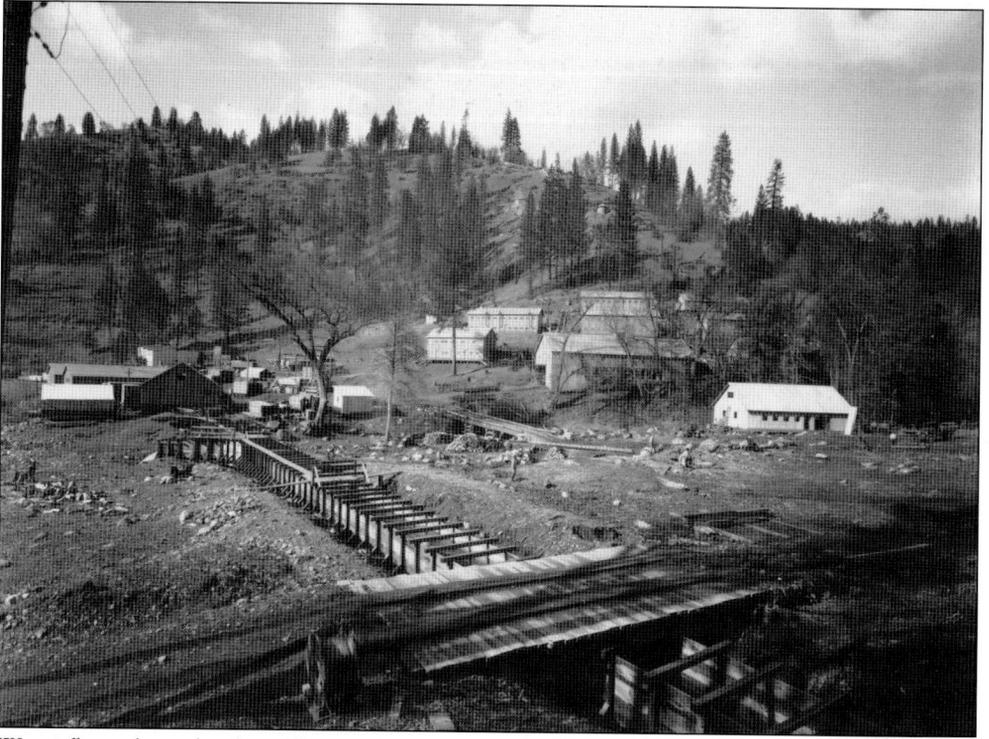

Water flows through a large flume at the Tiger Creek Camp in 1930. It appears to run into the building in the background, where its use can only be guessed.

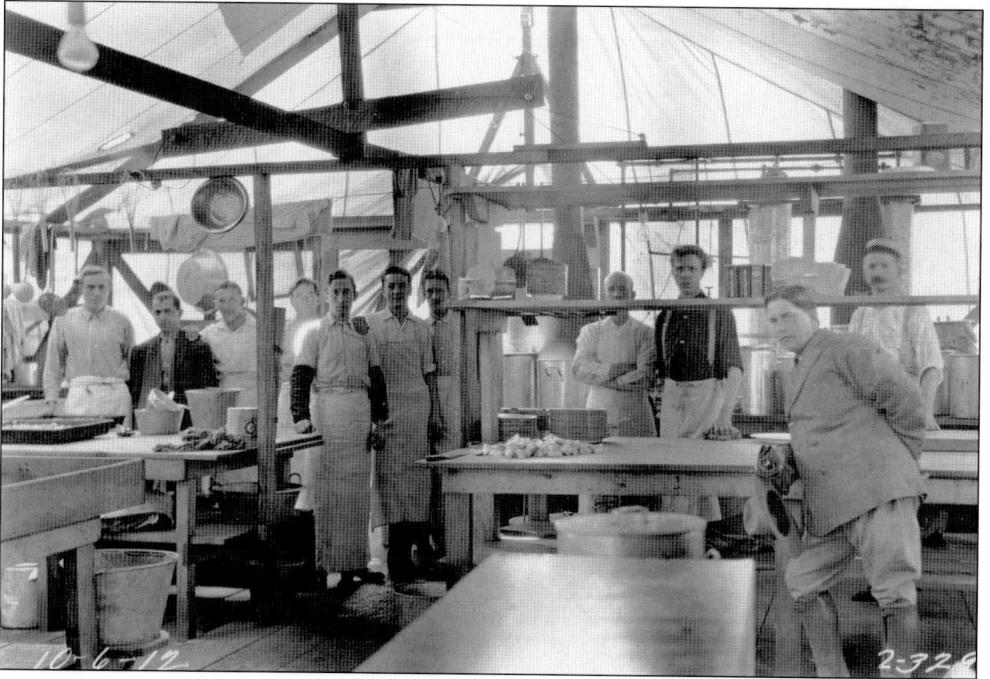

A kitchen crew of 10 plus a visitor in a suit and tie pose for a photograph at the Spaulding Camp in 1912.

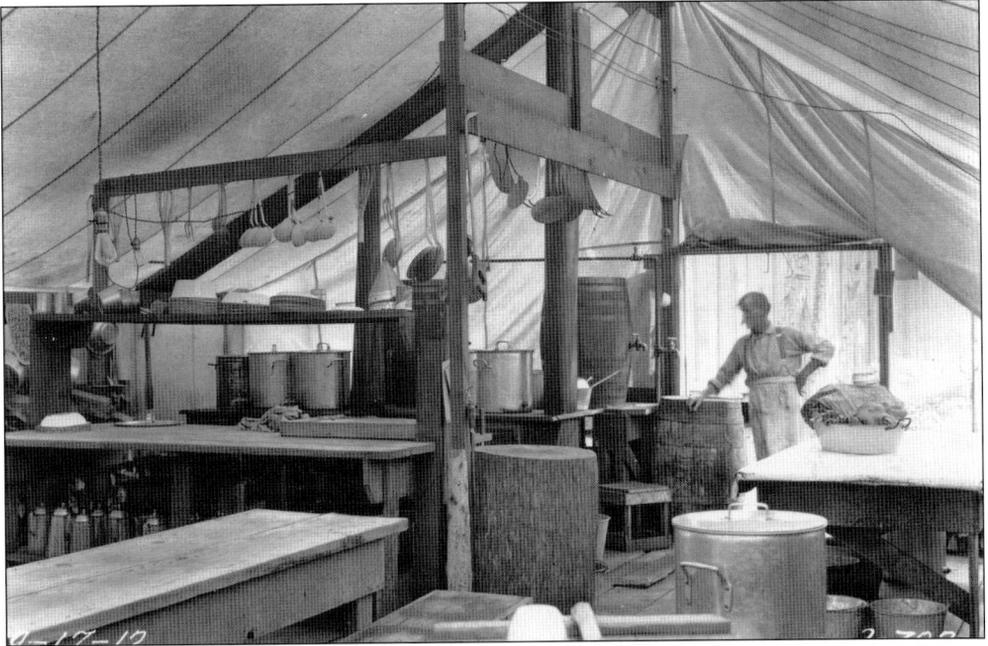

One has to improvise when the kitchen is 100 miles from nowhere; in this case, a stump of a pine tree is used as a chopping block.

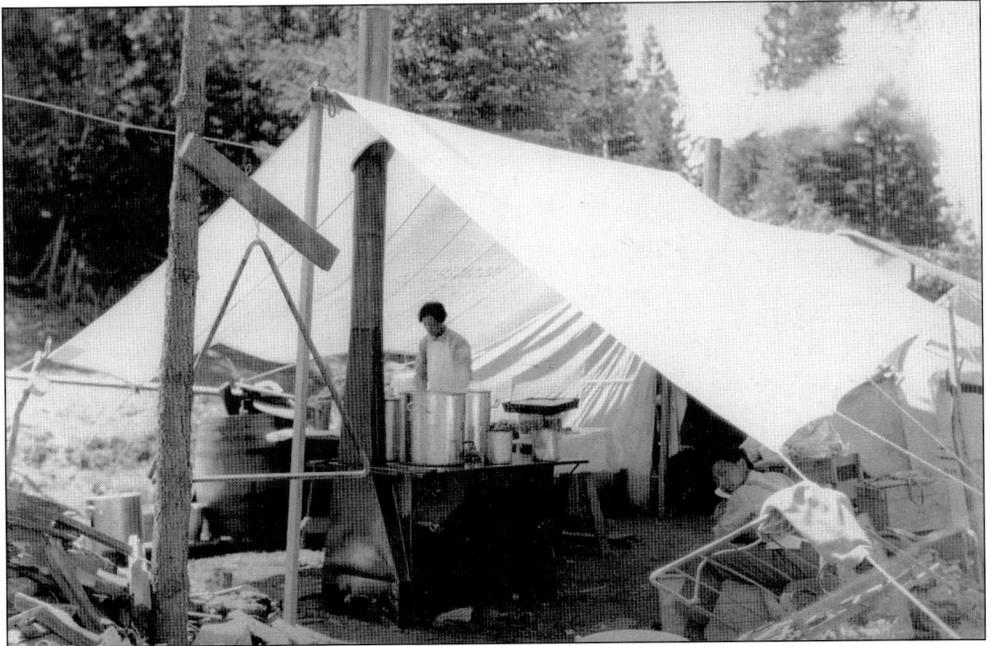

It appears from this photograph that the cookstove at the Spaulding Camp was separate from the main kitchen, probably for fire-safety reasons.

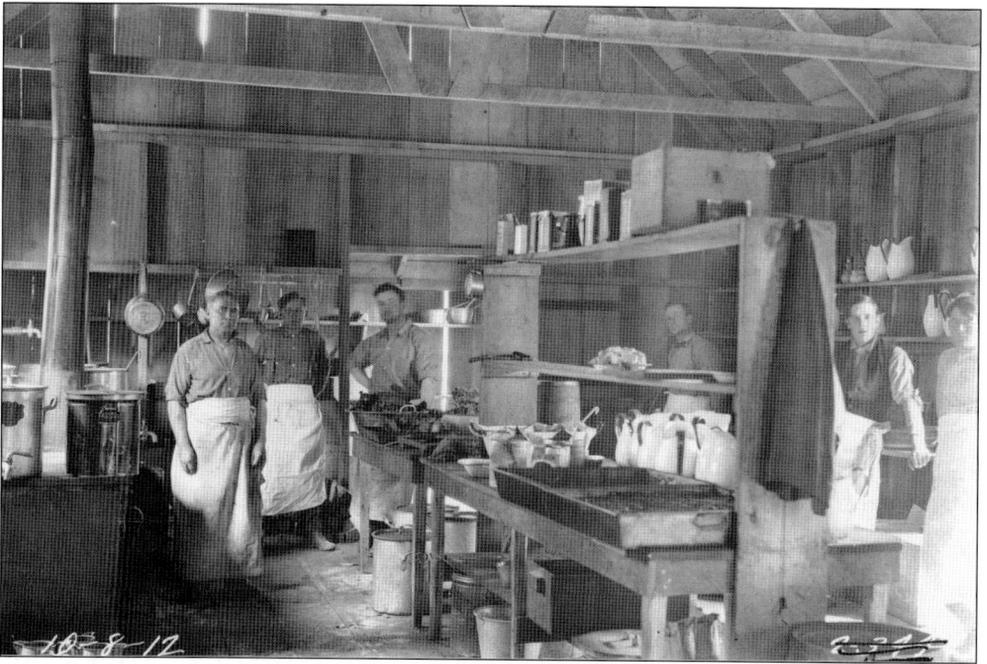

This photograph was also taken in the Spaulding Camp but of a different kitchen. The photographer's notes indicate it served a boardinghouse. Note the permanent construction.

Apparently the cook at the Electra Camp in 1912 was renowned for his skills. The photographer records his name as "Ah Charlie," and his assistant as "Electra." The fellow in the foreground is probably the chauffeur of the executives who visited the camp with the PG&E photographer.

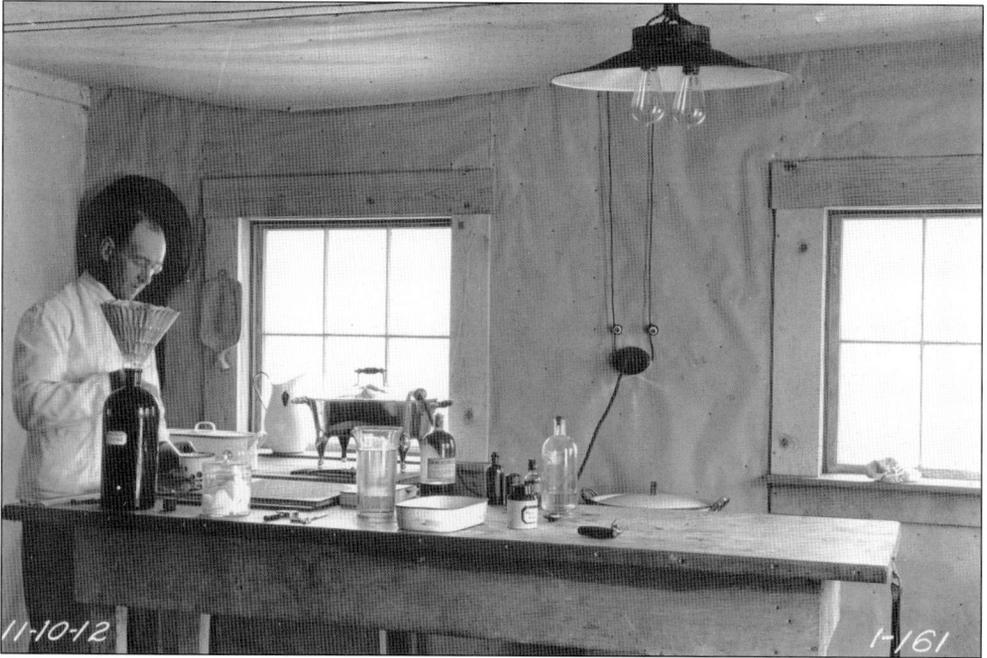

The camp hospital at the Drum Powerhouse construction camp is pictured here in 1912, and it appears to be clean and efficient. However, the medications on display are limited. The dark bottle near the doctor appears to contain a sulfa compound.

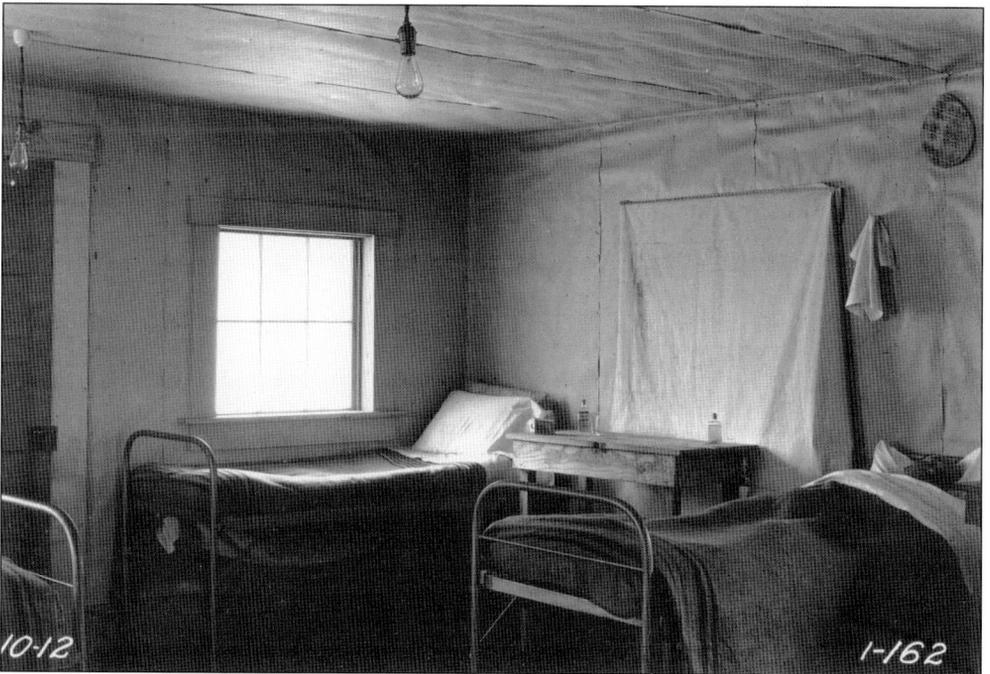

An unfortunate worker lies in a hospital bed at the Drum Camp. Specialized medical care in Sacramento was 100 miles away on primitive roads.

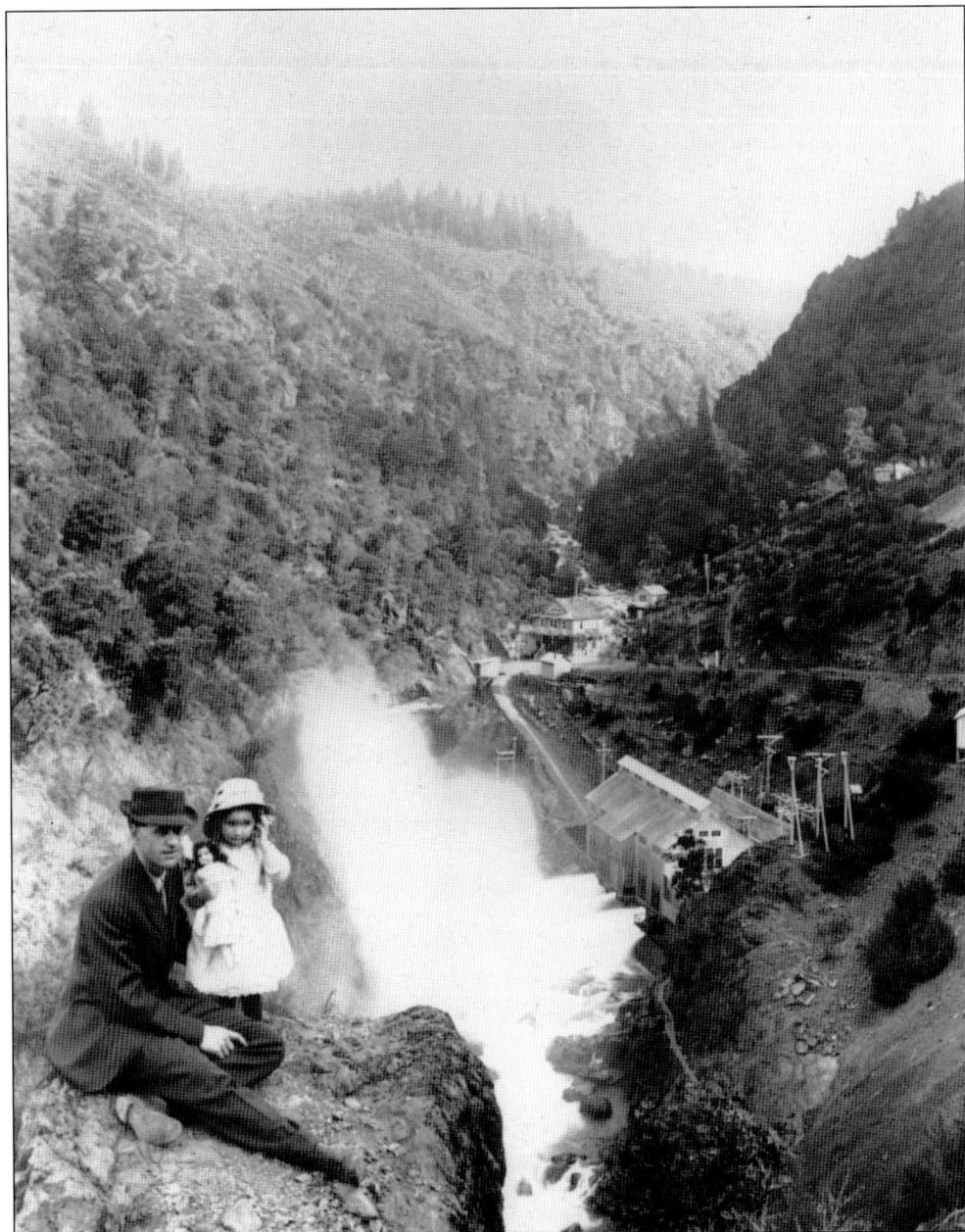

The location in this photograph is the DeSabla Plant, and the emotion of the moment is apparent. A man takes his daughter to see the powerhouse where he works. Note the little girl's doll.

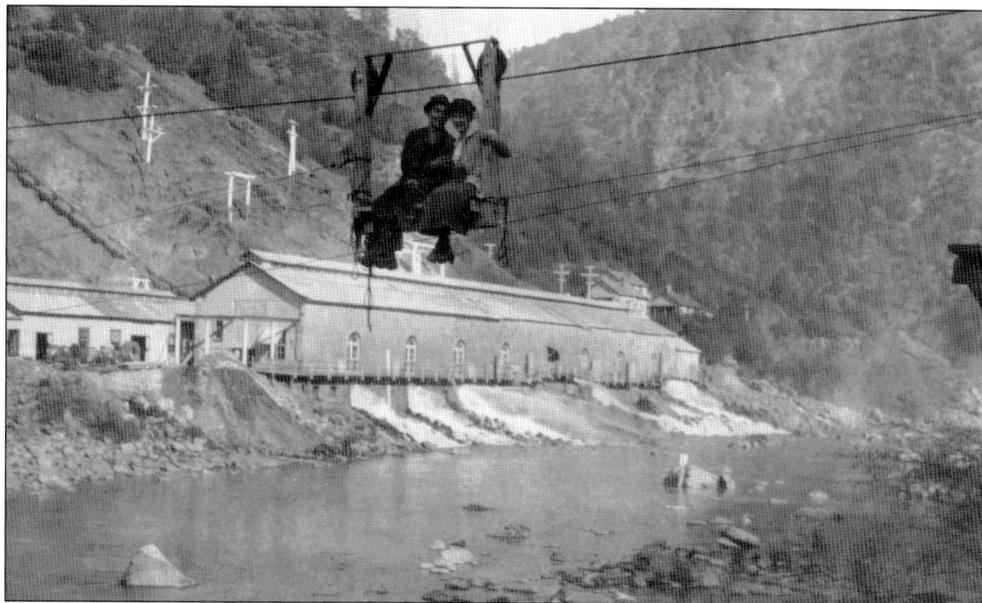

This photograph documents a merry day out for a couple at the original Colgate Powerhouse in 1916. The building was subsequently replaced.

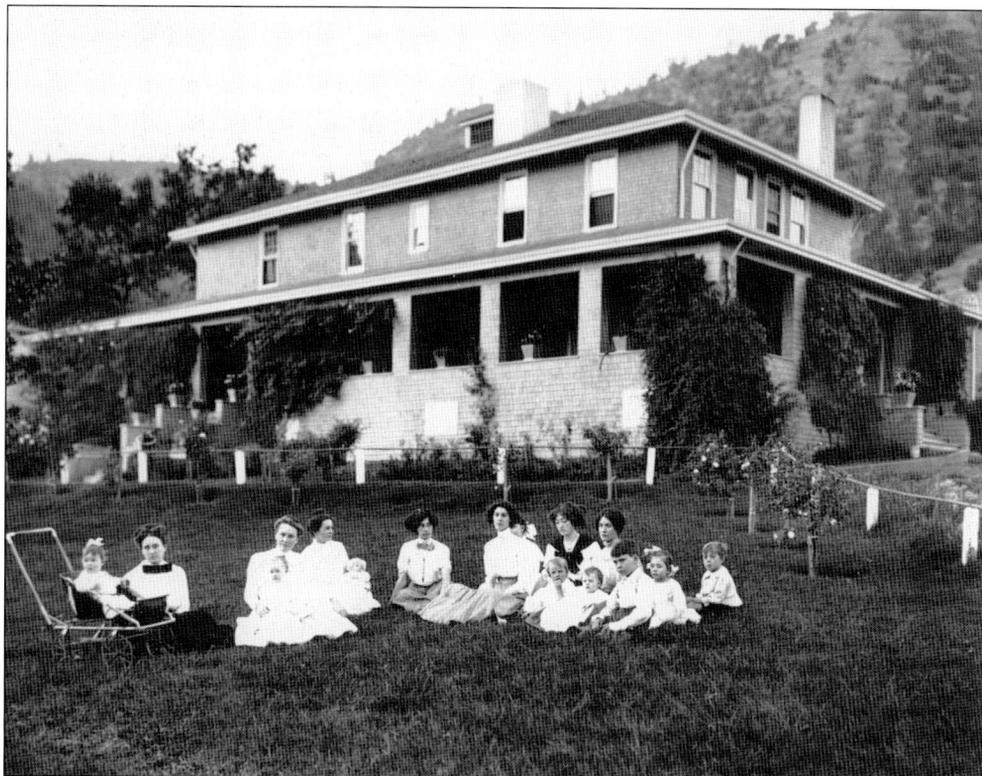

This building is identified as being at the Electra Powerhouse, but it is unclear if the families in the foreground live there. It is well maintained and landscaped and has the look of a boardinghouse.

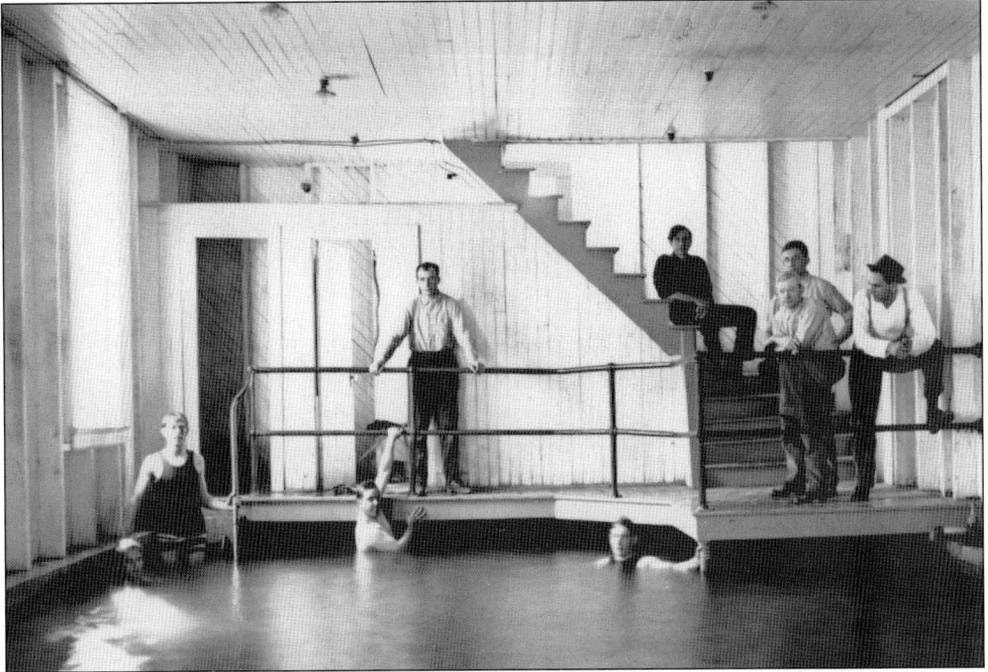

The Electra Powerhouse was one of the first built in Northern California. As this image demonstrates, the amenities of life could be pretty nice at a place like Electra once the construction phase was over and permanent quarters for the operators had been built.

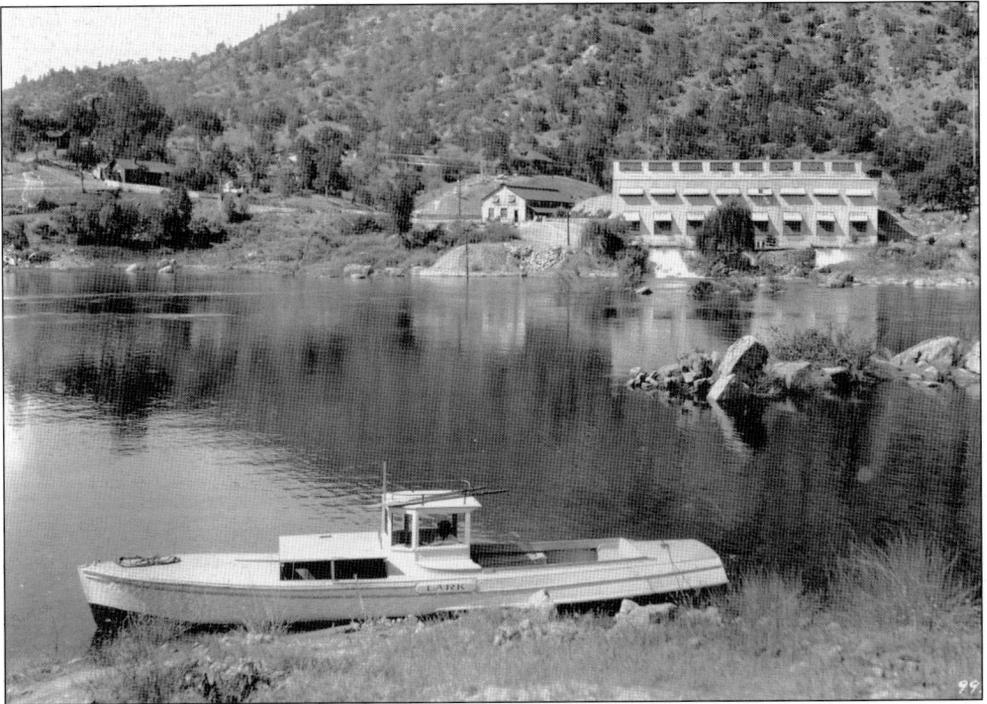

In 1939, if one was going on an adventure to the Wishon Plant on the San Joaquin River, it meant a jaunt on the company yacht, the *Lark*.

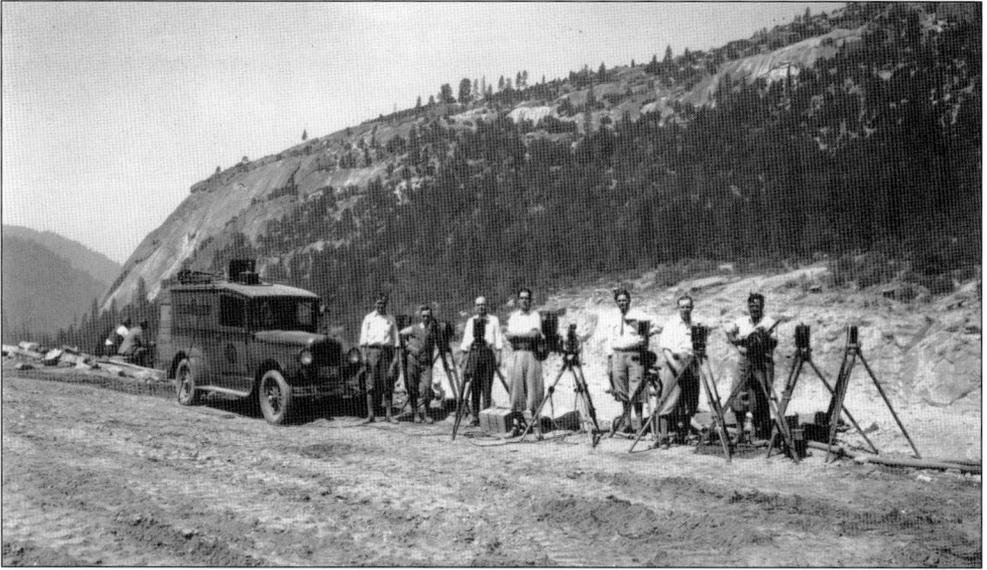

Archivists are uncertain of the year—possibly 1930 or 1933—but the purpose of this photograph is clear. "Motion photograph operators" have been invited to record the dedication of a hydroelectric facility.

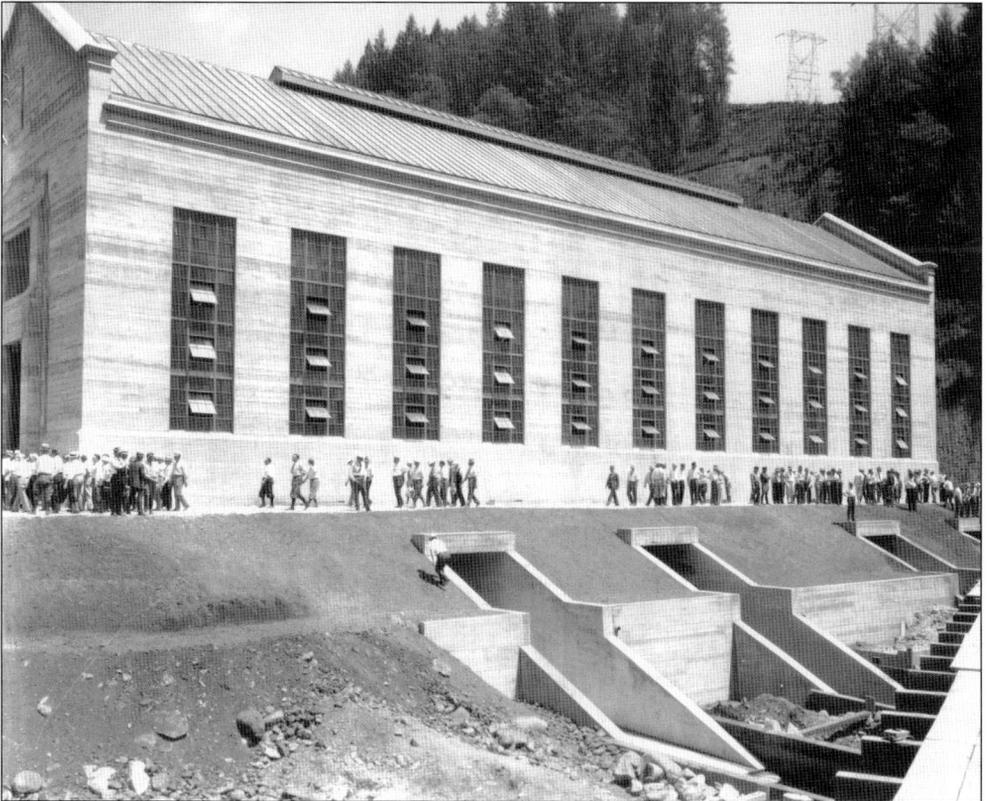

The date here is more precise. On July 12, 1931, in the depths of the Depression, reporters swarm around the Tiger Creek Powerhouse during its dedication ceremony.

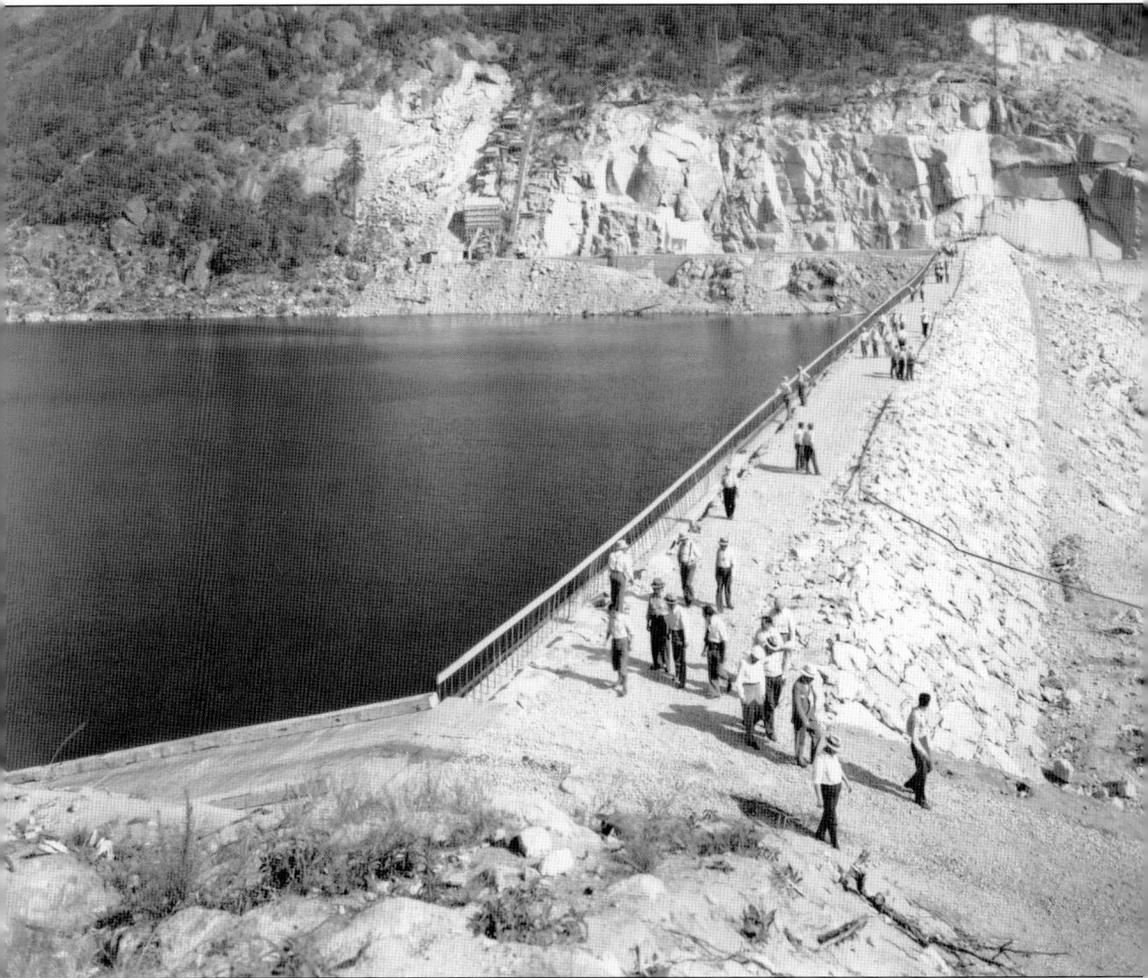

After their trek to the powerhouse, the newsmen got to walk across the newly finished dam. Hopefully their stories impressed the public back in Los Angeles.

Four

THE BUILDERS

Locations suitable for dam construction were well-known from the earliest days of California exploration, because agriculture required irrigation water during the dry summer.

Hydroelectric developers sometimes adapted existing irrigation dams, but in most cases (the old Spaulding Dam, for instance), they replaced existing pioneer dams with larger structures. Building the dams and hydroelectric sites were big projects, rivaling railroad construction for complexity and sheer quantity of manpower required. Initially, the tools that were used were basically the same as for railroad construction in the late 19th century: pick, shovel, wheelbarrow, and black powder. Steam shovels were deployed late in the 19th century.

Roads and bridges needed to be built to transport everything from food supplies to materials to make concrete. While the dam was being constructed, simultaneous projects building flumes and electrical transmission lines were under way.

Large units, such as generator windings, transformers, and sections of penstock pipe required unique transportation solutions. Locomotives were known to be lifted across canyons on steel cables. Twenty or more horses hauled generators on iron-wheeled wagons.

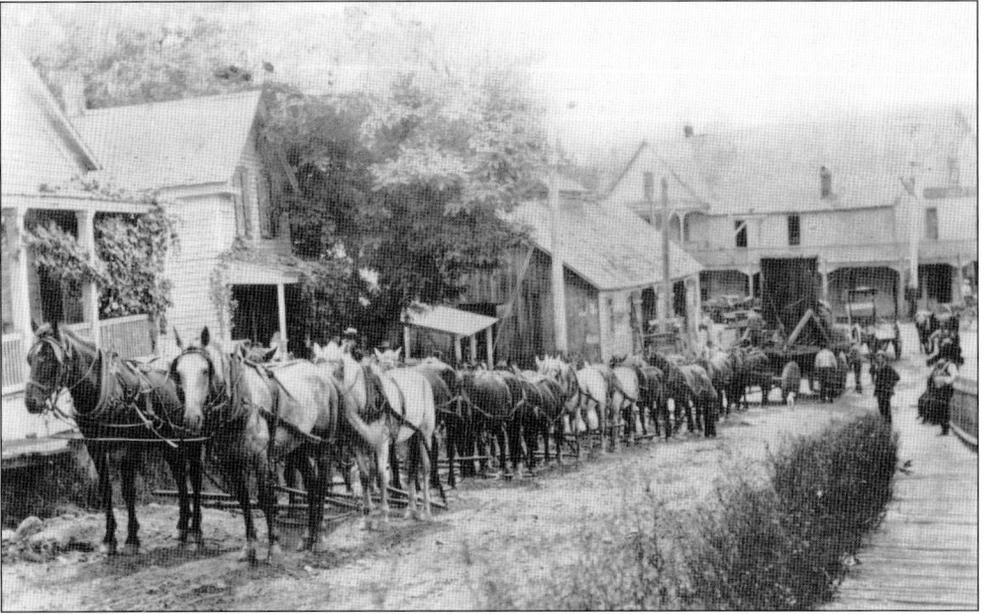

In 1903, teamster Charles Graham hauled his heavy load through the streets of Nevada City on his way to the Deer Creek Powerhouse. His horses pulled a 60,000-volt transformer on a trailer.

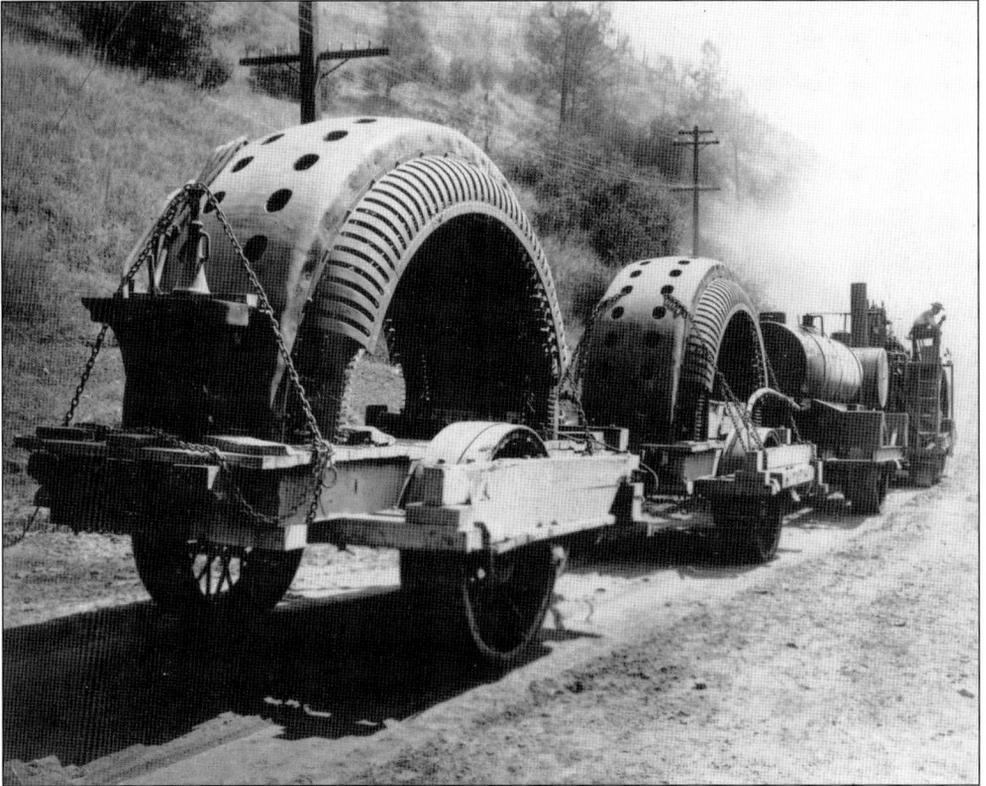

In 1906, a steam engine hauled the armature of generator No. 6 for the Electra Powerhouse, located on the Mokelumne River. Note the metal wheels of the trailer.

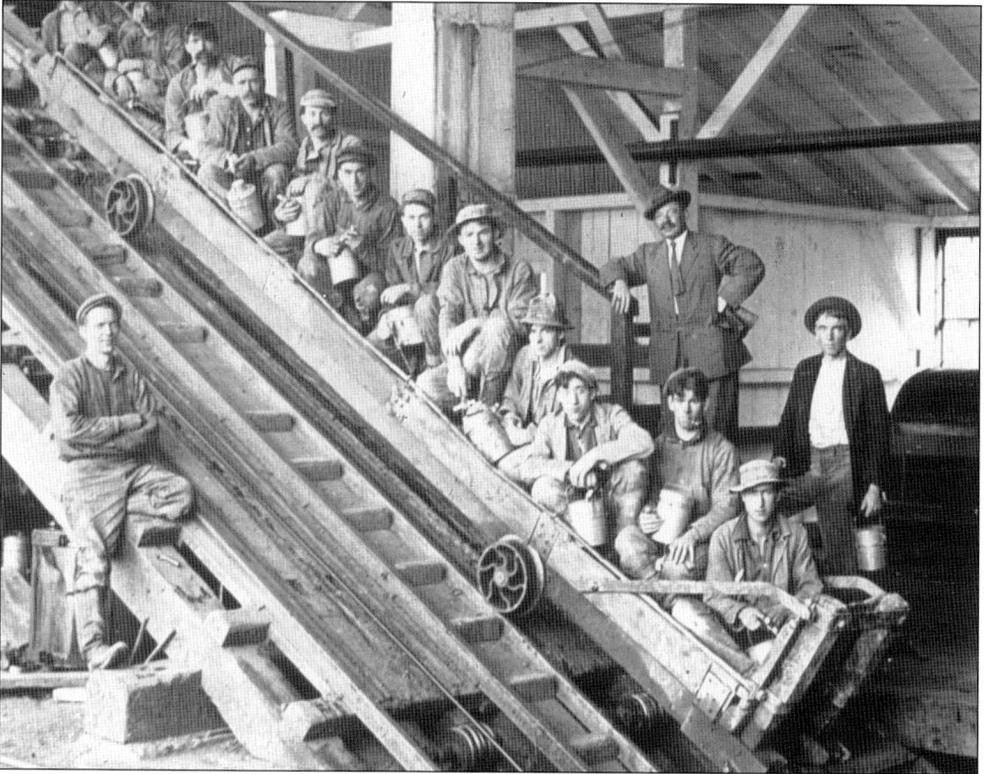

Mining companies had generated electrical power for some years for internal use. These miners at Nevada City worked with motors and air compressors that were electrically powered. The new commercial hydroelectric sites provided power to anyone who wanted to pay for it.

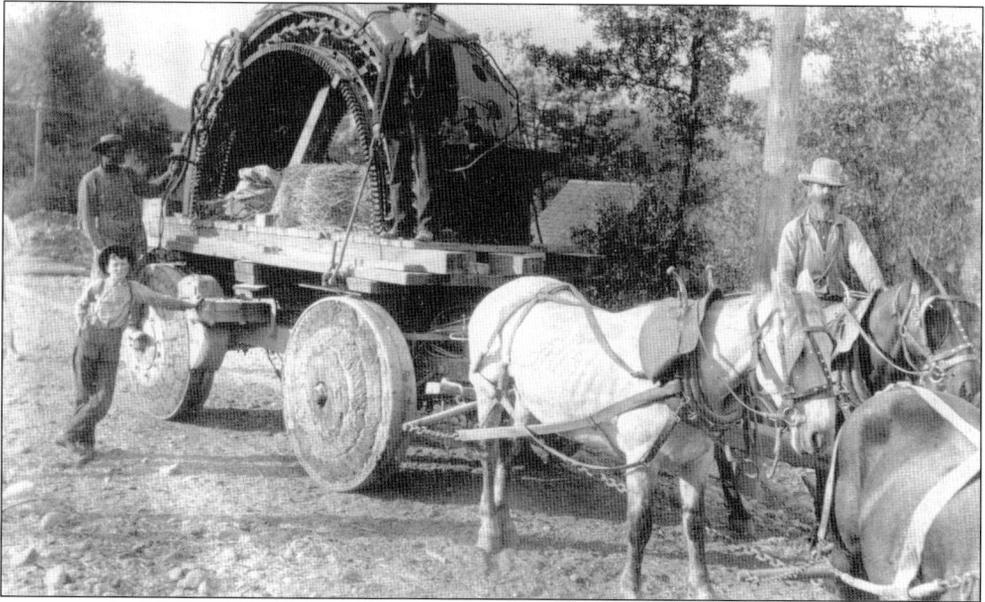

This photograph provides another view of a generator being hauled through the city streets. While a street urchin poses for the camera, the teamster and his thin, worn horses take a break.

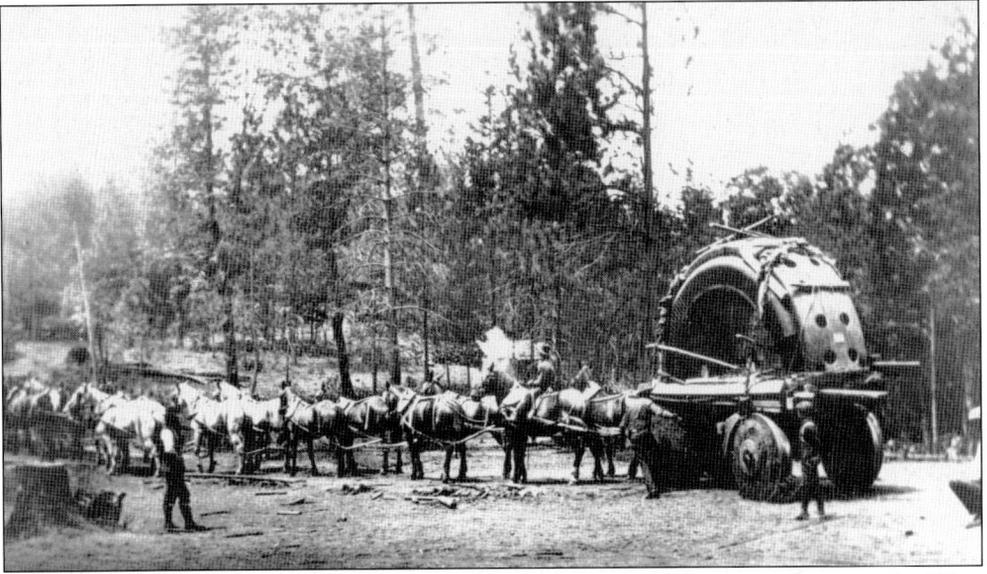

A mule train pulls a heavy object, probably an armature or stator winding, to the Wise Powerhouse. The railroad bridge in the background is still in use and can be seen from Interstate 80 in Auburn.

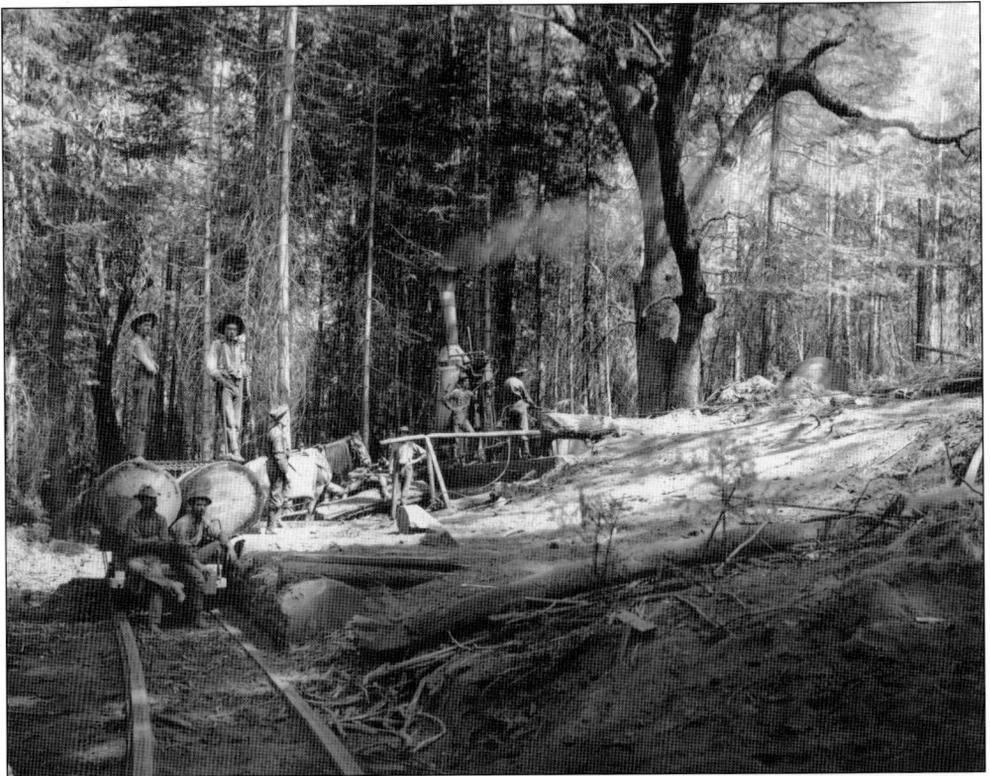

This is a steam-powered donkey engine pulling a small logging train to the construction site at the Spaulding project. Timber was harvested from areas to be inundated by the impoundment, and the lumber was used for flume construction.

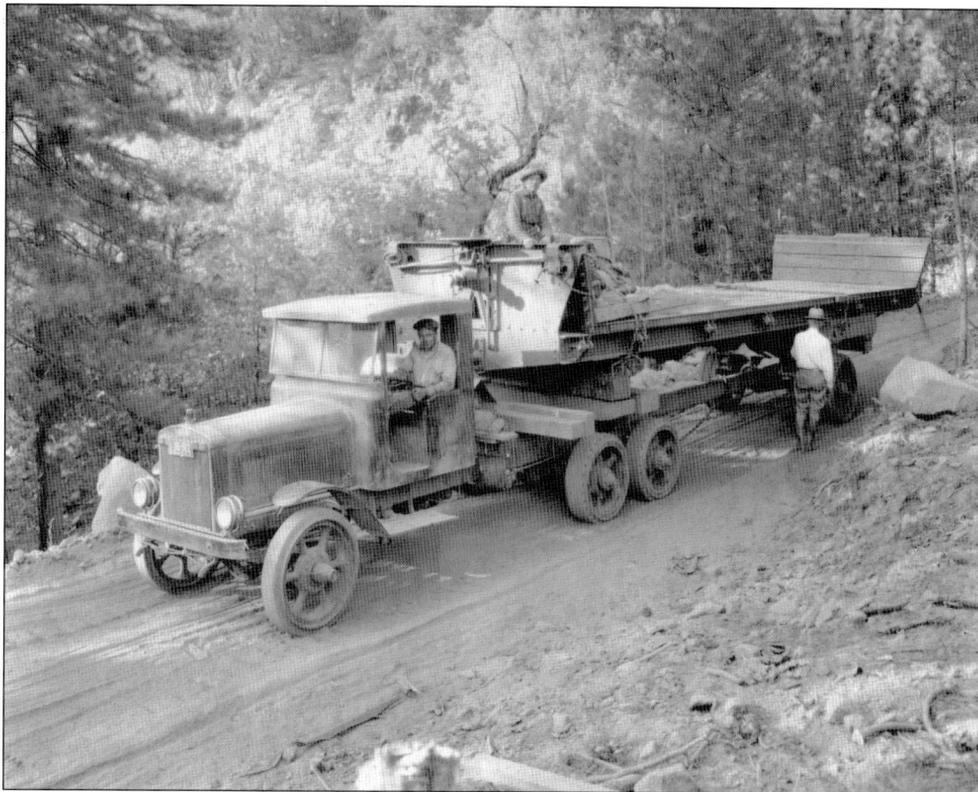

This October 1927 photograph shows one of the trucks used to carry 13-ton loads of quarry rock to the Spaulding Dam construction site.

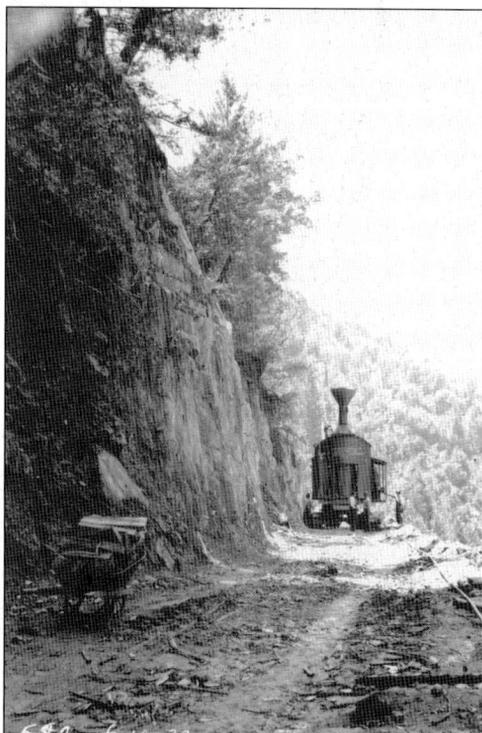

A steam-powered shovel works its way up a grade in 1922 at Spaulding. Steam power was unusual at this date because more powerful gas-powered equipment was available.

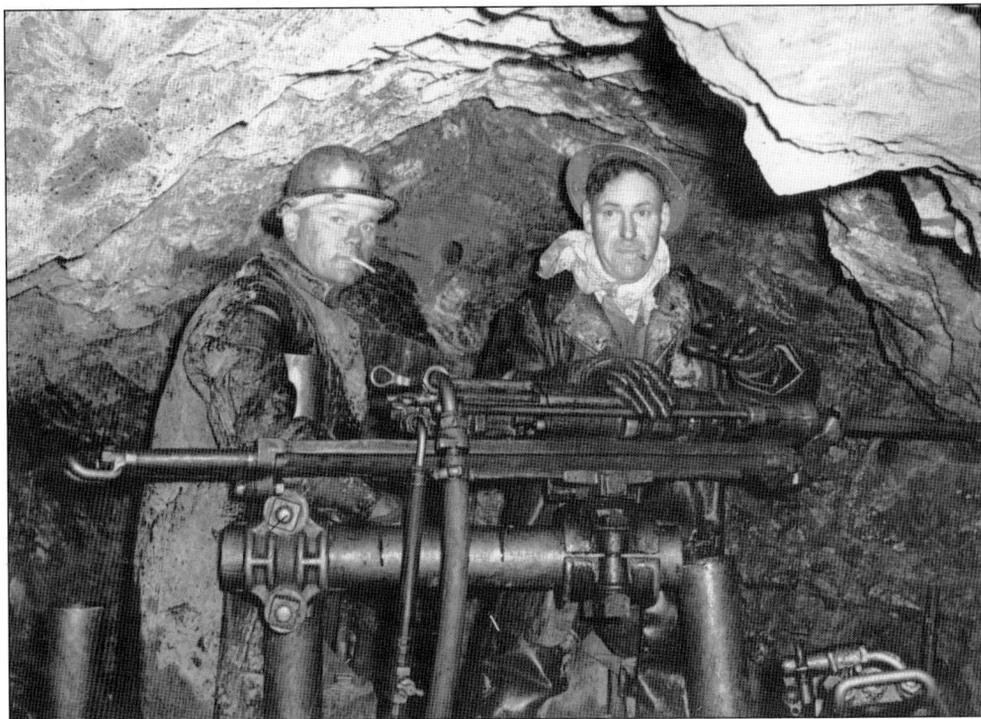

These are not miners but tunnel rats, boring the tunnel for the Colgate Powerhouse in 1941. It looks as though they took a cigarette break when the photographer showed up.

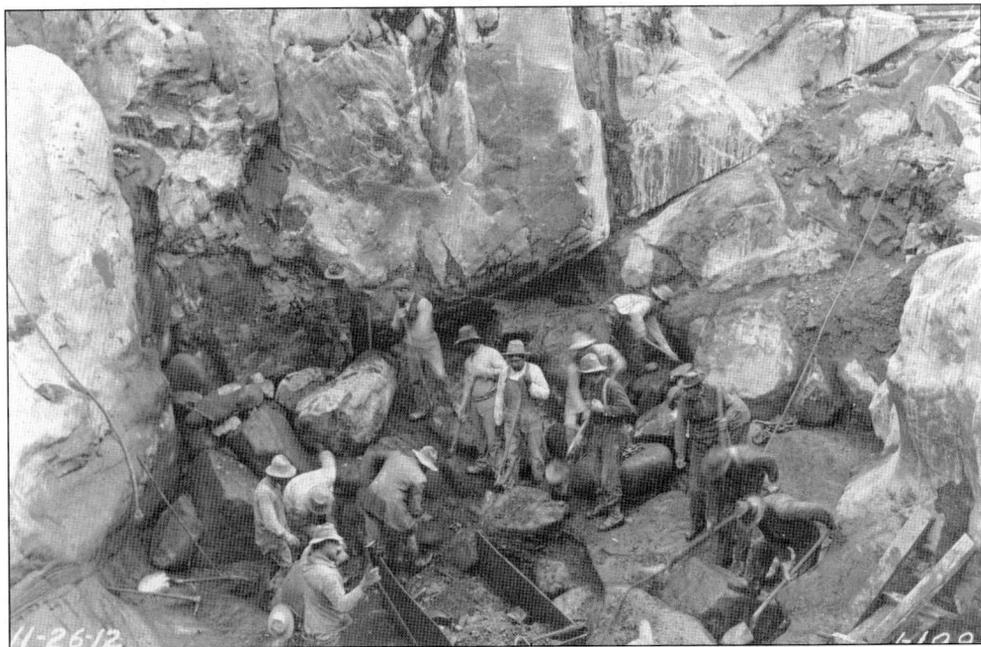

Spaulding was the site for several generations of projects dating from the earliest days of hydroelectric power and continuing into the 1940s. In this photograph, dated 1912, workers are digging a tunnel the hard way—no mechanized tools are in sight.

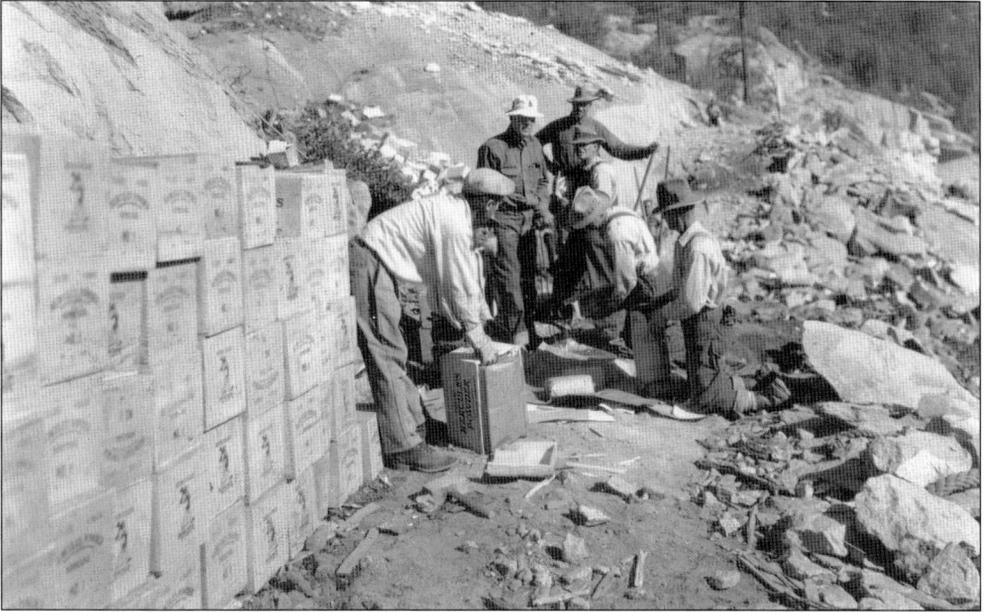

Those stacks of boxes next to the workers are filled with dynamite. This crew is filling powder holes on the Salt Springs project on November 2, 1929, two days after the stock-market crash.

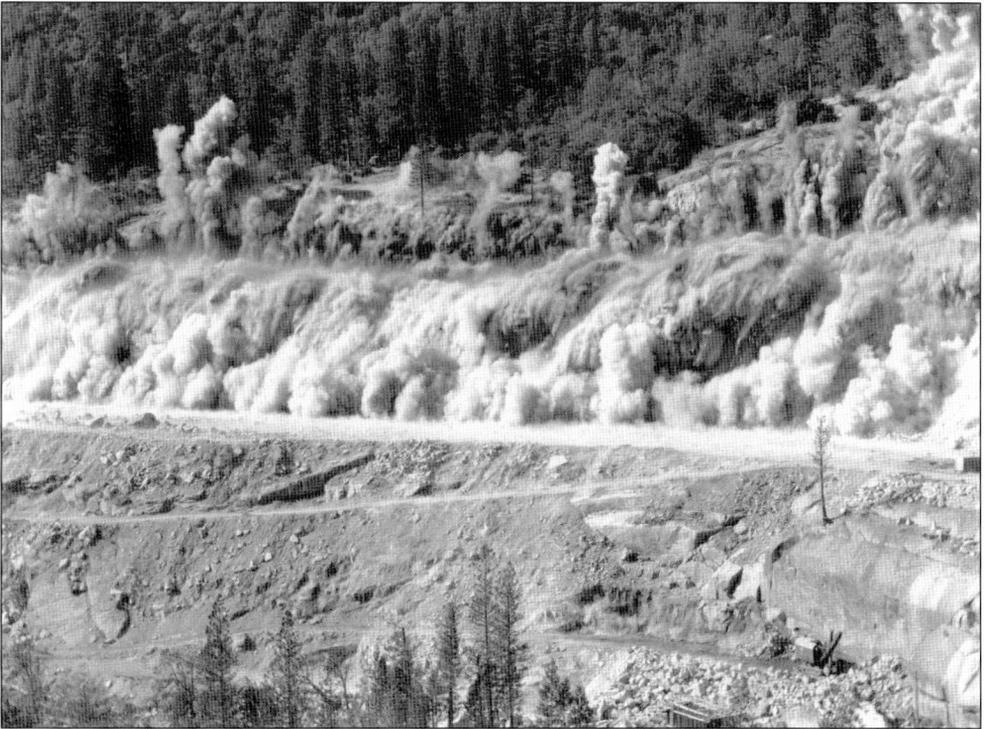

This crash was almost as big as Wall Street's, and it certainly accomplished more good. Early financing of hydro facilities depended on the sale of bonds. Fortunately, the sale of electrical power provided an ever-increasing cash flow to the power companies, which allowed expansion, even during the Depression.

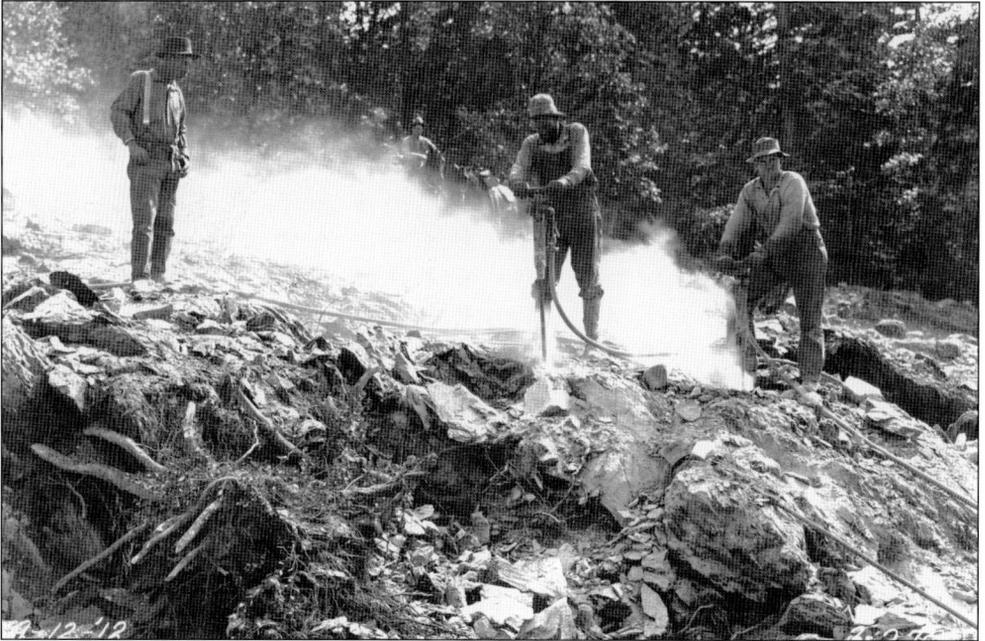

In 1912, workers used state-of-the-art, Ingersol-Rand steam-powered tap drills on the Sierra Nevada granite.

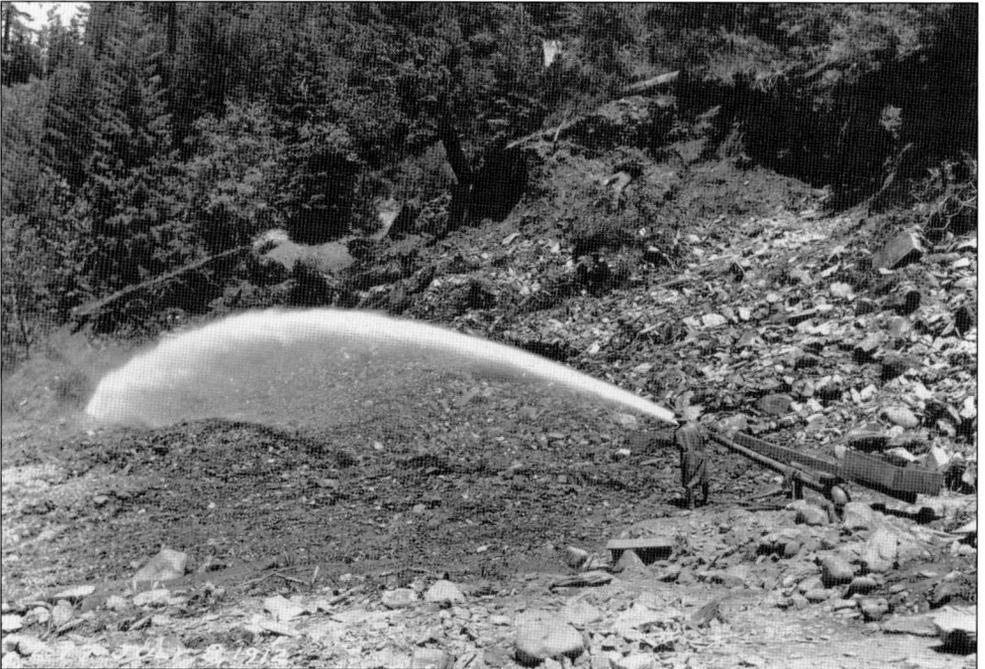

Hydraulic mining worked by aiming high-pressure jets of water at hillsides, washing down the soil and rocks, which could then be processed to remove gold deposits. It was outlawed in the 1870s because of the devastating effect on the environment. Hydroelectric builders two decades later converted some of the flumes and ditch systems for their own use.

A worker clambers precariously at the top of a temporary cable tower by the machine shop at Spaulding, while other workers look on. Note the rickety steps he used to climb to the top. The purpose of the tower is unknown.

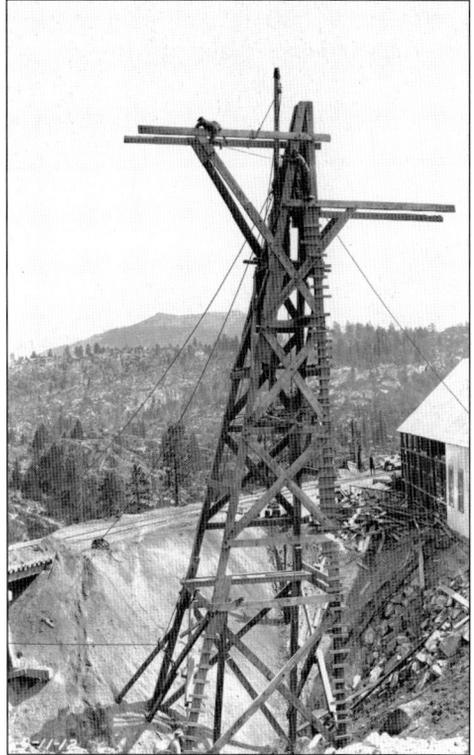

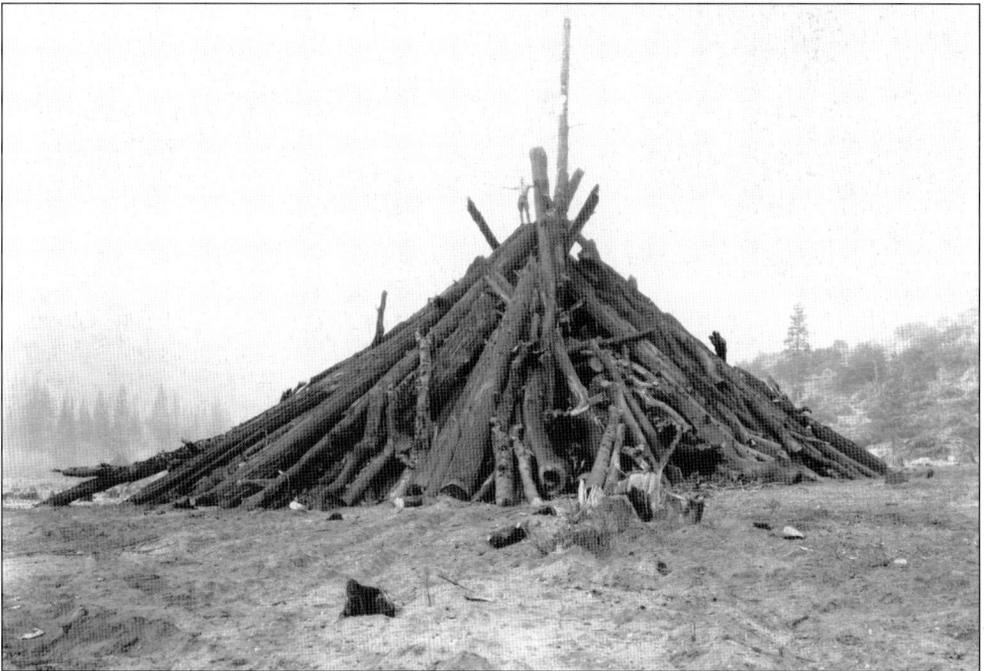

When a reservoir was being created, usable timber in the area that was to be flooded could be removed for profit. Unusable wood was gathered and burned. Pictured here on December 17, 1930, the man standing at the top of the stack provides scale.

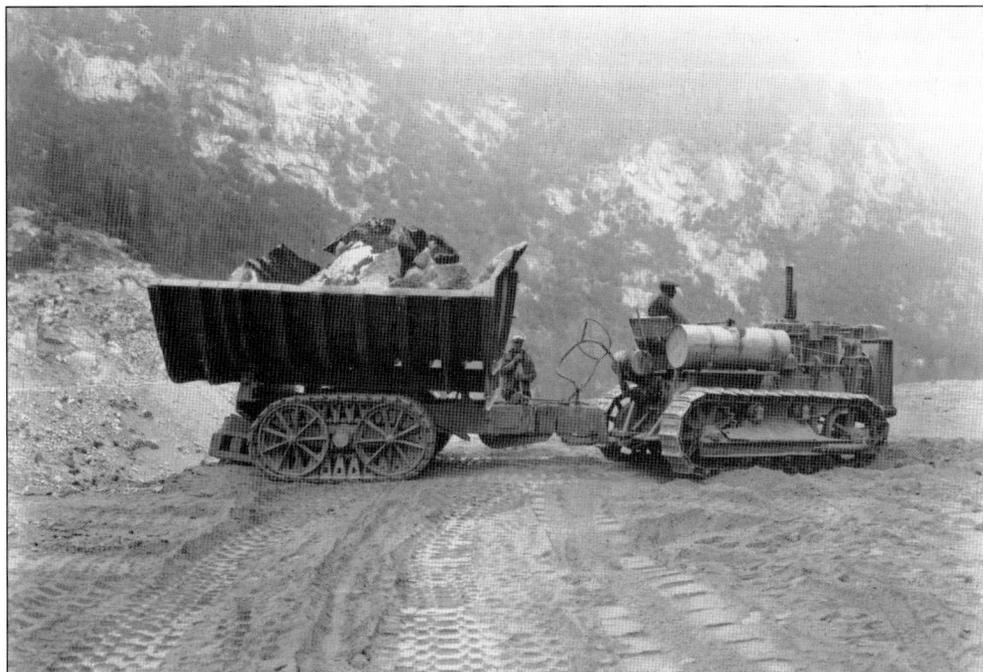

Pictured here at Salt Springs in 1929, a two-ton, rock-hauling trailer is being pulled by a gas-powered tractor manufactured by Best or Holt, precursors of the Caterpillar company. Recall that only seven years earlier, a steam tractor was being used at Spaulding.

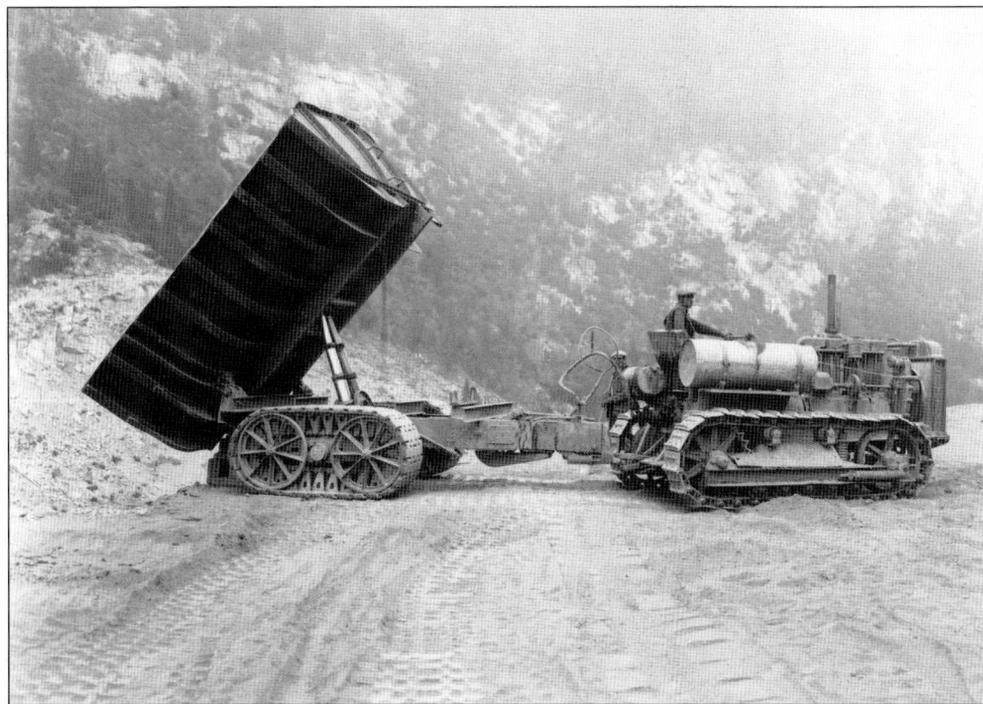

Not only was the use of gas vehicles a great advance, hydraulic systems were also in use by 1929, making the dumping of rock safer and more efficient.

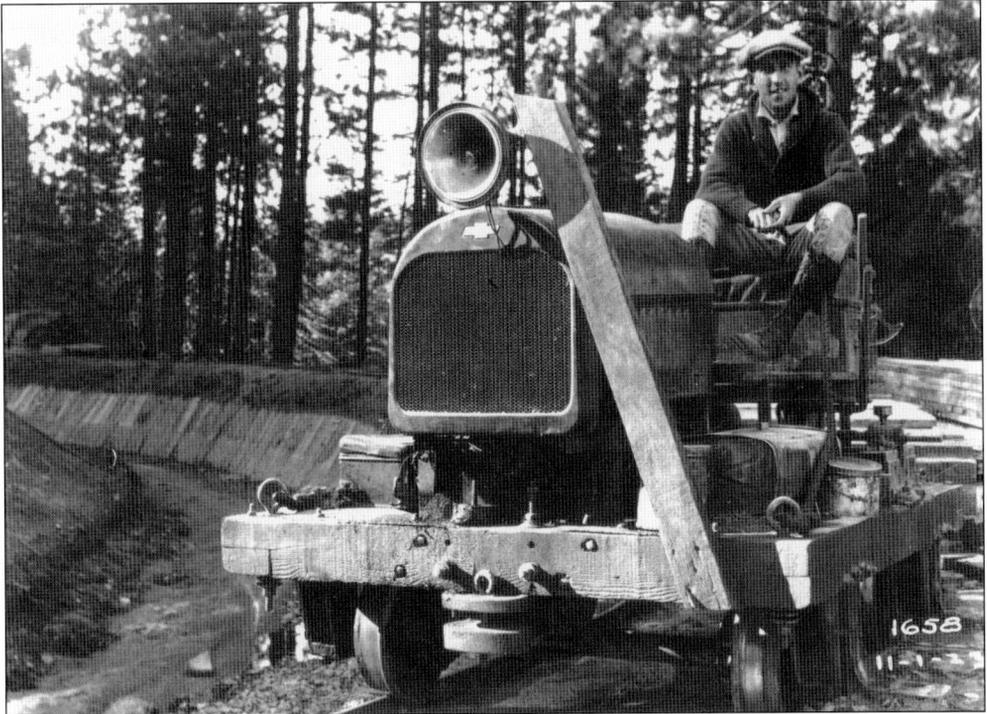

This photograph depicts adaptive technology at its best. A gas-powered Chevrolet jitney is mounted to a wood platform supported by railroad wheels. The driver looks proud of his rig, even though the glass lens over the headlight has been broken.

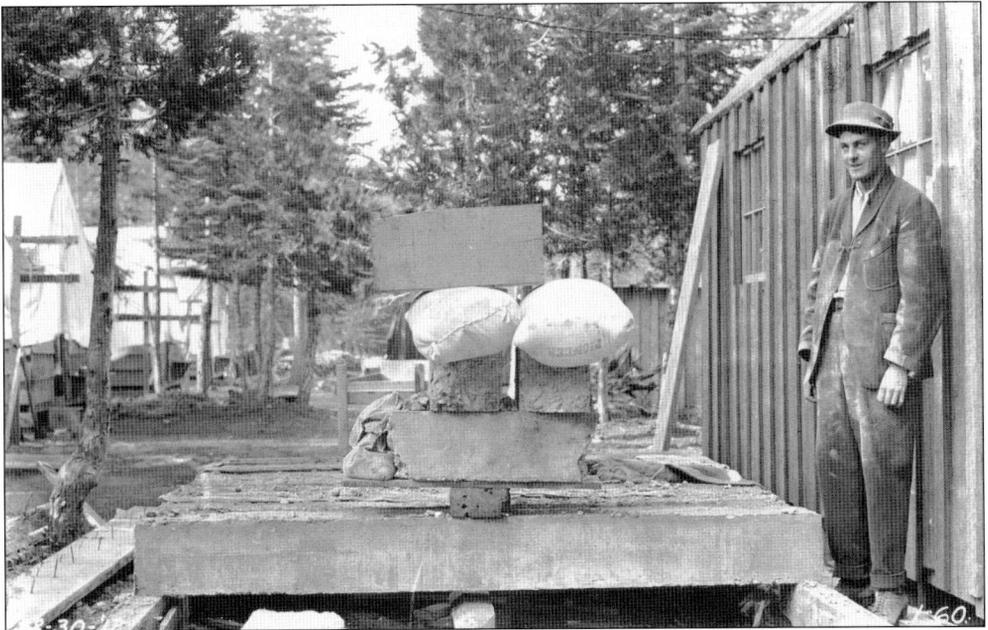

A worker at the Spaulding Camp tests the strength of the concrete. The eight-foot slab is supported on the edges, and then 750 pounds is placed in the middle. This fellow seems confident that it will not break.

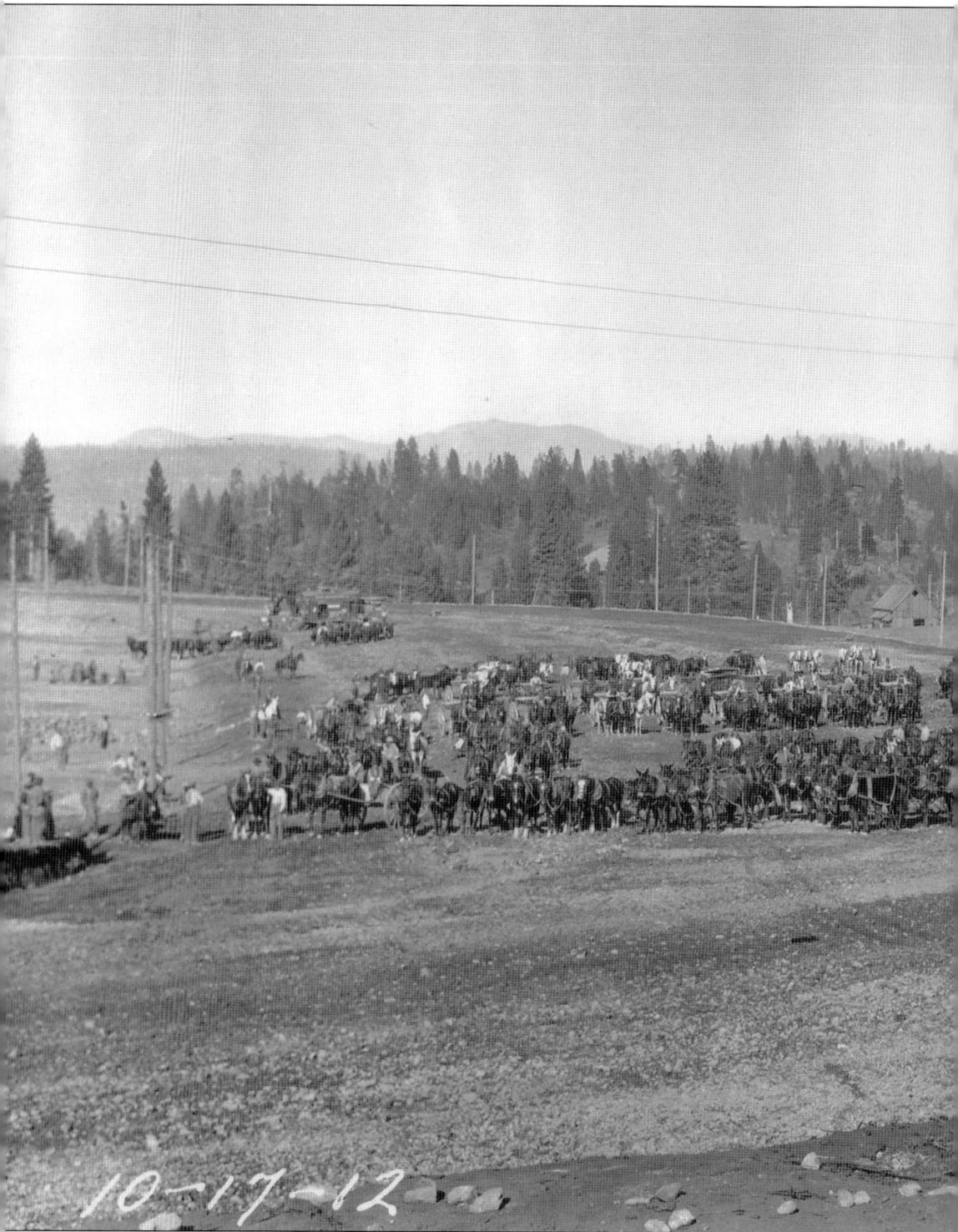

10-17-12

In this remarkable photograph, the construction supervisor, on horseback, rides in front of his assembled workers at the Spaulding Camp in 1912. Note the number of horses and mules, and

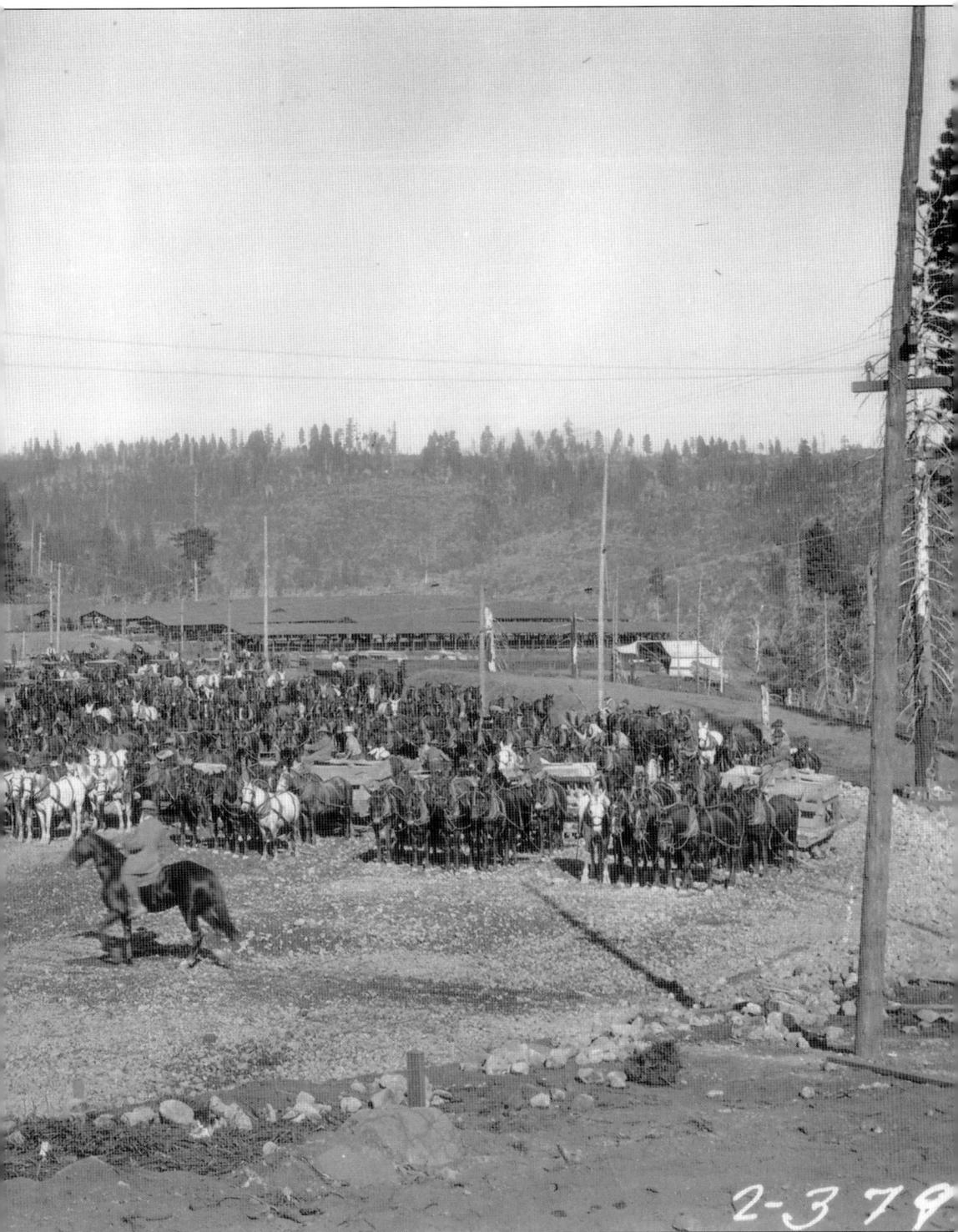

the size of the barracks in the background. Perhaps in his boyhood, this supervisor had heard stories of how Civil War generals reviewed their troops before battle.

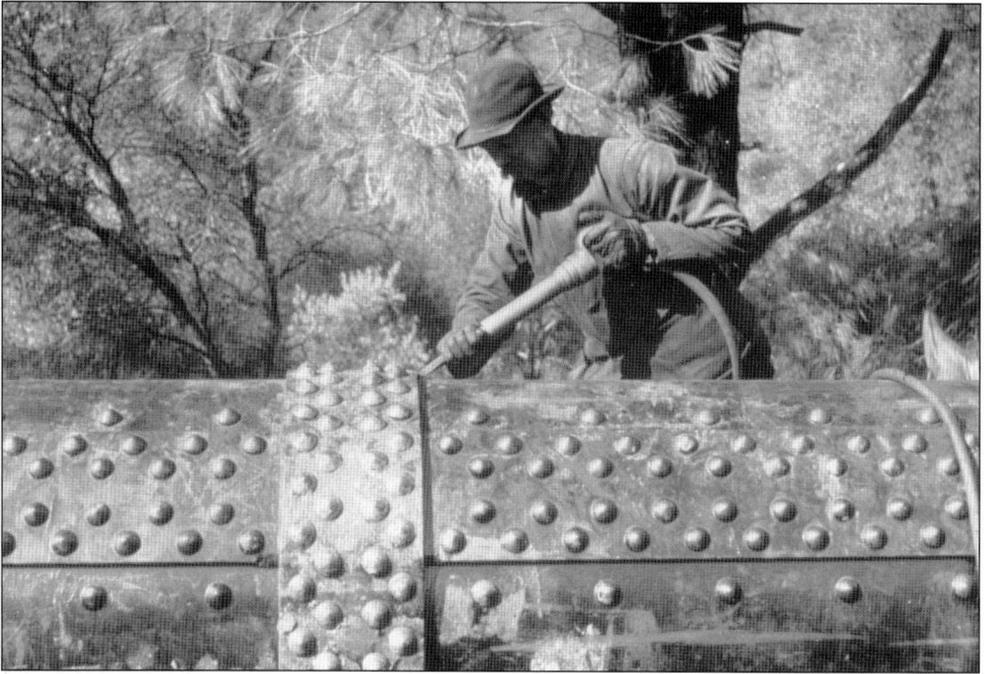

This penstock section, resembling an armored tank, is an excellent example of the respect early engineers had for the high water pressure that was developed in the lower sections of penstocks.

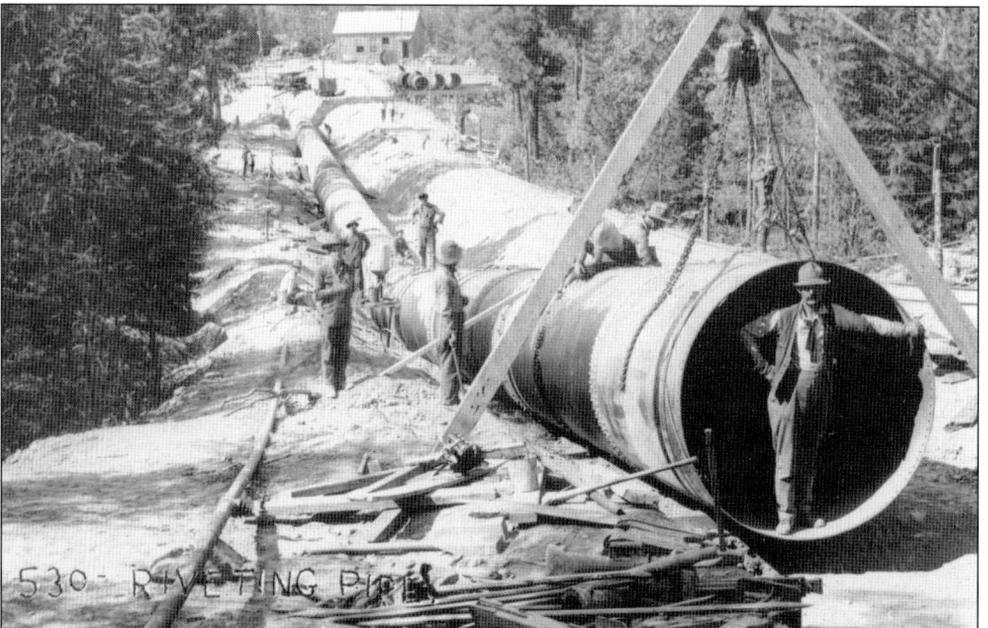

530- RIVETING PIPE

The wall of this section is thin compared with that of lower sections, where water pressures could exceed 600 pounds per square inch, greater pressure than had ever been worked with at the time.

This lower section features massively reinforced steel walls an inch-and-an-eighth thick. It appears that the section is being lowered into place.

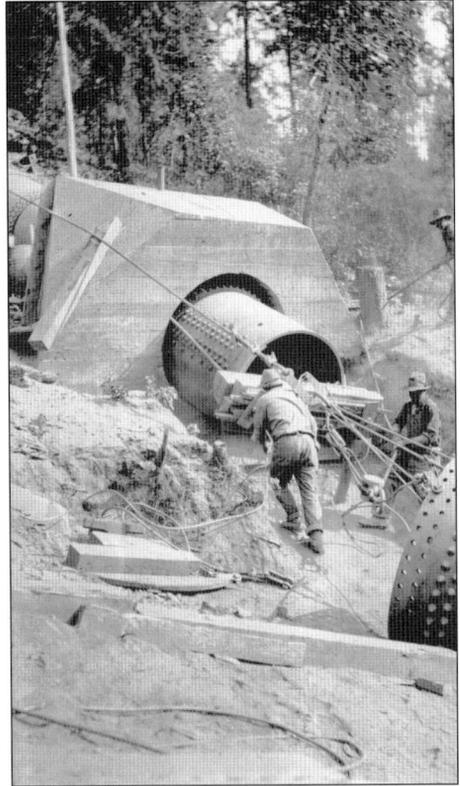

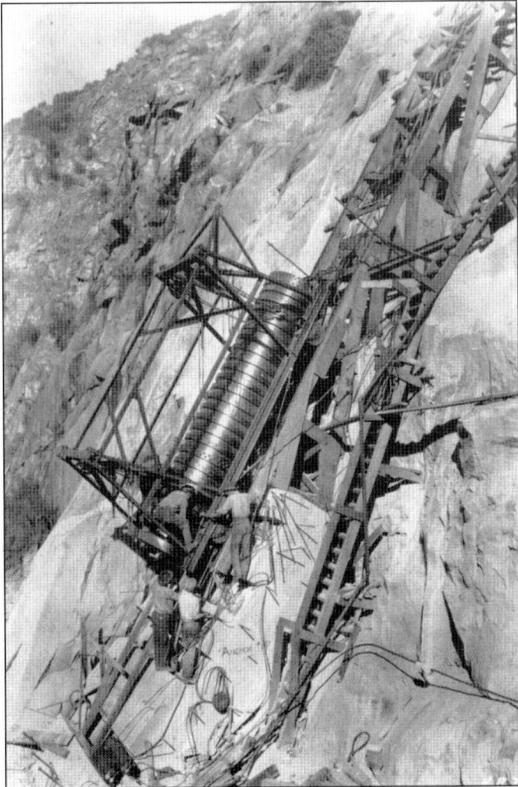

This photograph captures a good example of how penstock sections were moved into place on cliff walls. The tramway would be used to position the sections, which were then bolted together.

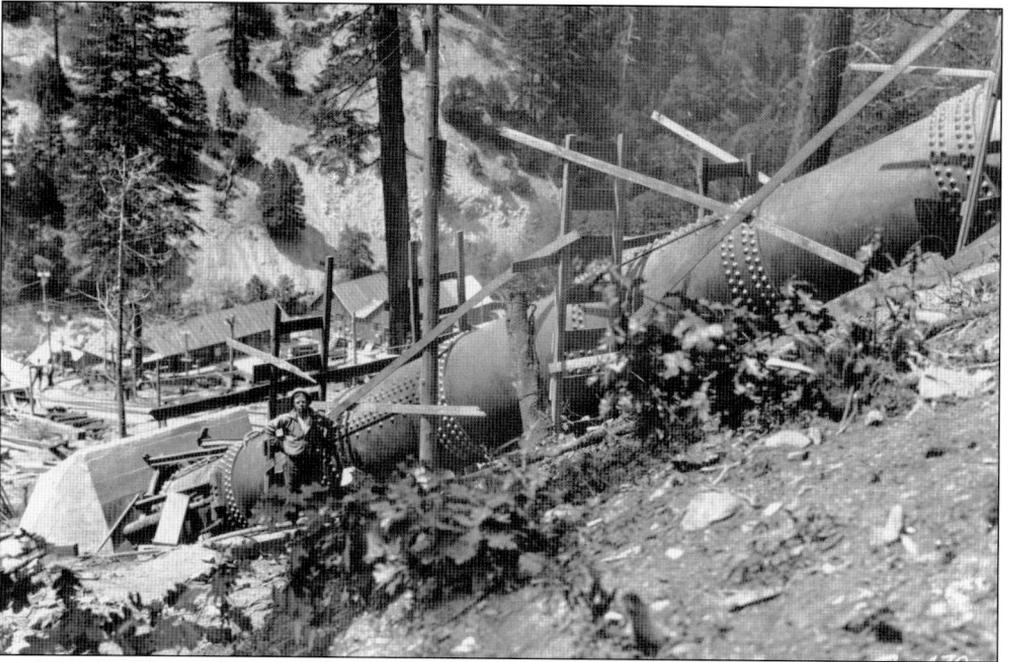

The concrete abutment to the left anchors the penstock section, and the powerhouse will be built a few hundred feet down the hill. This appears to be the Deer Creek site in Northern California.

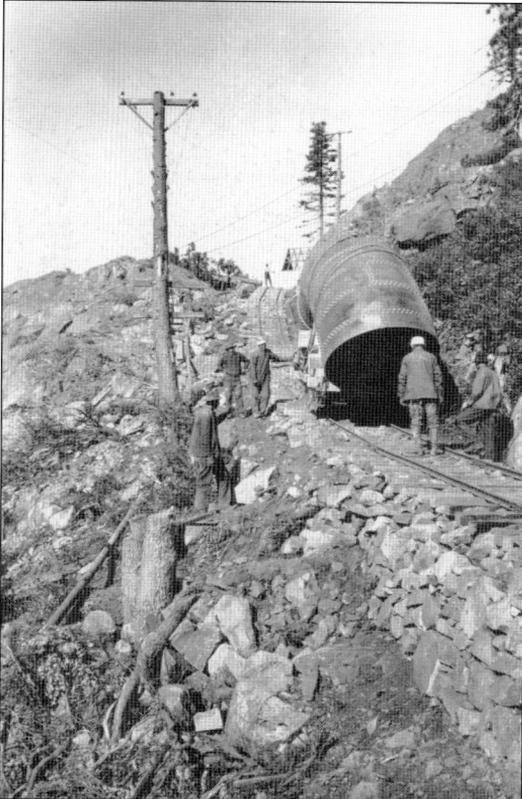

In this photograph, note the tree that has been trimmed of branches so it can be used for a power pole. The tramway parallel to the penstock was usually temporary, but in the case of the Drum Powerhouse, the tramway rails are still visible.

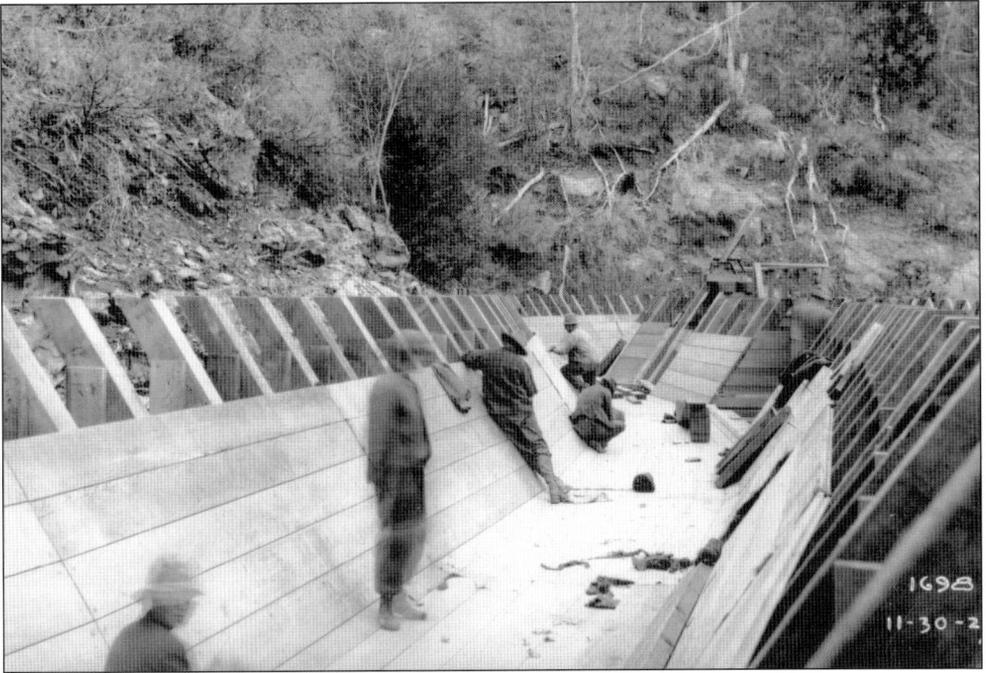

Flumes were built of concrete when it was available, but it was usually quicker and cheaper to build them of wood. In the early years, timber was the ideal building material—flexible, inexpensive, and available in great quantities.

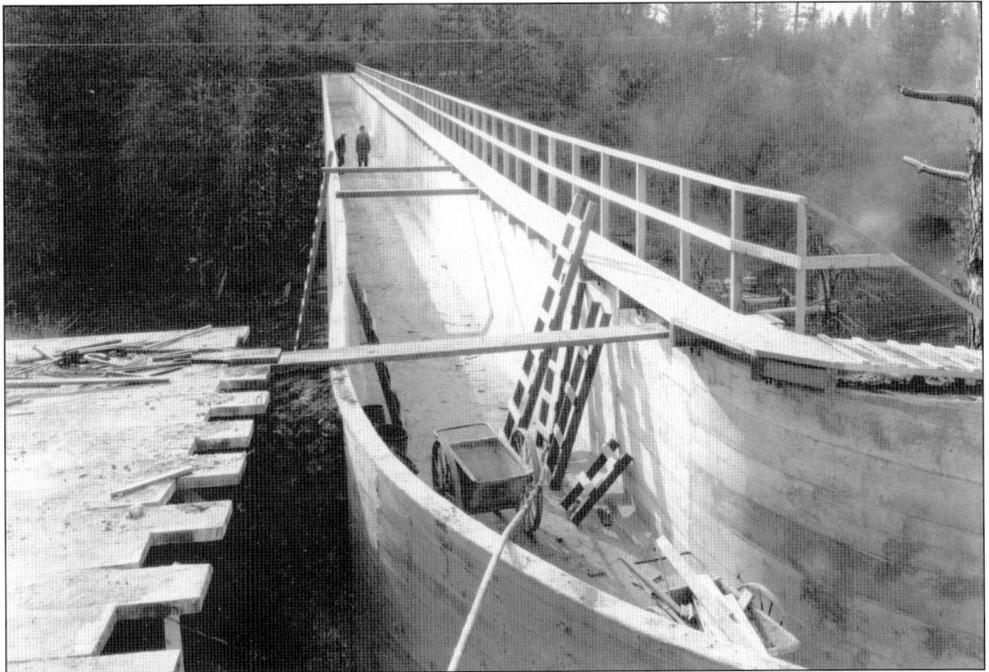

This photograph, taken only a few years after the preceding one, shows the scale of building that concrete made possible. Built on the Bear River, it appears that this concrete flume rests on top of a structure that spans a wide canyon.

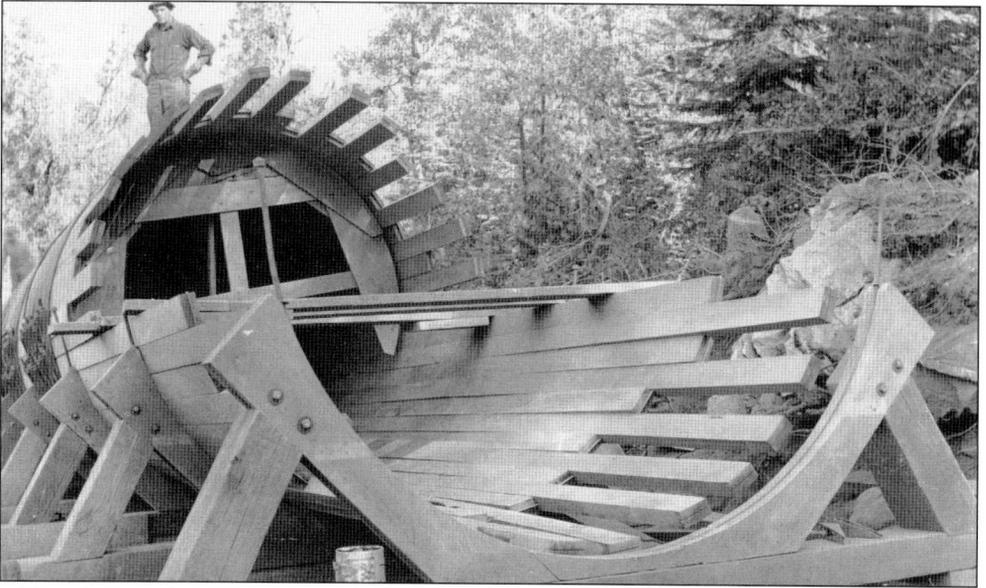

Although most had long since been replaced, a few sections of wooden stave penstocks were still in use in 2000, only suitable in lower-pressure applications. Unlike the example in the photograph, most were built of tongue-and-groove boards. The construction of the penstocks required the best skills of both barrel makers and shipwrights.

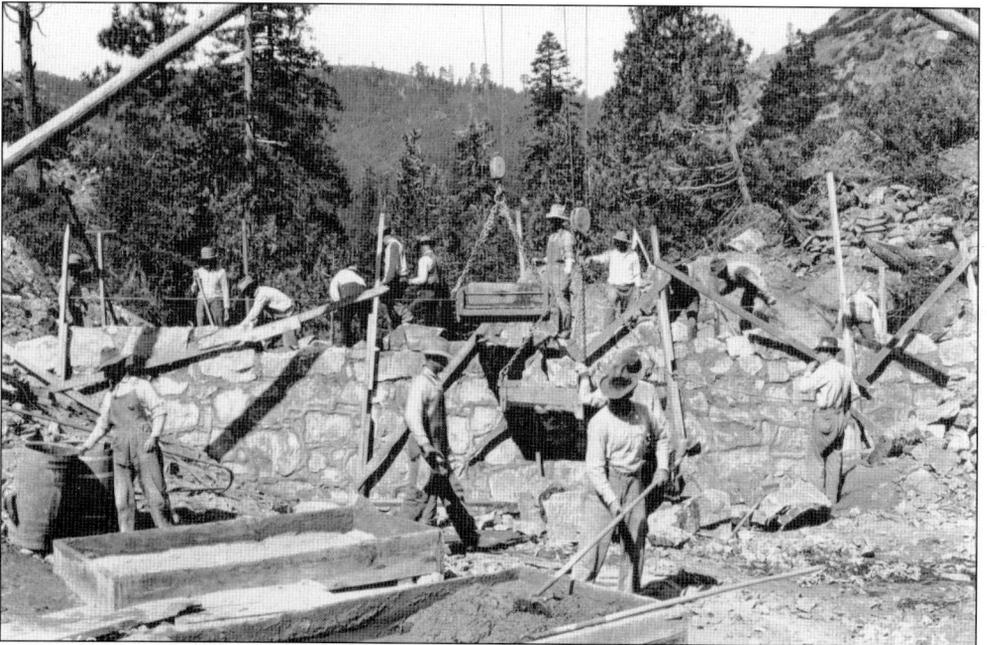

These men are mixing cement in containers called boats to build the curtain wall behind them. Note the hoist that is used to lift rocks and mortar into place.

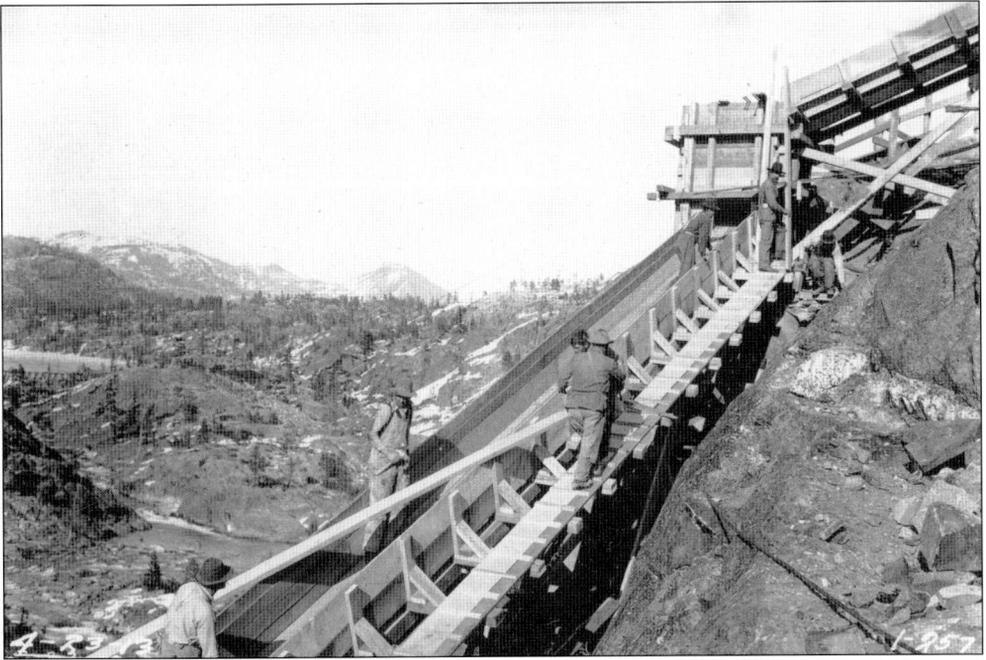

This photograph gives a view of the Spaulding construction site, with the original Spaulding Dam in the background. This water flume probably delivers water to the site of the new dam.

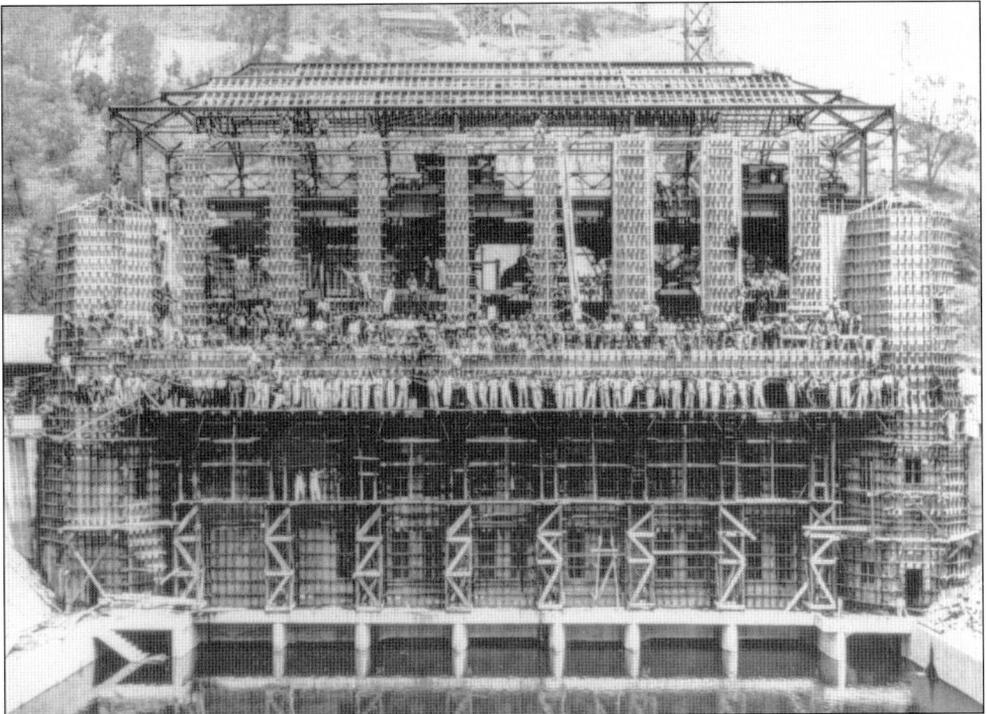

Scaffolding hangs from the wall of Pit River Powerhouse No. 1. Note that in the 20 years of building experience, construction changed from solid rock walls to modern, steel-girder construction. Hundreds of workers took a break from their labor to pose for this photograph.

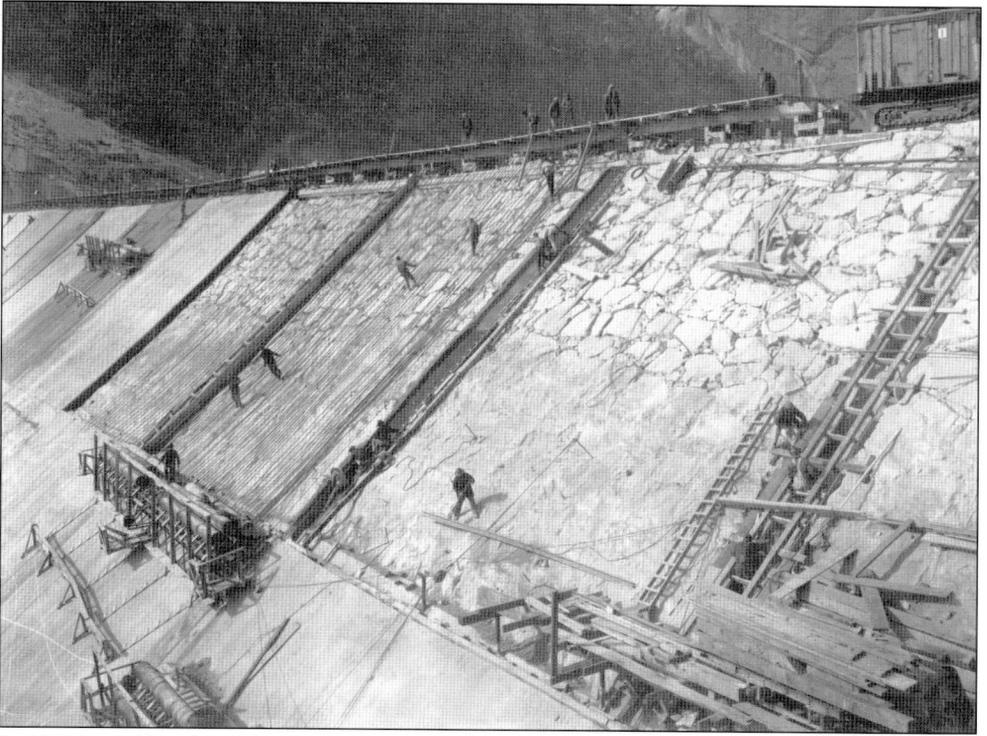

In 1931, in the depths of the Great Depression, workers finished the face of the Salt Springs Dam. It appears that steel reinforcing bars, delivered from the tramway on top of the dam, are being positioned on the center section.

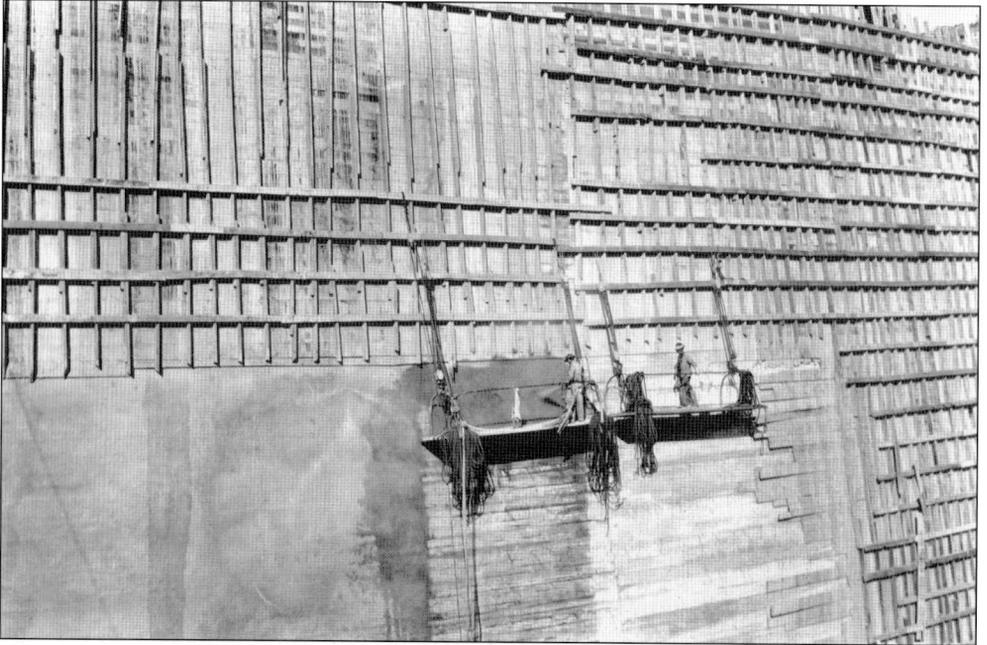

Here the face of Spaulding Dam is being finished. Concrete is sprayed, apparently with a pneumatic system, to provide a smooth finish.

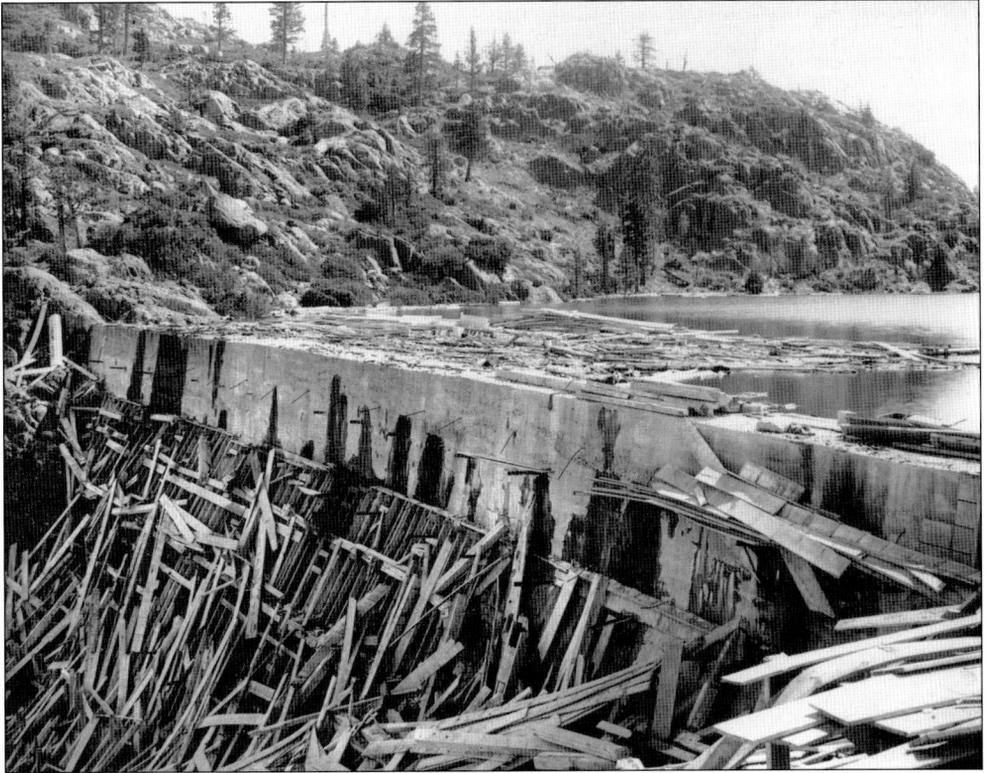

The Spaulding spillway is pictured here. Where wood used for concrete form boards could be reused—for building flumes, for instance—it was salvaged. Where it was more expedient, it was left in place, and nature eventually washed it harmlessly down the canyon.

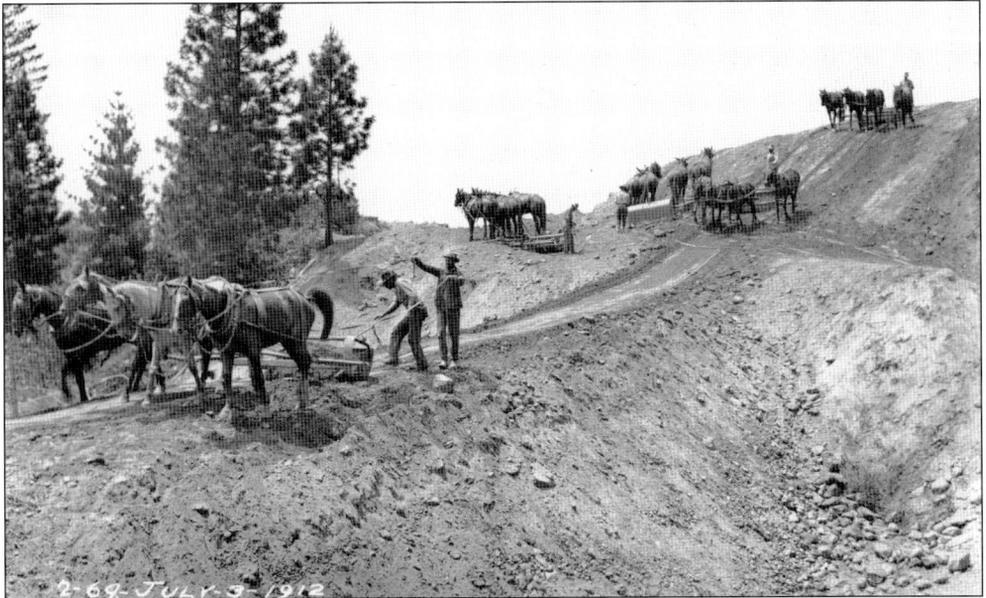

In this scene from the Spaulding project, several mule-pulled scrapers, or fresnos, are being used to build a roadbed, possibly for the tramway, which supplied building materials from Colfax.

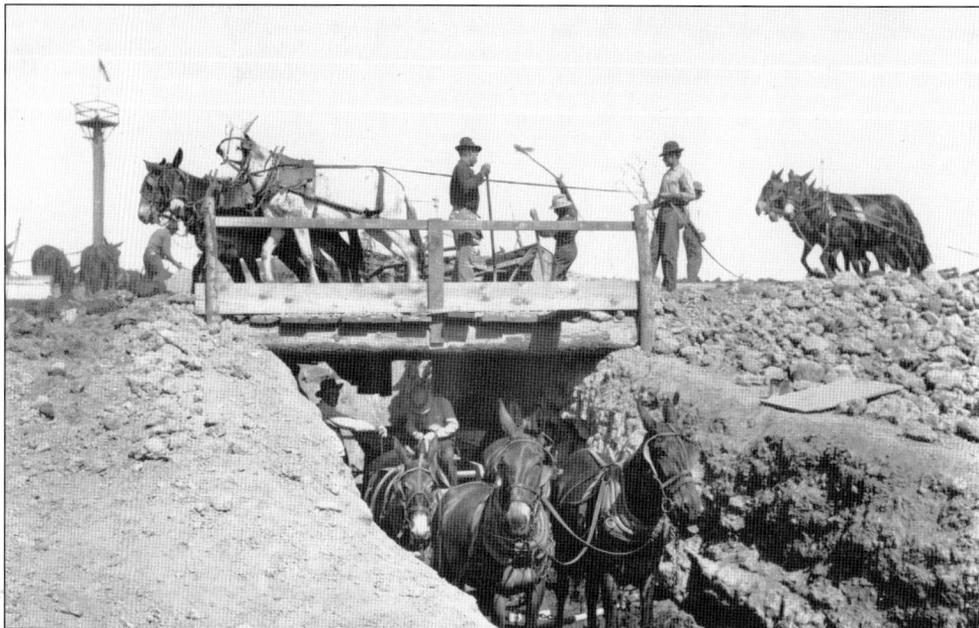

What appears at first to be a mule-wagon version of today's freeway overpass is actually a loading chute. The wagons above dump their load onto lower wagons. Note the mysterious tower in the background. Its function is unknown.

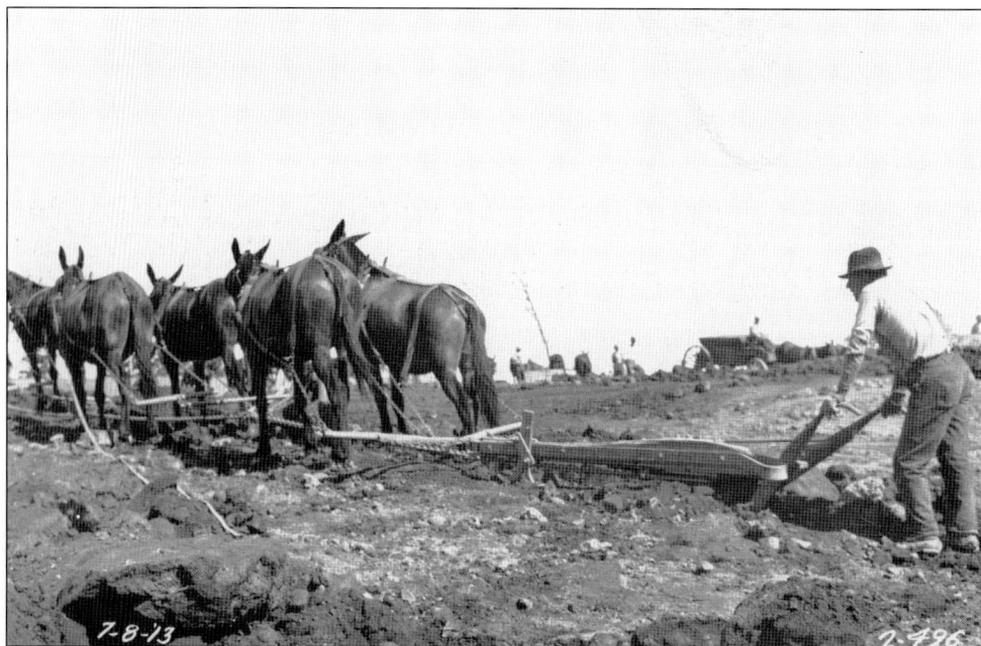

This plow-like device is a ripper, or rock plow, which digs into the ground, breaking up rocks and loosening soil for excavation.

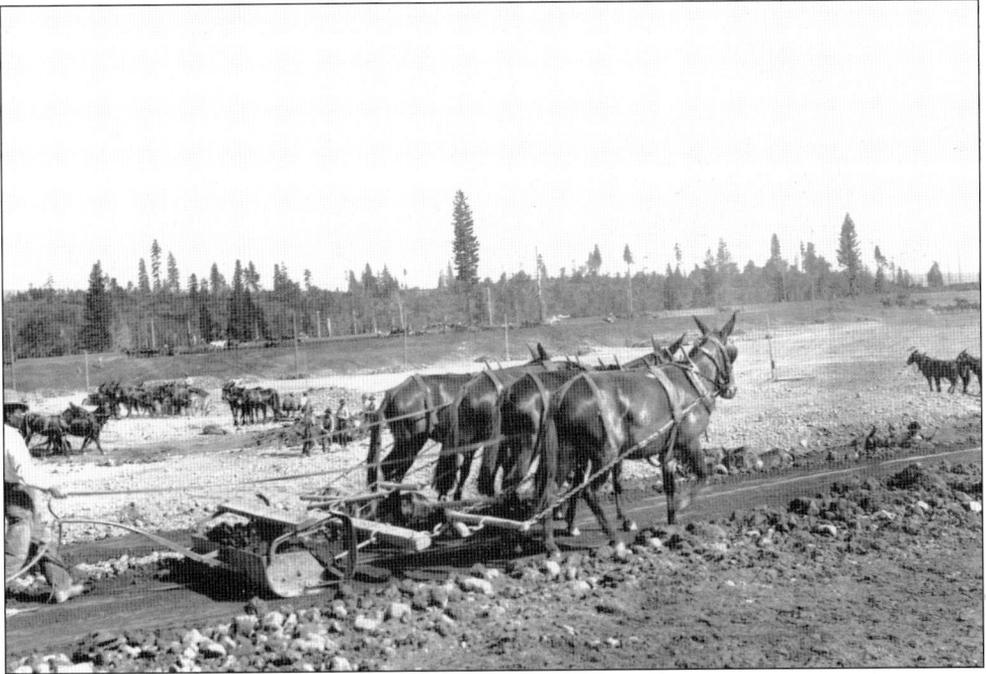

Fresnos were also known as "tumble-bugs." When the bucket was filled with dirt, the operator emptied it by pulling up on the lever. The mules, pulling forward, tipped the bucket forward on the rails, and the dirt "tumbled" out. It was a dangerous piece of equipment to operate.

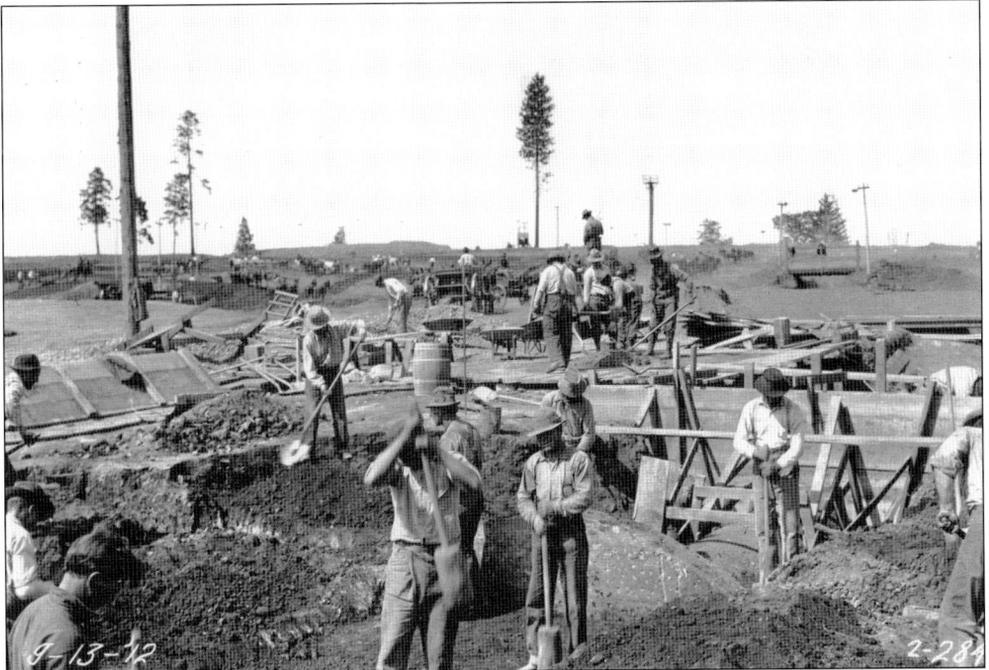

Although thousands of draft animals were employed, human muscle power was in evidence everywhere, especially before the introduction of mechanized machines. This photograph was taken in August 1912.

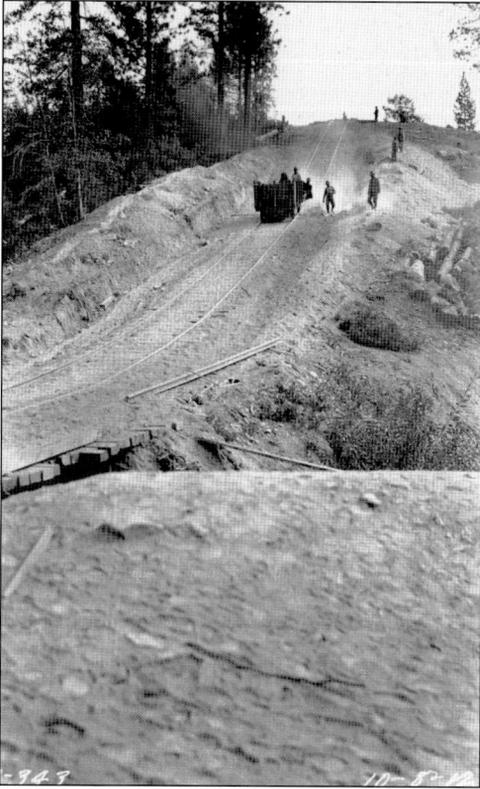

There was no road access to the Drum site. A narrow-gauge railroad was built from Colfax to the ridge overlooking the site, and this vertical tramway carried the load the rest of the way up.

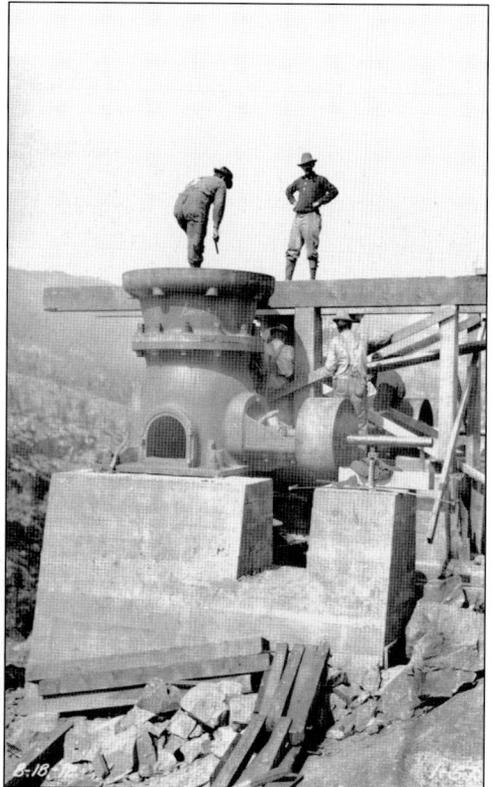

In the process of being installed at Spaulding is a rotary rock crusher, driven by a web belt, which has not yet been installed. Note the notch in the concrete base for the belt.

PG&E owned several narrow-gauge rail systems. This unit probably operated between the Colfax Union Pacific station and the tramway at Drum.

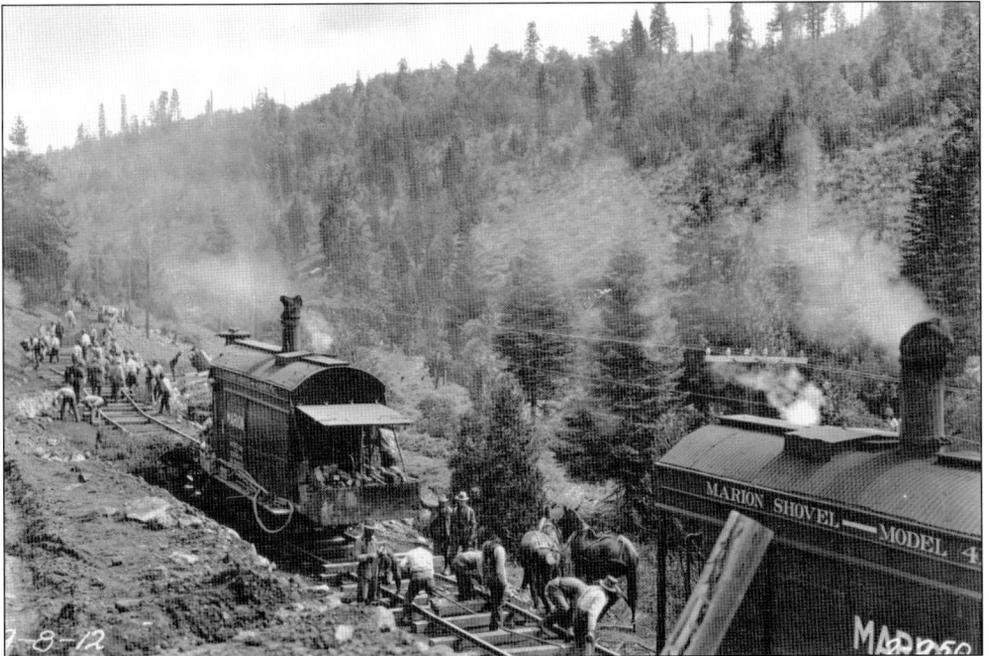

These Marion steam shovels operate from narrow-gauge rail tracks. In this view, it looks like the track layers are barely staying ahead of the steam shovel.

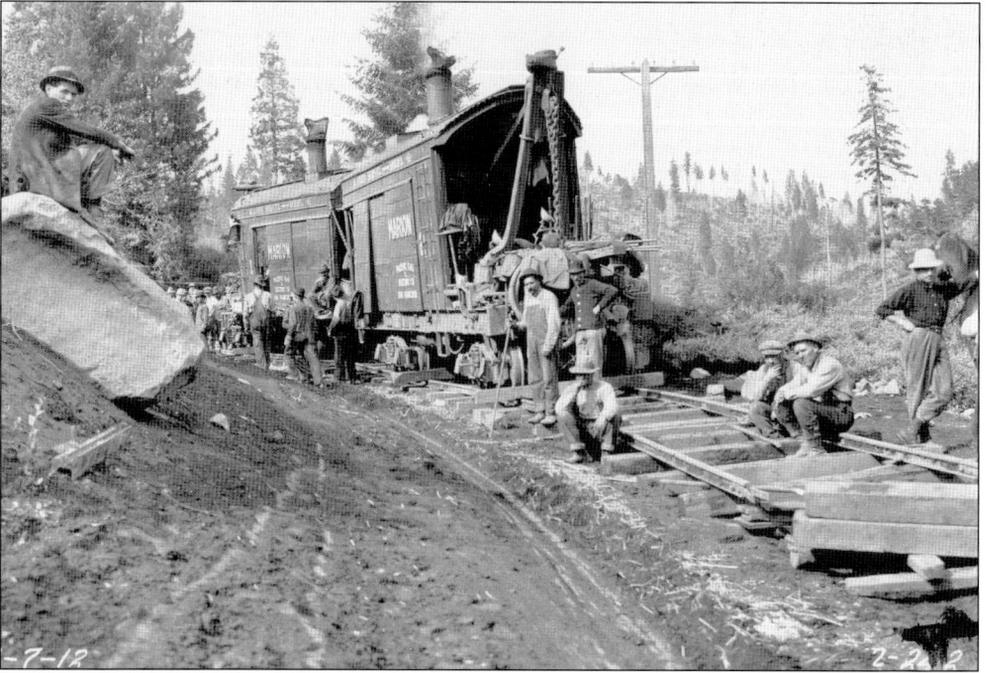

In 1912, a steam shovel is on the way to Drum Camp. A crew builds the track it rides on.

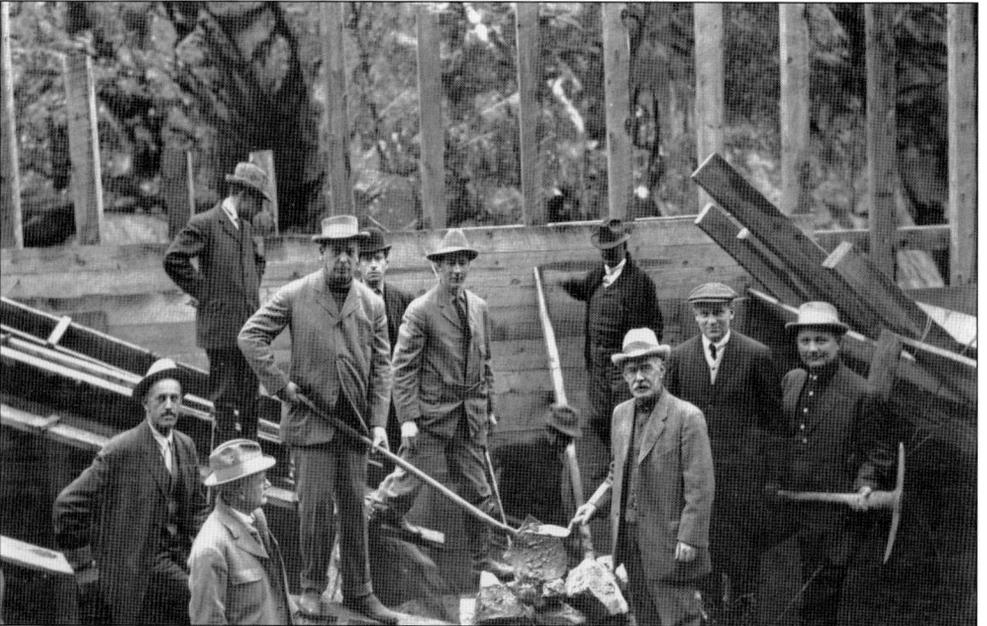

On October 28, 1912, the first shovels of concrete were mixed for the Drum Powerhouse. PG&E executives included Frank Drum himself (holding a shovel). John Britton (third from right) and Frank G. Baum (holding a pickax) are also pictured.

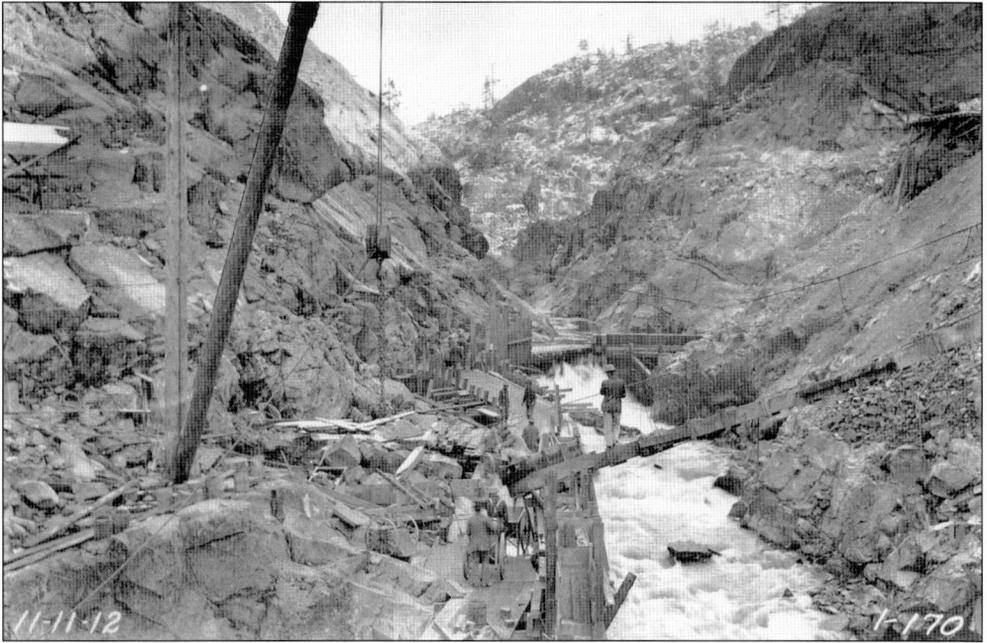

The keyway for the main dam at Spaulding is on the South Yuba River. Note that the men and material arrive at the site from the wooden structure on the left riverbank. The bridge in the foreground provides access to the other bank.

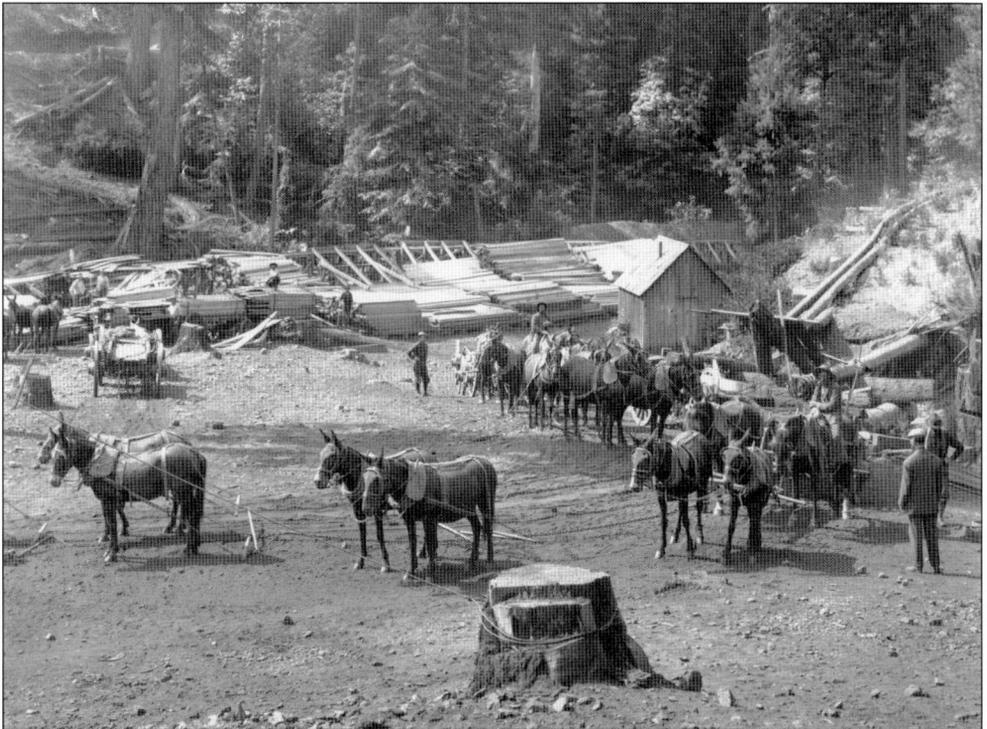

Construction camps sometimes included sawmills to process timber from inundated areas. The Electra site on the Mokelumne River is a good example.

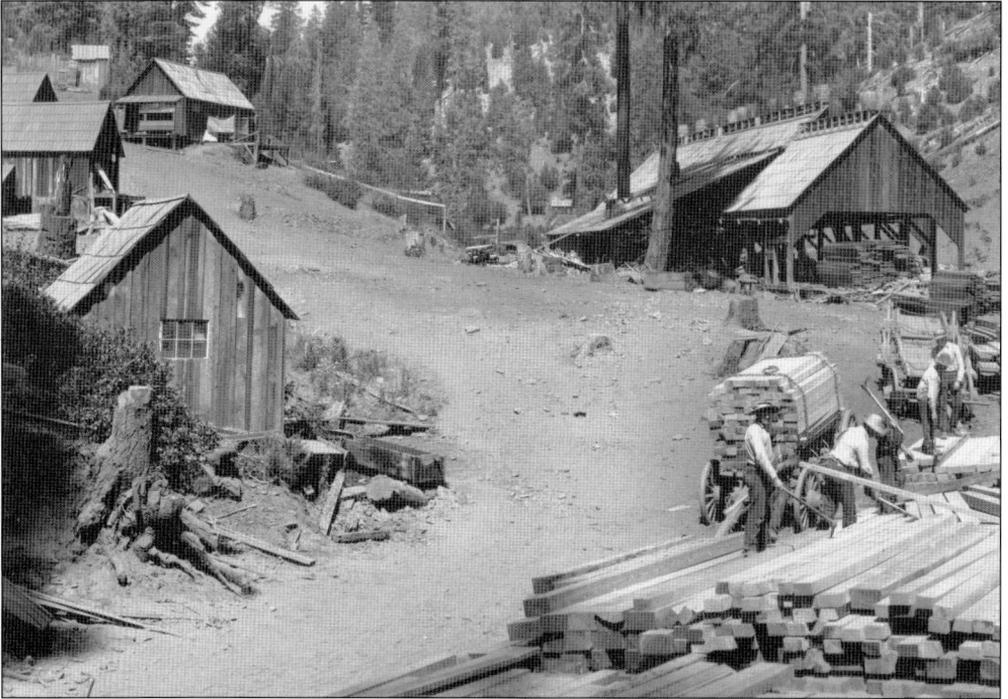

Finished lumber was loaded onto wagons. The wood might be used for flumes or trestles, or even fashioned into low-pressure penstocks, also called wooden stave pipes.

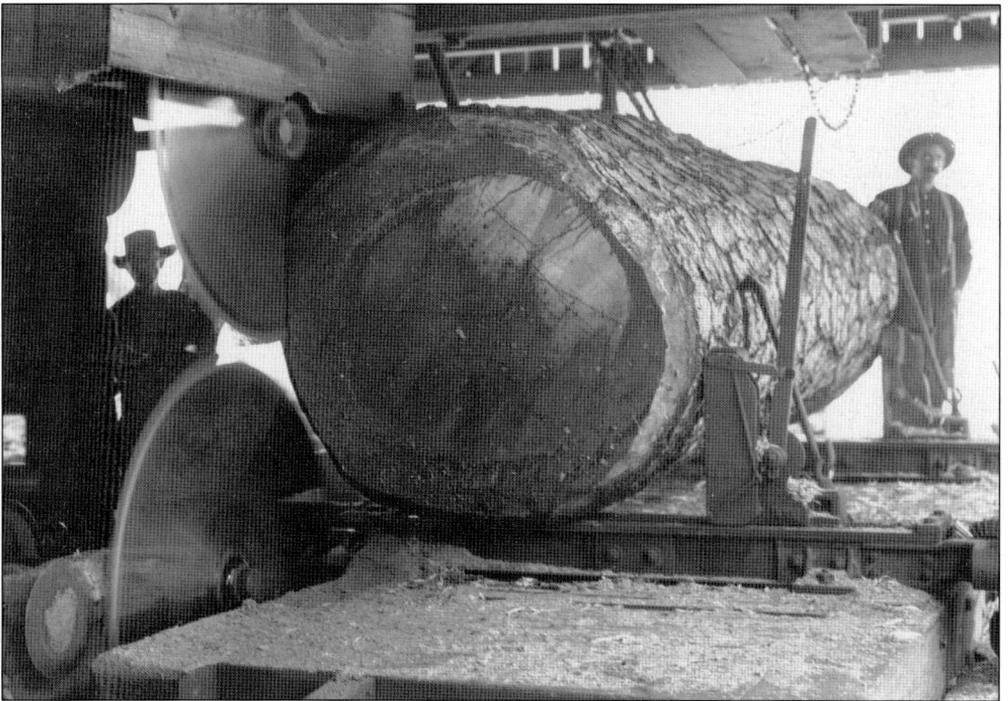

A pine log fresh from the woods is fed into a steam-powered ripsaw. The log is moved on the carriage below it for successive passes through the saw.

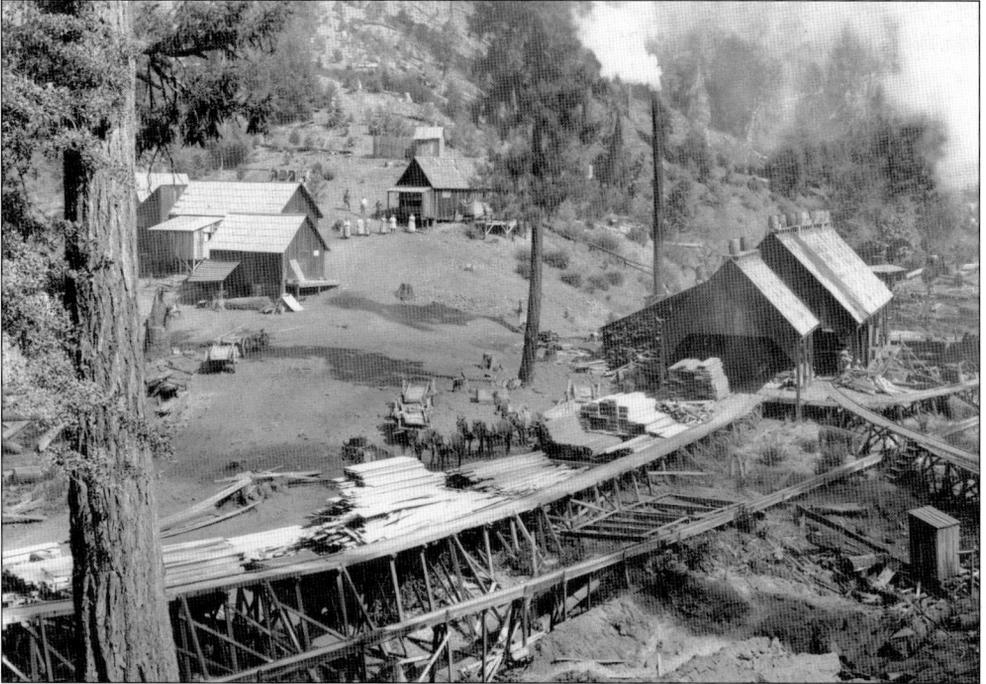

This photograph gives a good view of the Electra timber operation. Finished lumber moved from the steam-powered sawmill to the loading area. Several women pose outside the building in the background.

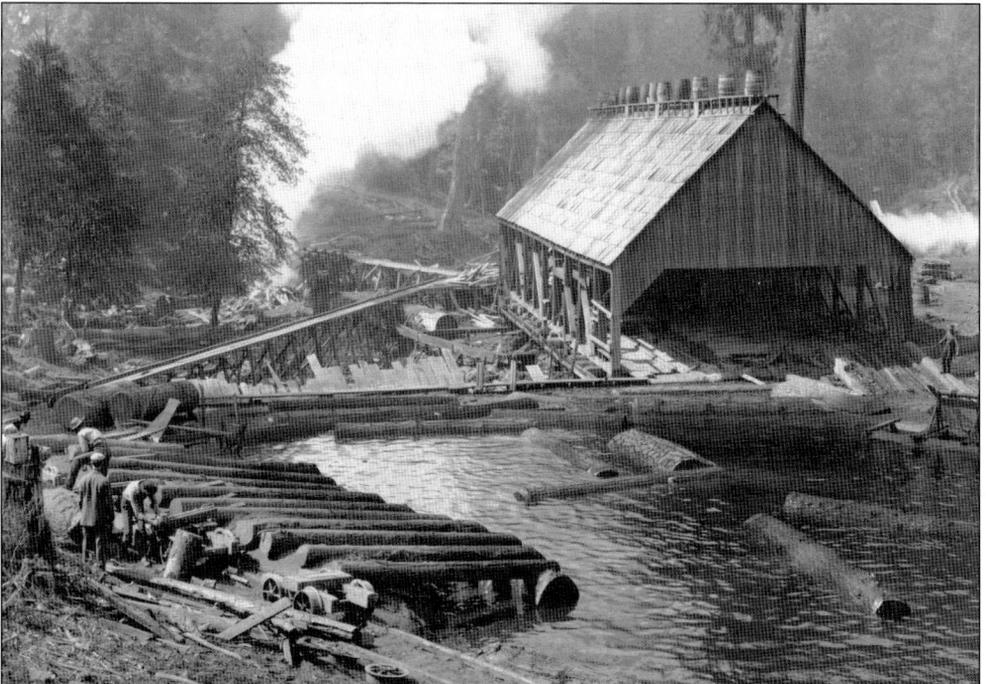

Here is a view of the sawmill from the opposite side, seen in the previous photograph. The log pond floats logs to the saw, and raw logs are loaded onto the skids at the left.

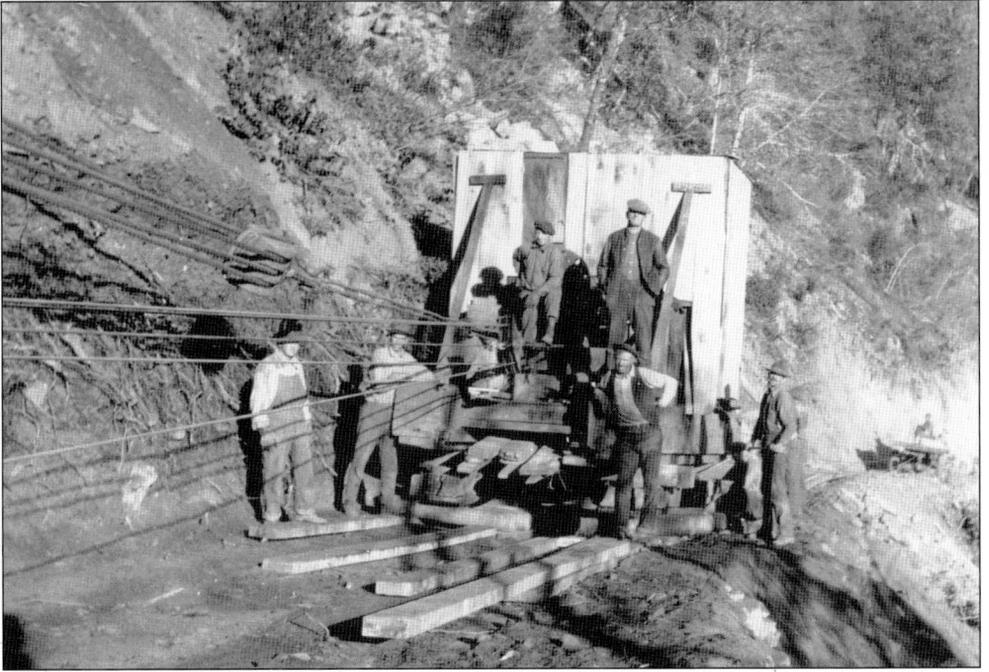

Crews move an unknown but heavy object up a steep incline. Skids are placed in front of the load, and steel cables pull it up.

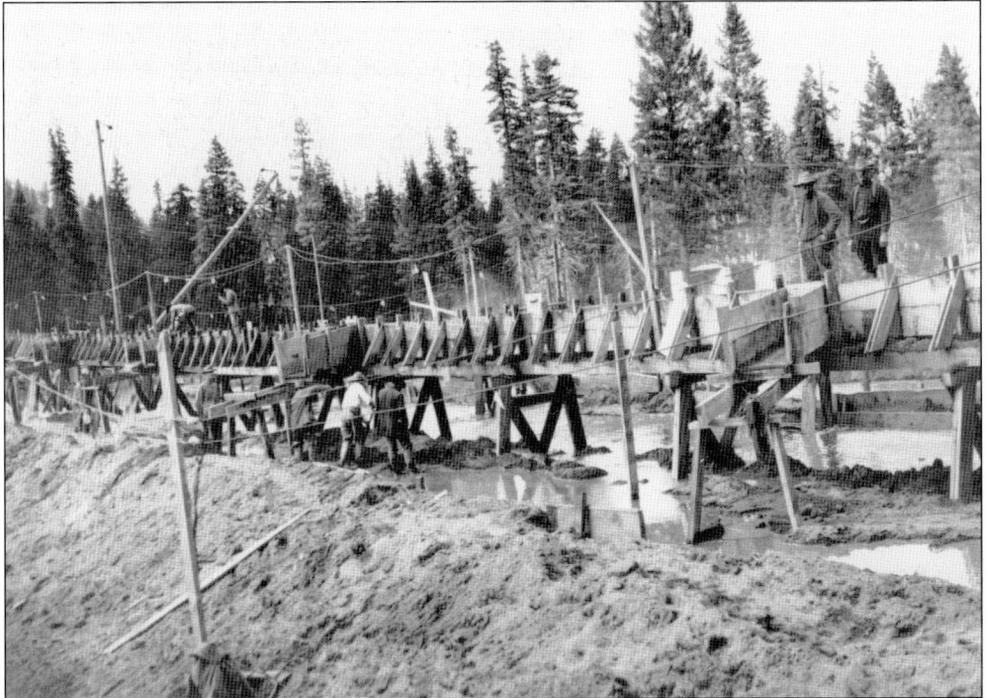

This photograph shows a curious flume. The three-sided chutes were obviously built to dump water, yet there were no ramps for wagon access, and the lack of footings indicates that the structure is temporary. The light bulbs strung above indicate the flume was in use 24 hours a day.

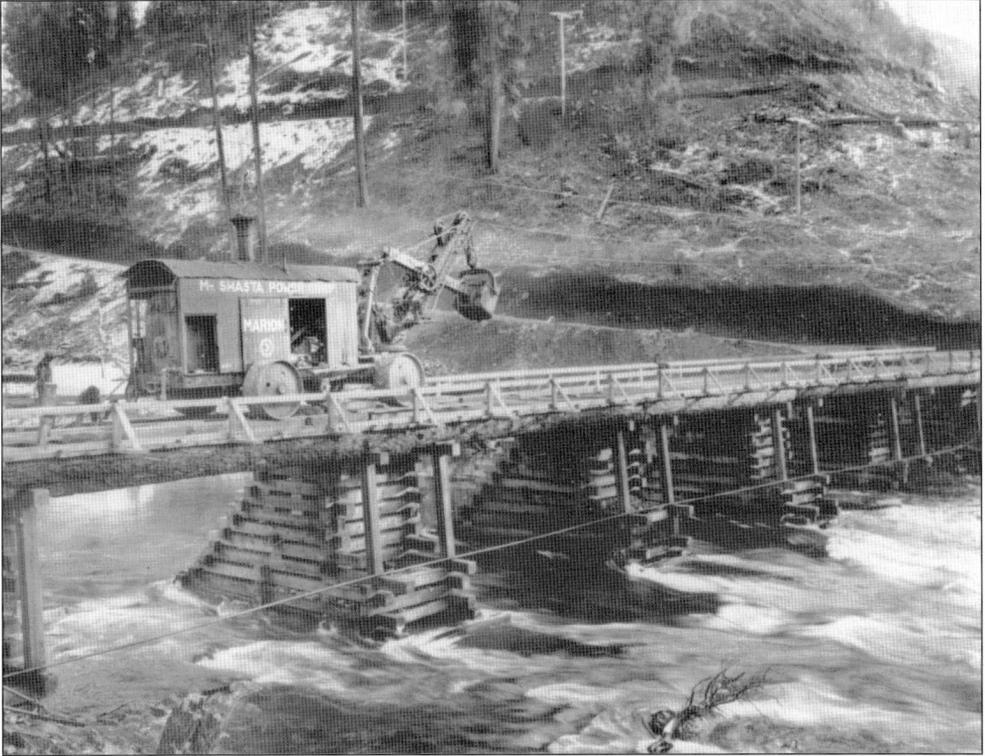

This steam-powered Marion steam shovel rode not on rails, but on metal wheels. Although the bridge was wooden, indicating that it was a temporary structure; it is nonetheless well reinforced to carry the weight of heavy equipment.

Workers snub ropes around a capstan to aid mules in moving a load down a steep hill. Perhaps they are preparing a base for a penstock.

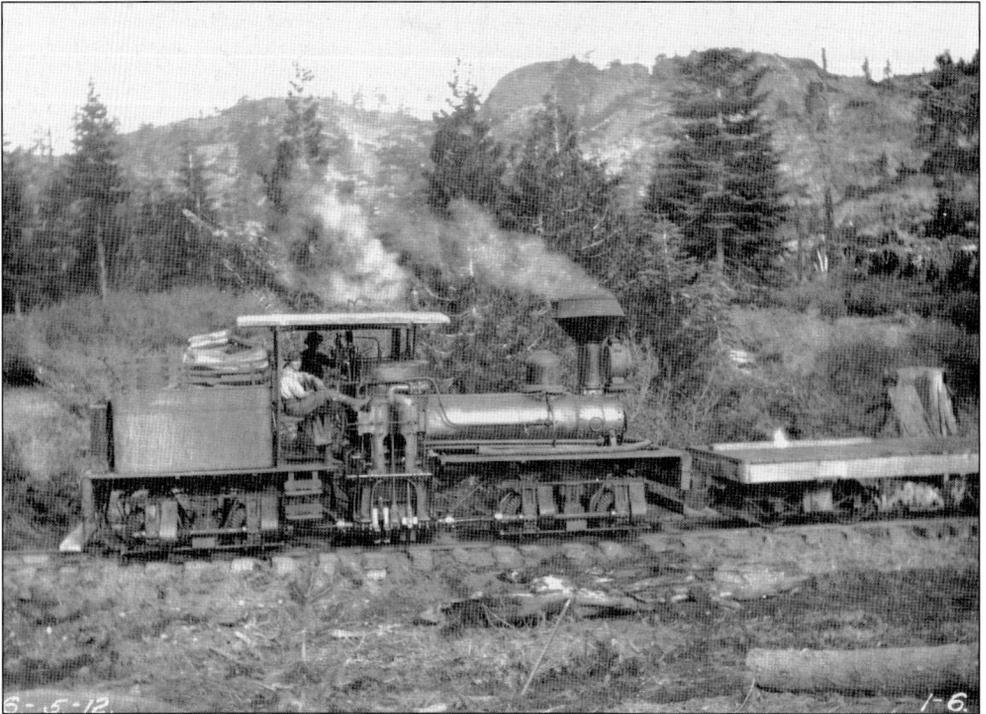

An unusual steam engine, or shay, is pictured here. The steam pistons, positioned vertically, just forward of the cockpit, turn a drive shaft that engages external gears on the wheels. Instead of one or two driven wheels, as in a conventional locomotive, all the wheels, including those on the tender, are driven.

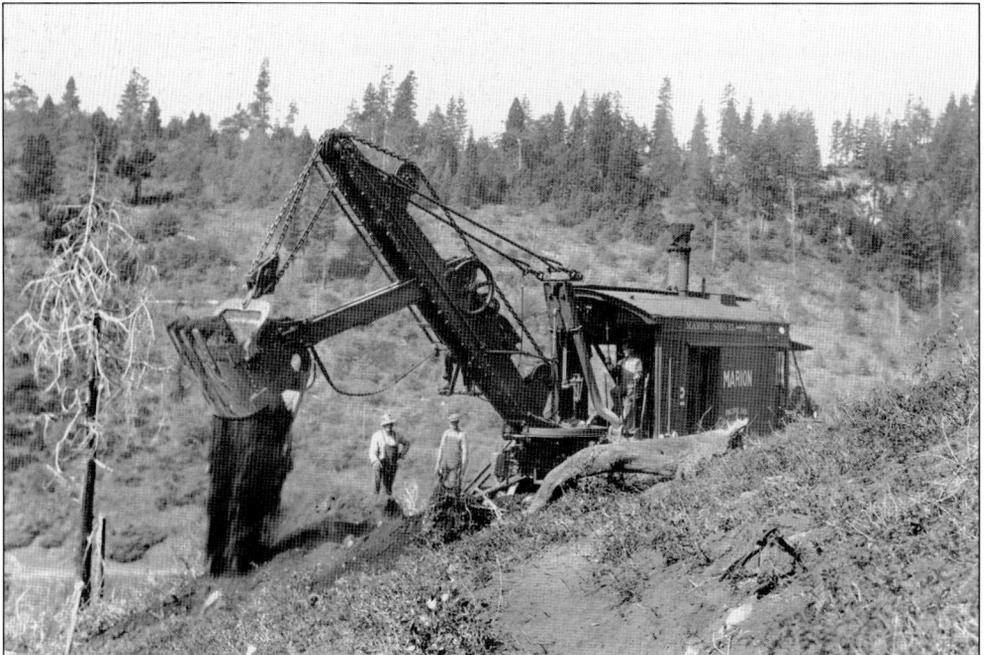

This Marion steam shovel moved not on rails, or wheels, but on tracks.

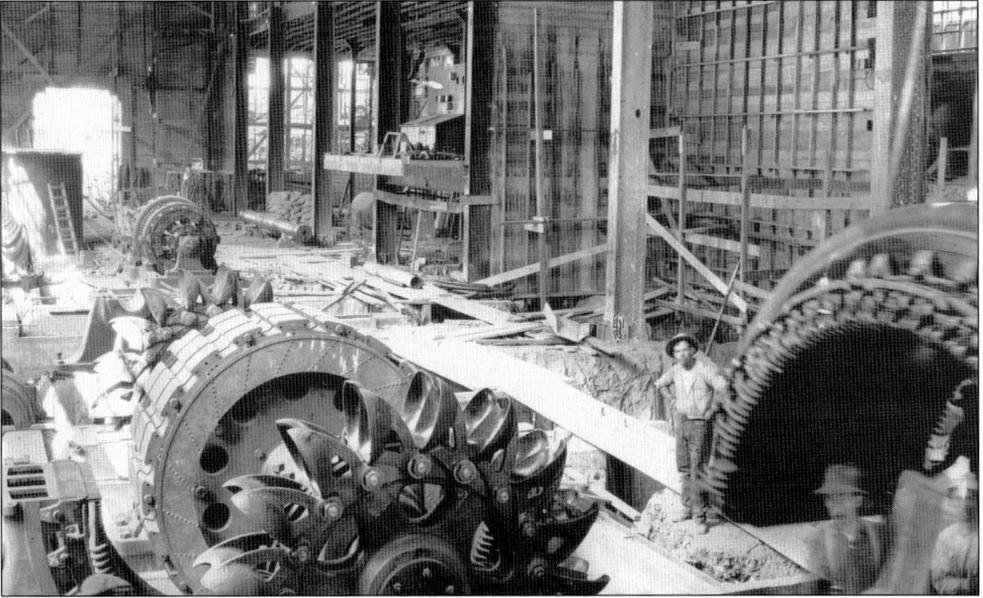

Here the No. 1 generator at Drum is being installed. Configured in a double-overhung mode, it is driven by two waterwheels, one on each side of the generator. The poles can be seen on the rotor, and the field stator awaits installation at the left.

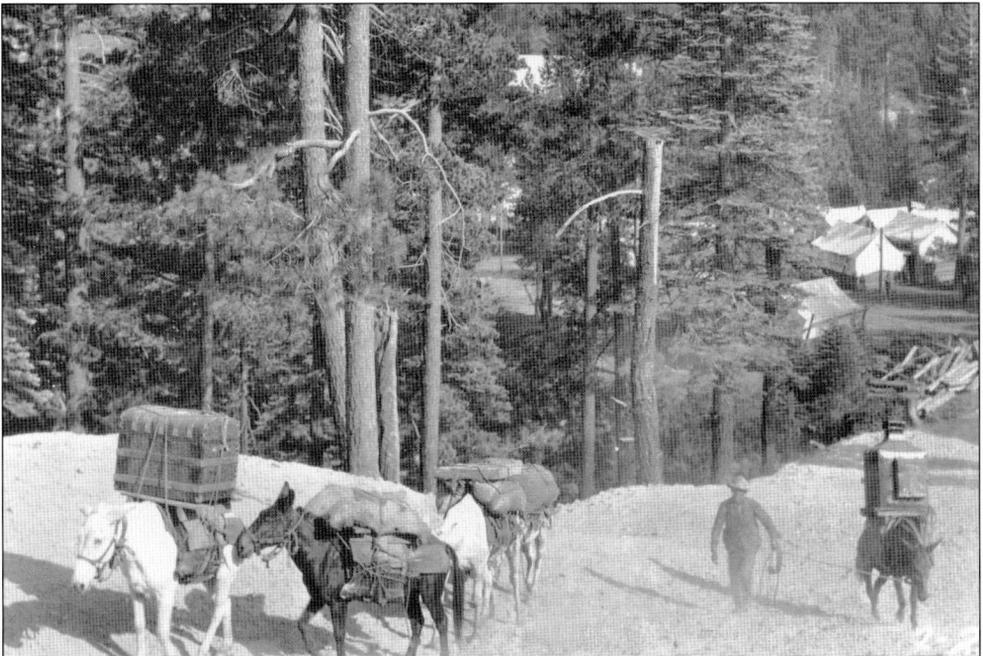

Patient, dependable, and strong, the mule was central to transportation in the early days. Note the large chest balanced on the white mule in the foreground and the metal stove perched atop the animal in the rear.

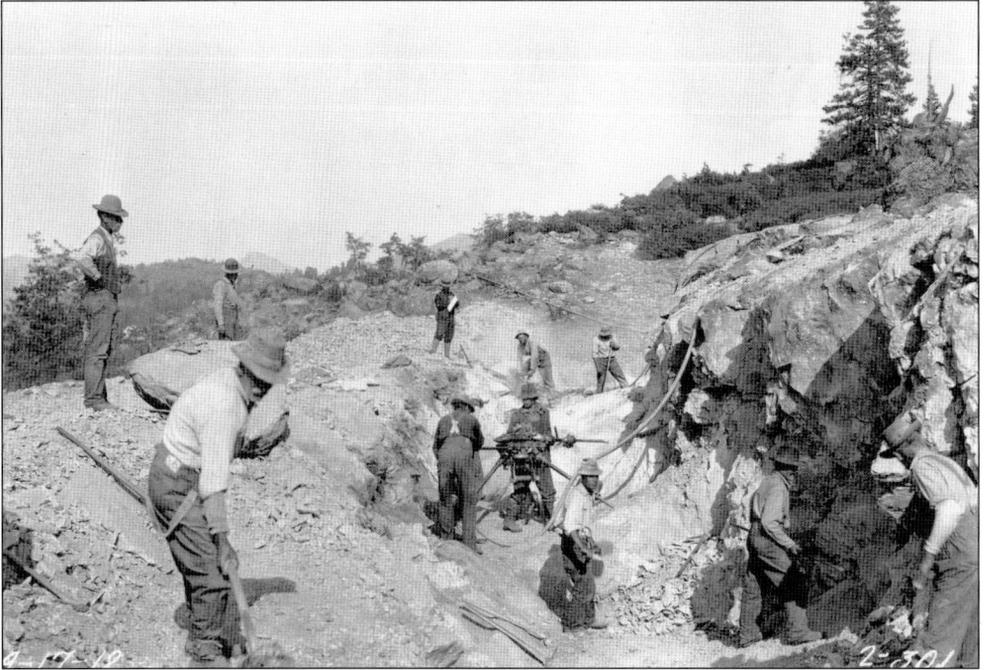

These men dig the Drum Canal at Spaulding. While most work is being done with pick and shovel, note the air-powered drill at the bottom of the trench.

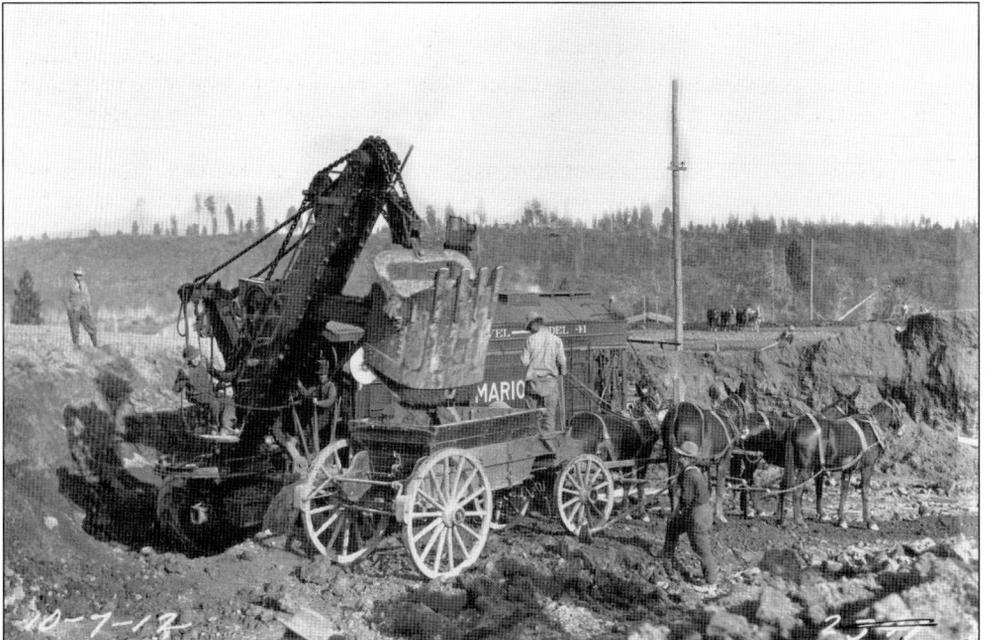

Steam power meets horsepower as this Marion shovel dumps fill dirt into a wagon.

Five

FOLSOM POWERHOUSE

The Folsom Powerhouse is perhaps the most important historic hydroelectric site in the state of California for a number of reasons. Built by the Sacramento Electric Power and Light Company, it was one of the first major hydroelectric projects in the United States. In addition to building a generating facility on the banks of the American River, General Electric contracted to construct a 22-mile, 7,000-volt transmission line, one of the first in the country, to provide electricity to the city of Sacramento.

The generators went into operation in 1895, and by the fall of that year, four generators were producing 3,000 kilowatts of electricity. Until the Niagara Falls Plant came on line in New York, the site was said to be the largest producer of electricity in the United States. In 1905, the Sacramento Electric Power and Light Company was merged with PG&E, who continued operating this historic site until 1952, when it was acquired by the State of California.

Since then, the plant has been open to the public as a state park. Much of the original operating machinery, including the penstocks, turbines, and generators, has been preserved in place. Access is easy from the historic district of Folsom.

The old powerhouse at Folsom is one of the most accessible in Northern California. Operated as a state park, it allows the visitor close access to the workings of a pioneer hydroelectric plant.

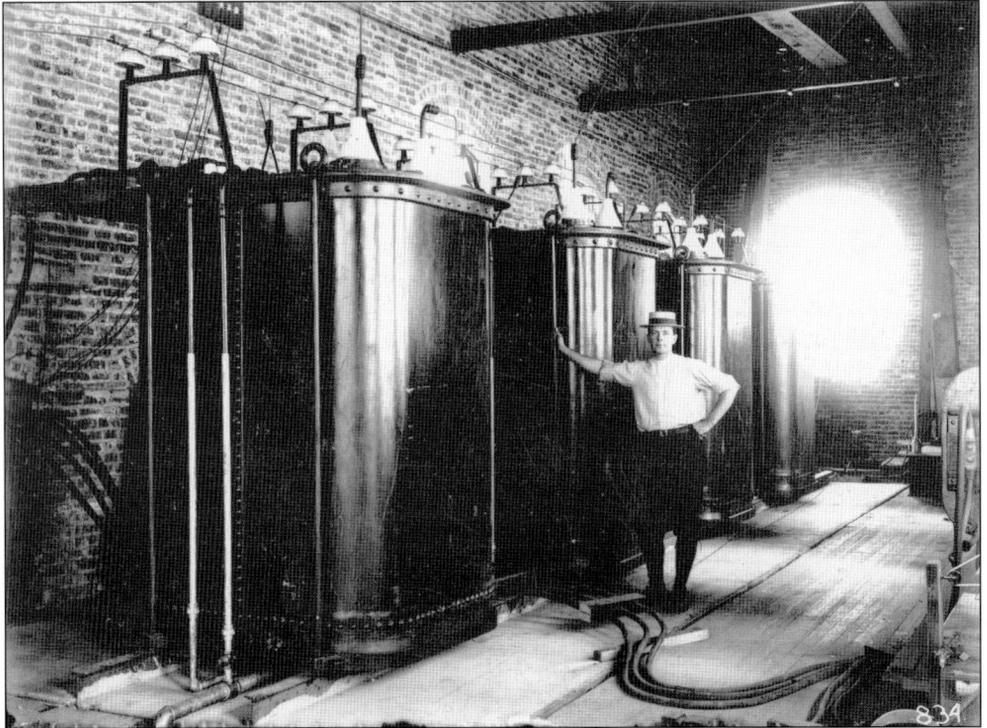

A fashionable visitor to Folsom in 1903 stands next to the transformers. At the time, Folsom was probably the largest hydroelectric producer of electricity on the West Coast.

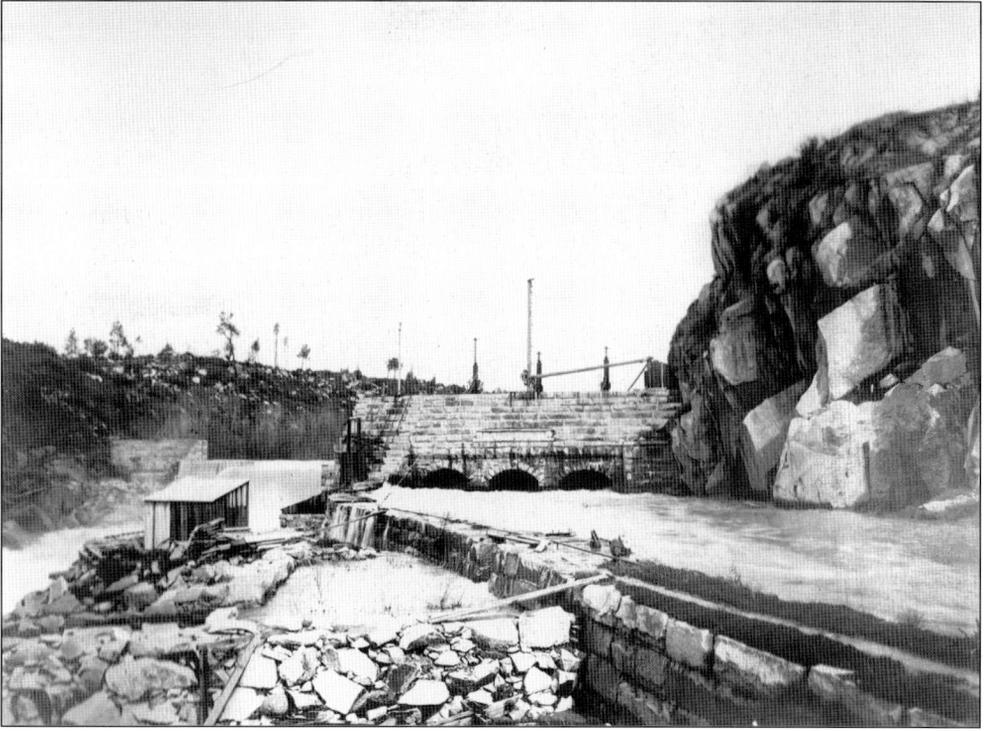

A diversion dam upstream from the powerhouse directed most of American River's water to the forebay of the powerhouse.

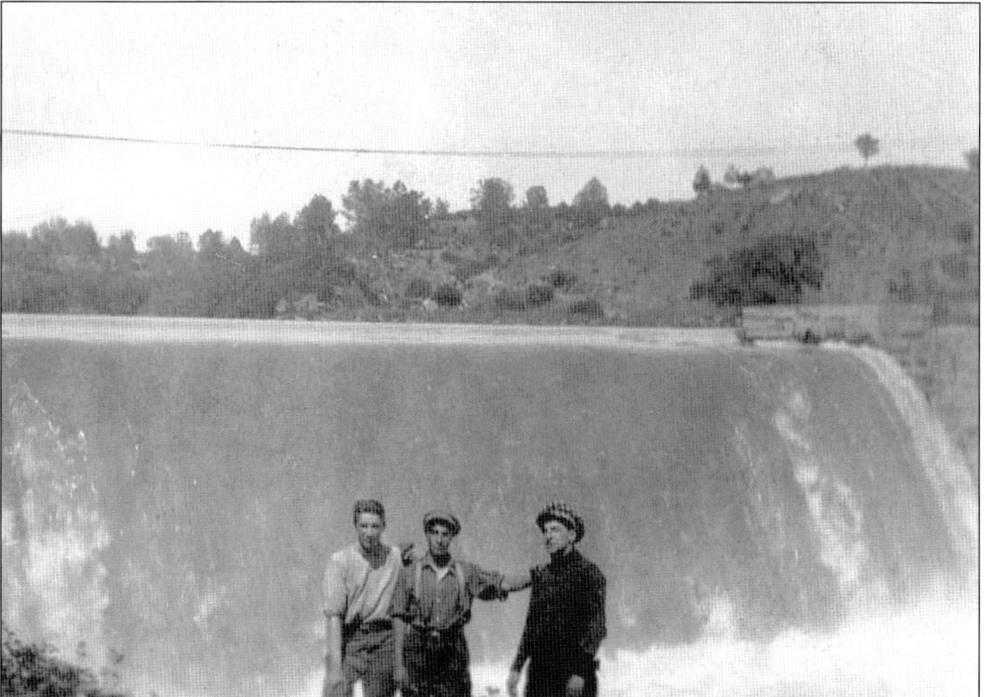

Three chums stand next to the diversion dam at Folsom.

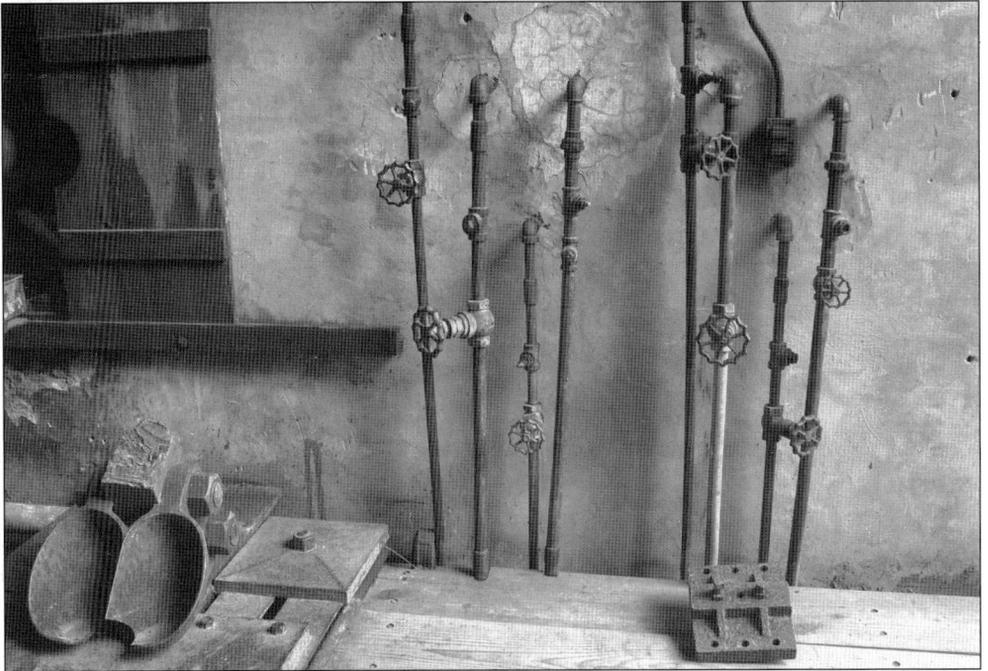

The Folsom Powerhouse was not engineered in its entirety from the start. Instead, it was continually modified as new equipment was introduced. For instance, when electrical-speed governors replaced mechanical governors, old machinery had to removed and new installed. The result was pipes and valves whose purpose is lost to history.

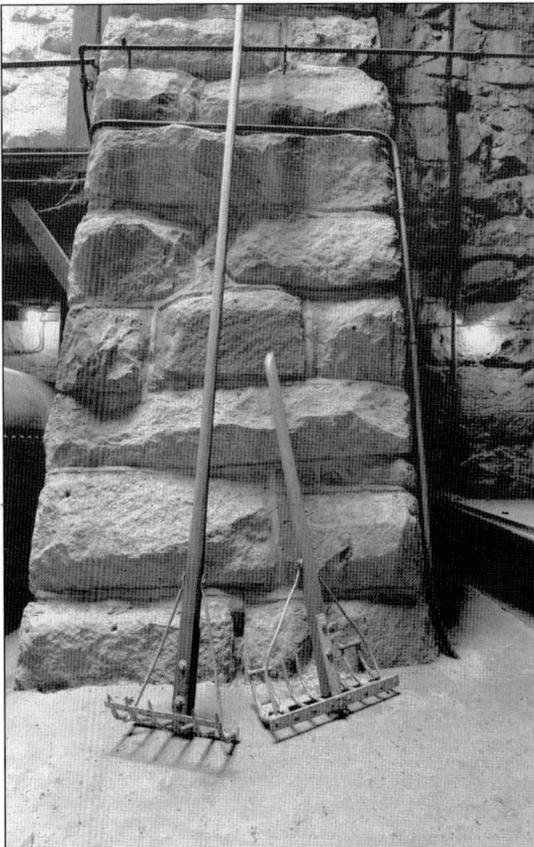

These curiously shaped rakes, called potato hooks, were used to remove debris from the water in the forebay and to remove leaves from the racks, which filtered the input to the generator.

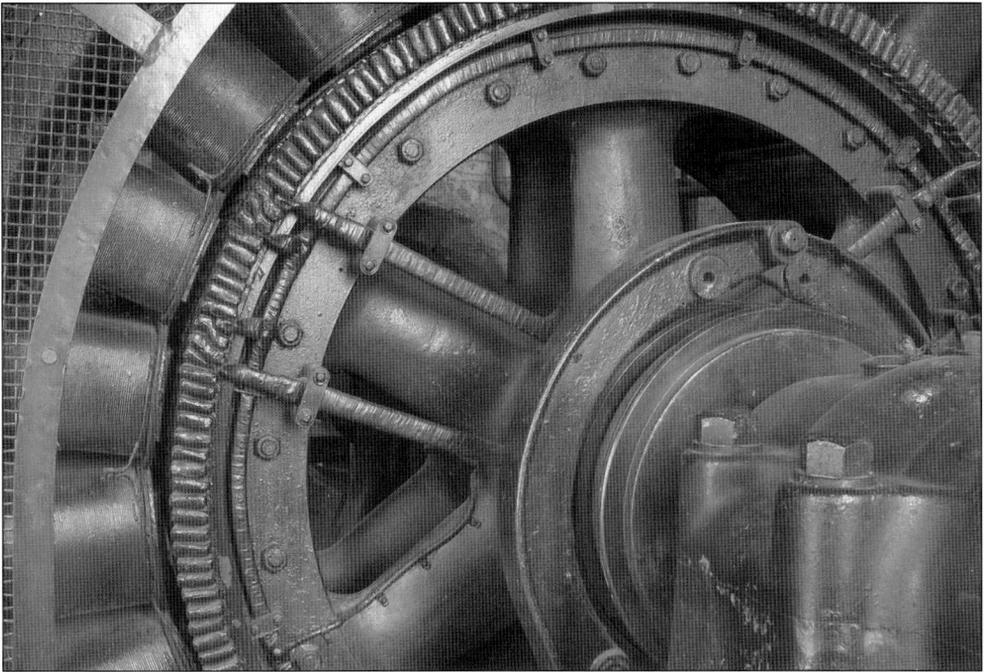

A contemporary close-up view shows one of the Folsom generators and the electrical windings on the stator, which remained stationary. The armature turned within it.

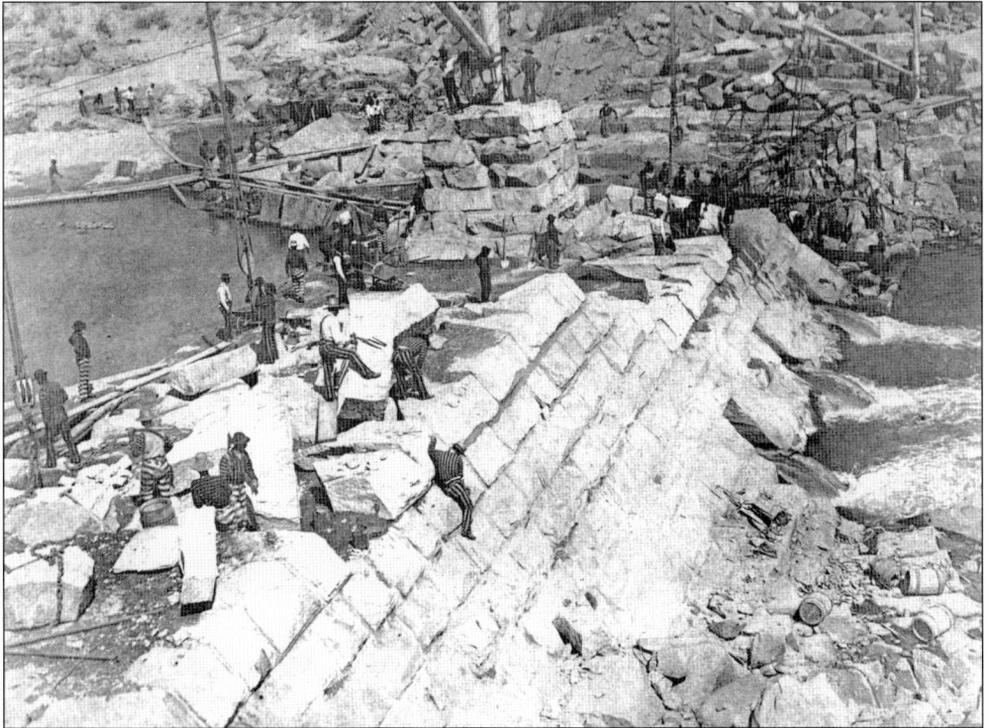

Convict labor from Folsom Prison, one of the first prisons in California, was used extensively in the rock work required for the Folsom Dam.

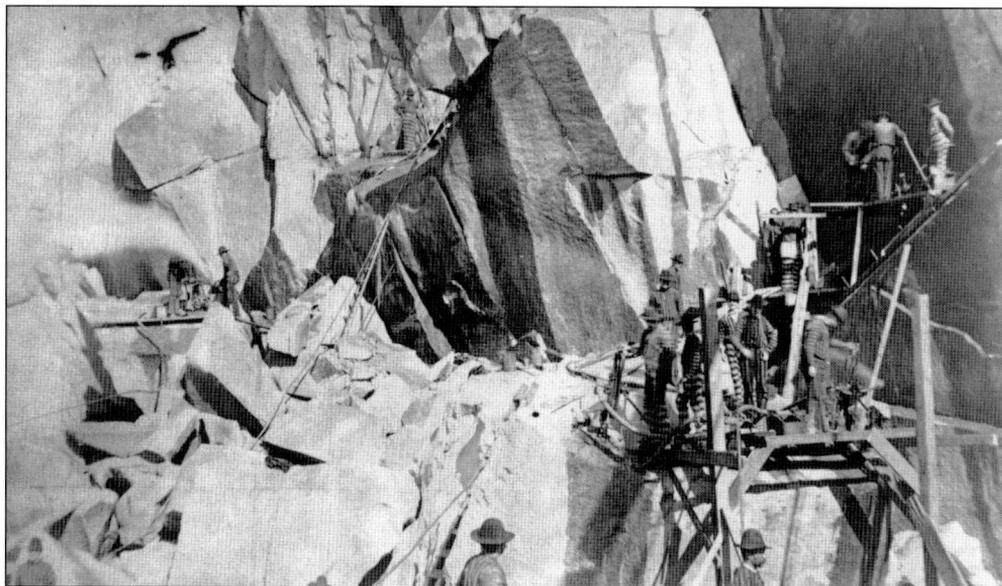

Granite was quarried locally. Here prisoners use an air drill to bore holes for blasting power in the rock.

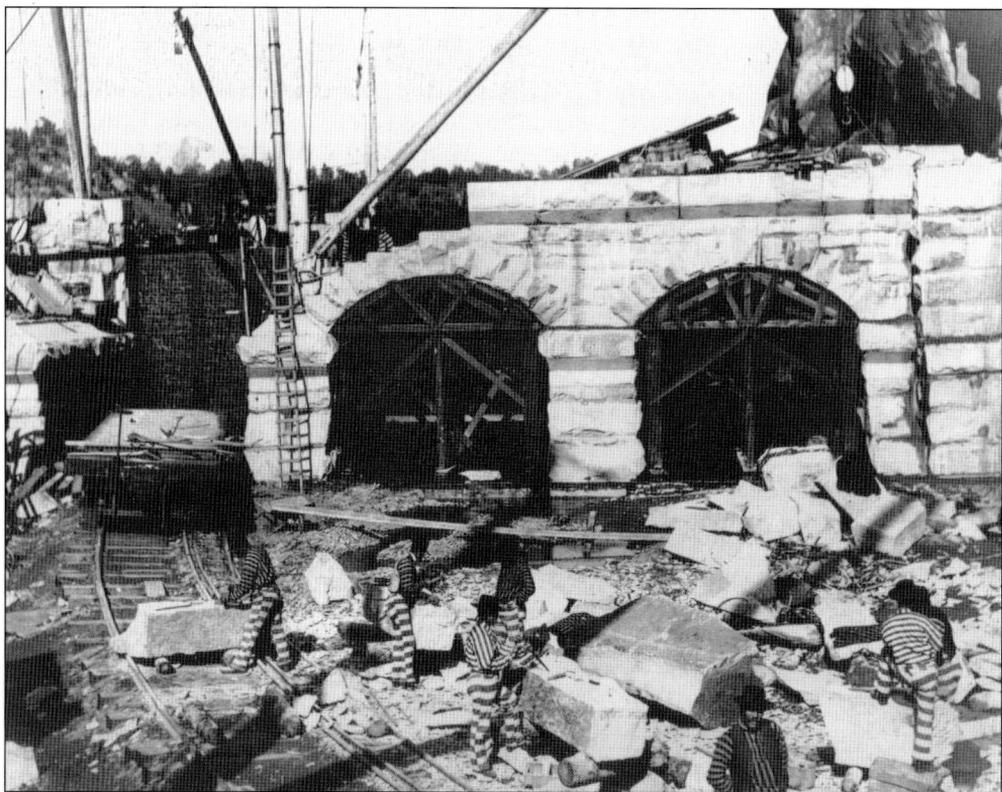

Prison laborers are in the midst of building this structure, also pictured on page 91. Note the cranes for lifting rocks and the temporary rail system for bringing in granite blocks.

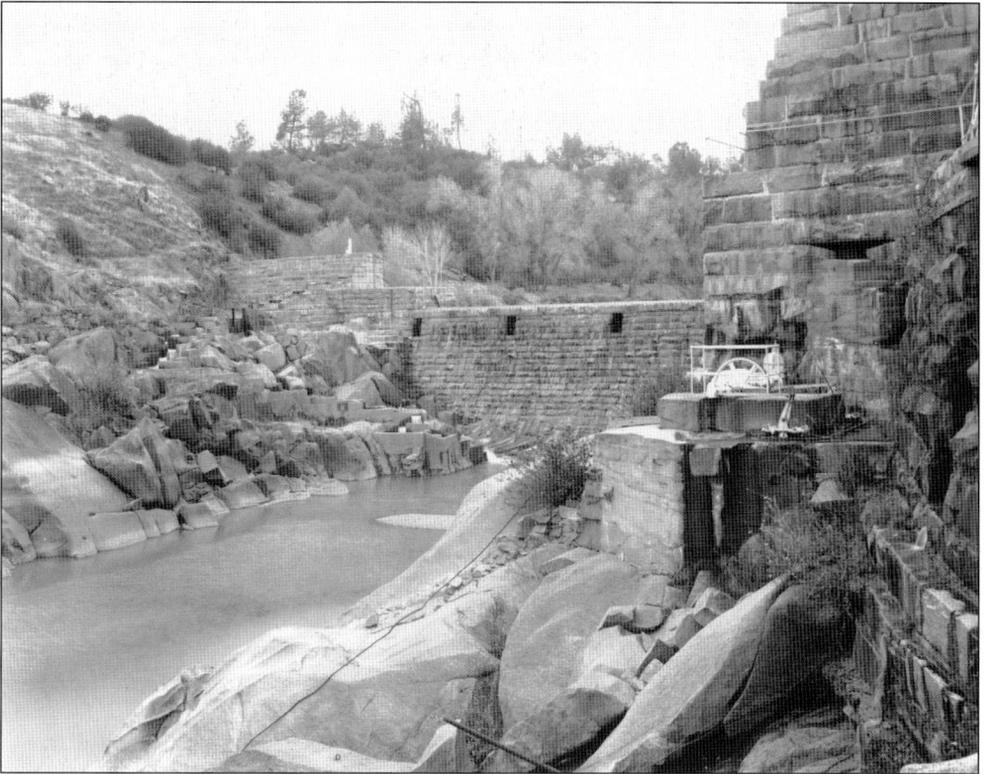

This 1941 view shows the diversion dam and the intake canal structure at the right. Note a concrete fish ladder at the right side of the dam that allowed spawning salmon access to the upper American River. When this structure was replaced by a modern dam in the 1950s, the fish ladder was omitted.

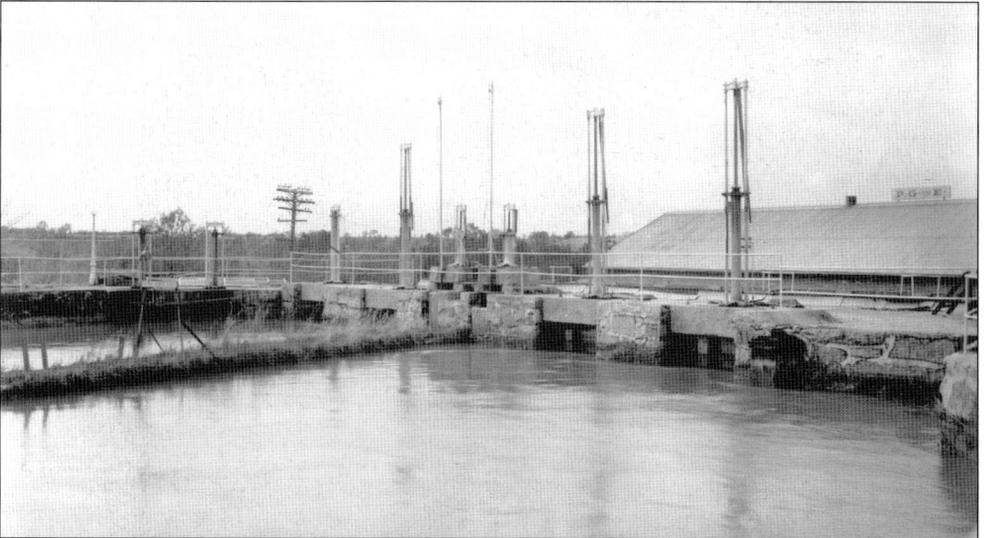

Compared with powerhouses in the mountains, such as Drum, which operated with extreme water pressure, the only vertical drop in the Folsom system was from the forebay to the generators. Lower pressure meant less power.

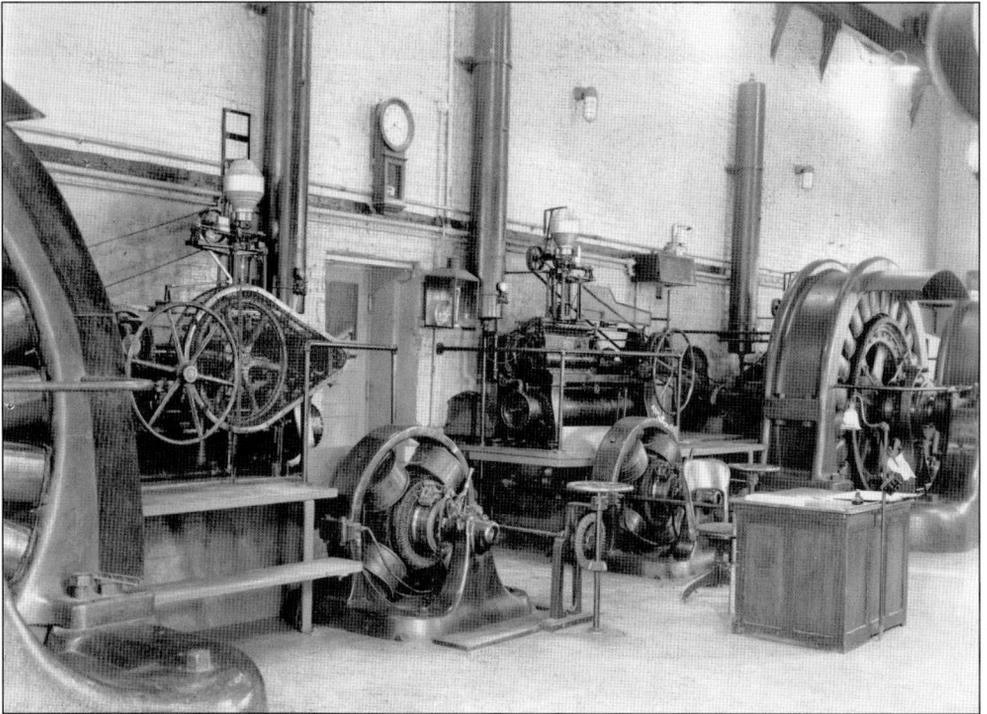

This good view of the generators, exciters, and mechanical governors was captured in 1941, when they were still in use. The governors were mechanical and used centrifugal speed regulators to control the speed of the waterwheel.

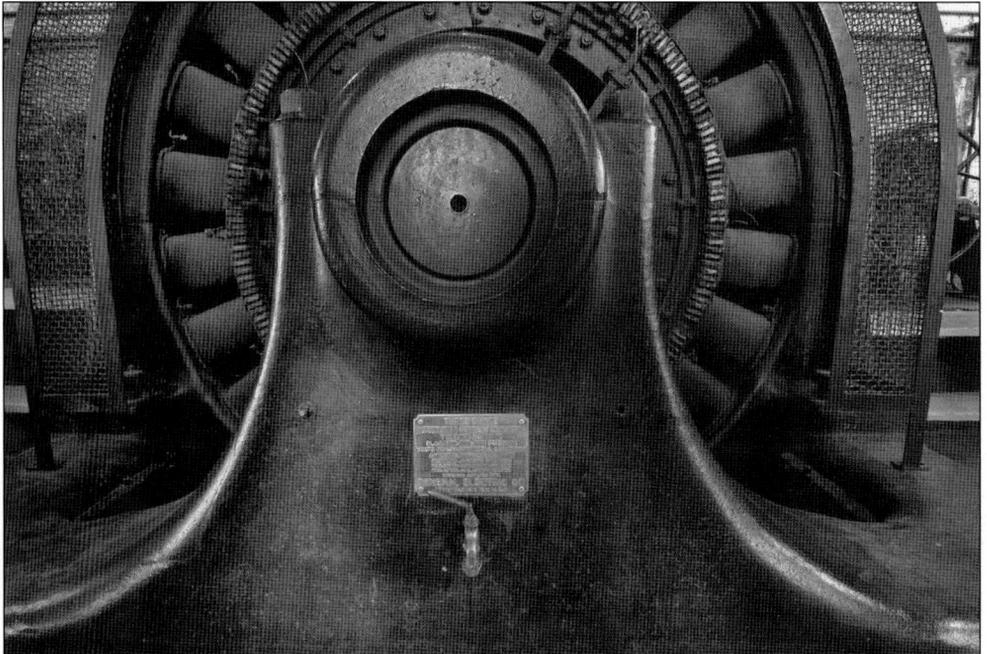

The manufacturer's label on this generator shows that it was made by General Electric and was protected by patents granted as early as 1880.

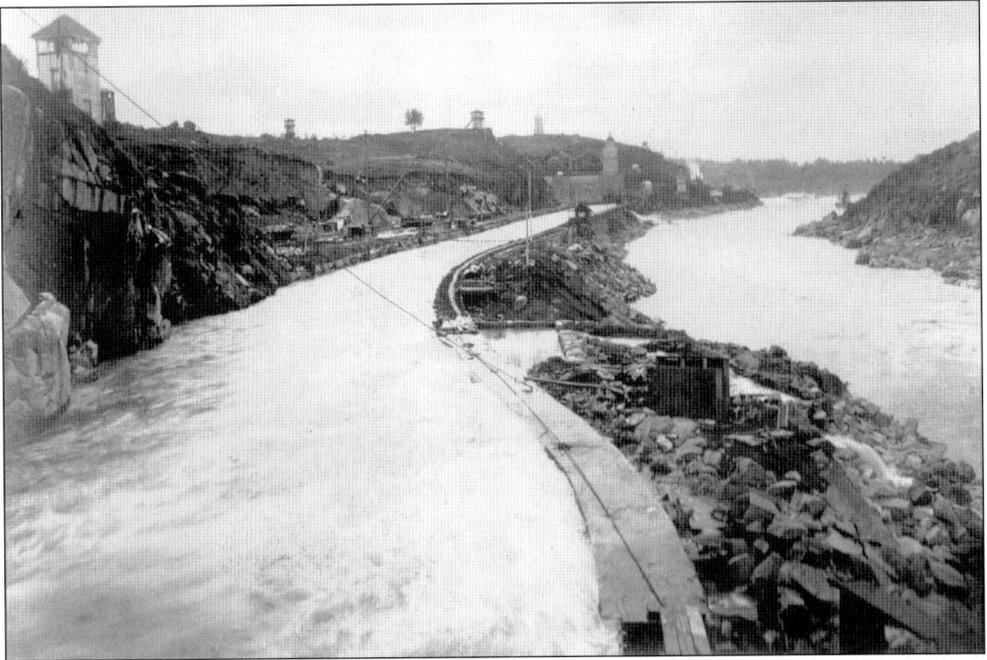

A downstream view of the diversion canal shows prison guard towers on the left. With only a few feet of water drop, the Folsom Plant was a low-pressure facility.

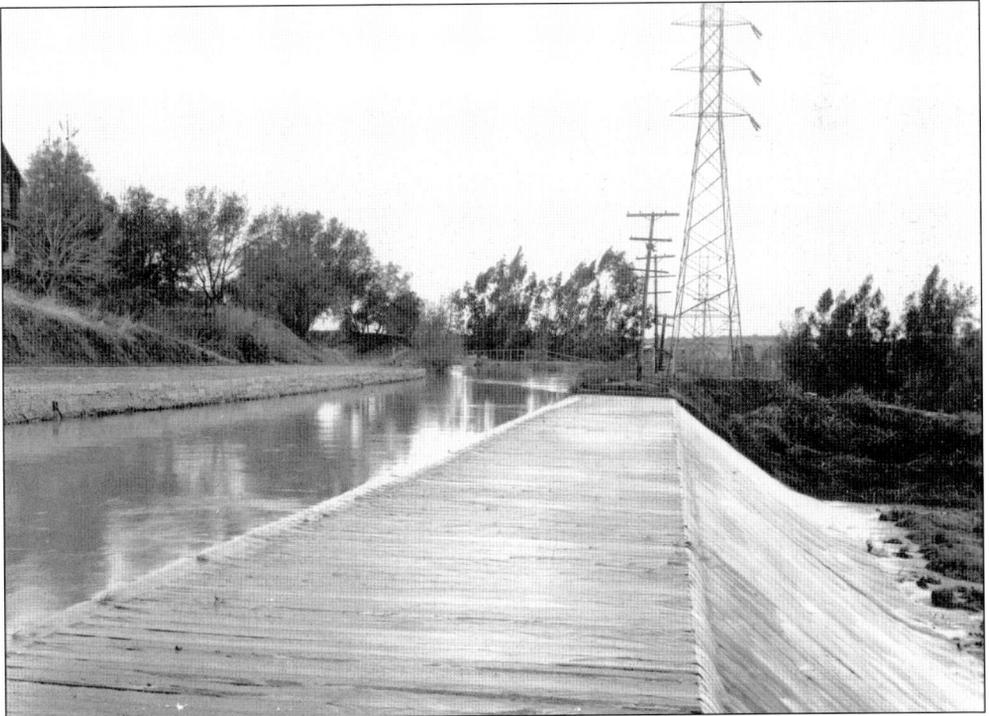

The Folsom Canal had a spillway section, which returned excess water to the American River. In 1941, when this photograph was taken, the transmission line in the background had been increased to 100,000 volts.

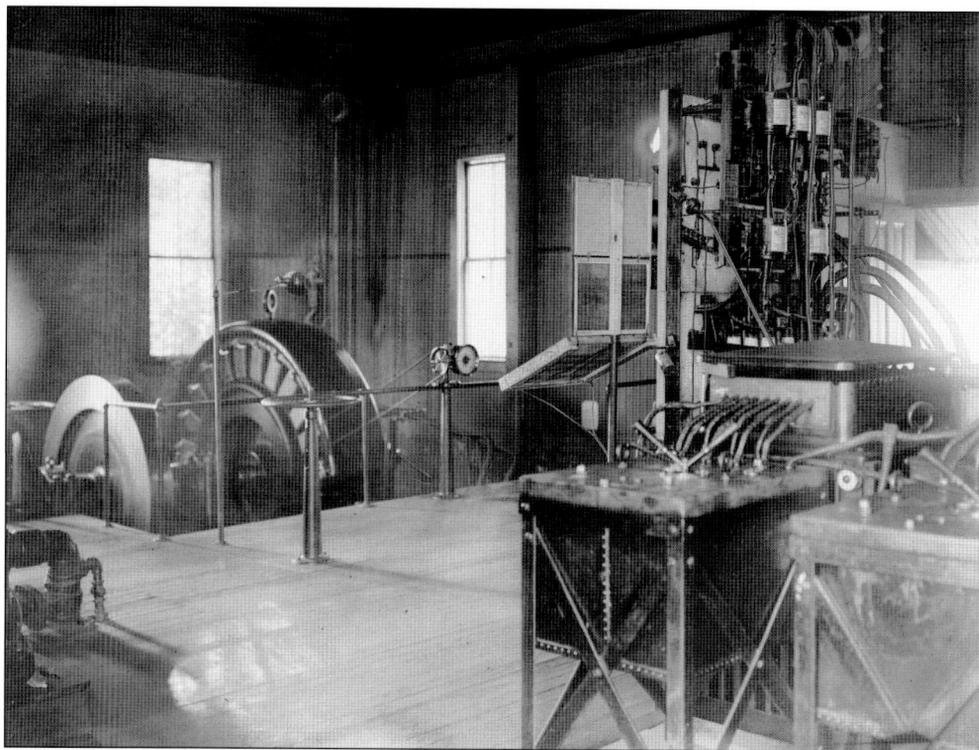

A smaller, secondary powerhouse adjacent to the main facility is pictured. Preceding the main facility, the equipment is even more primitive.

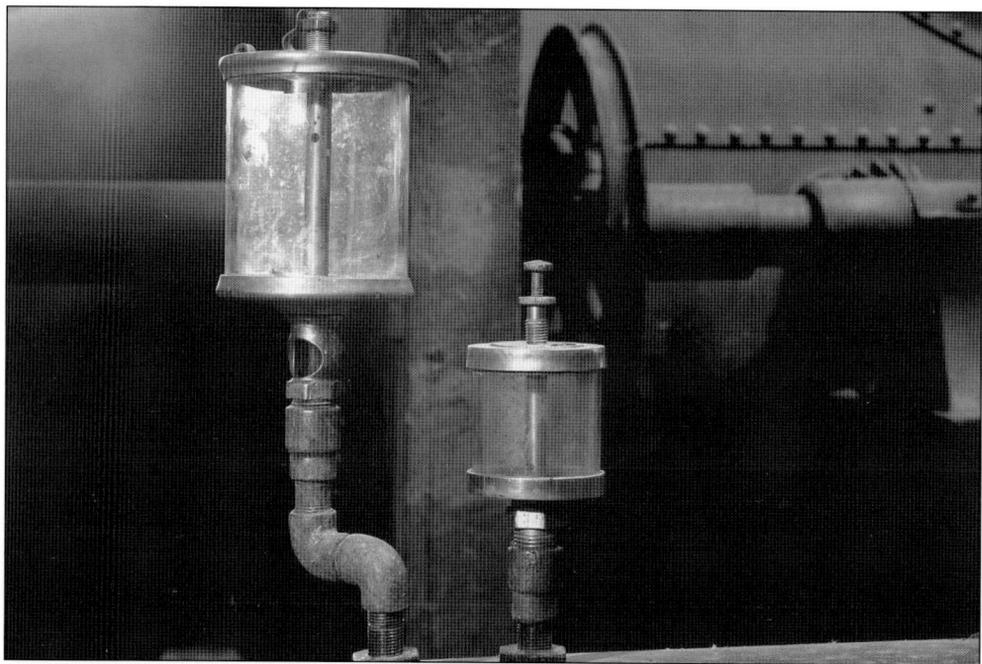

The moving parts of the machinery were lubricated by oil; these oil cups were filled, and gravity delivered the lubricant. The operator could tell with a quick glance when it was running dry.

Six

WISE POWERHOUSE

The farthest downstream plant in the Bear River system, the Wise Powerhouse, receives the flow of water from the Halsey Powerhouse, located a few miles upstream in Auburn.

It was named for the initiator of the Bear River project, James H. Wise, a PG&E engineer who died at the age of 32 in 1912, some five years before the powerhouse came on line. The photographs show his widow at the dedication ceremony, along with other PG&E dignitaries, such as John Britton and John Martin.

The architecture of this plant is notable for its grace and beauty. Large windows frame the upper walls, and corniced eaves blend the walls into the Mediterranean roofline.

Today the Wise Powerhouse is easily accessed from Interstate 80 in Auburn. Take the Highway 193 exit and turn right on Ophir Road, which runs adjacent to the freeway. The powerhouse is two miles on the left.

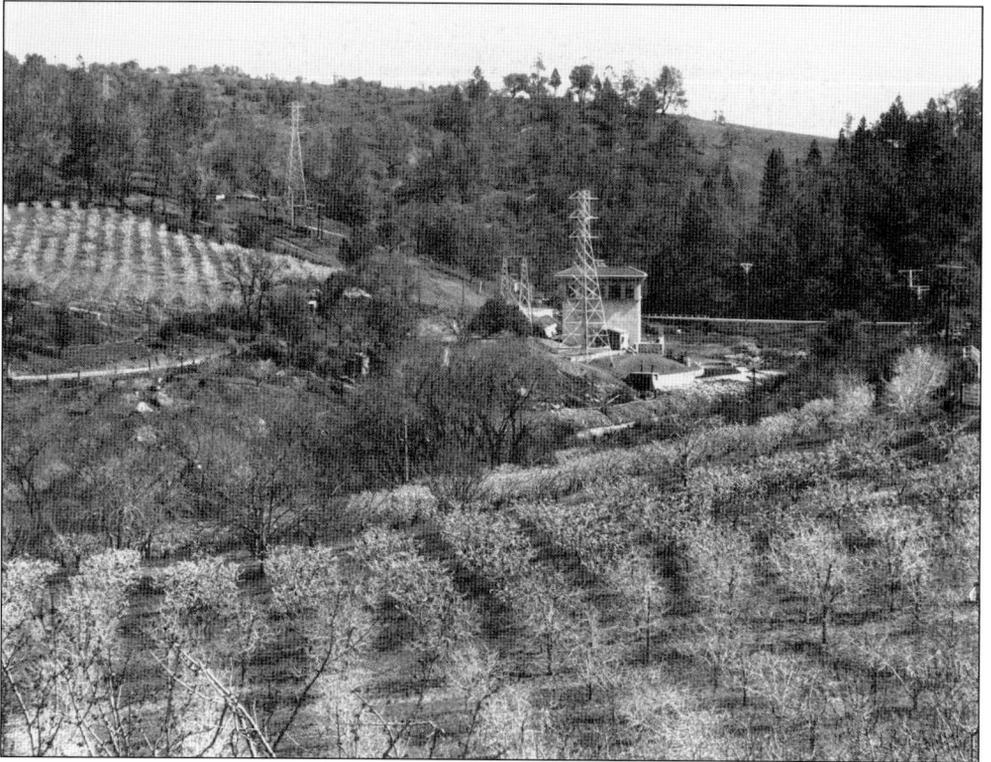

Wise Powerhouse is pictured here at about the time it went on line. The penstock is seen on the hill behind the powerhouse. This June 1917 photograph shows surrounding orchards in early bloom.

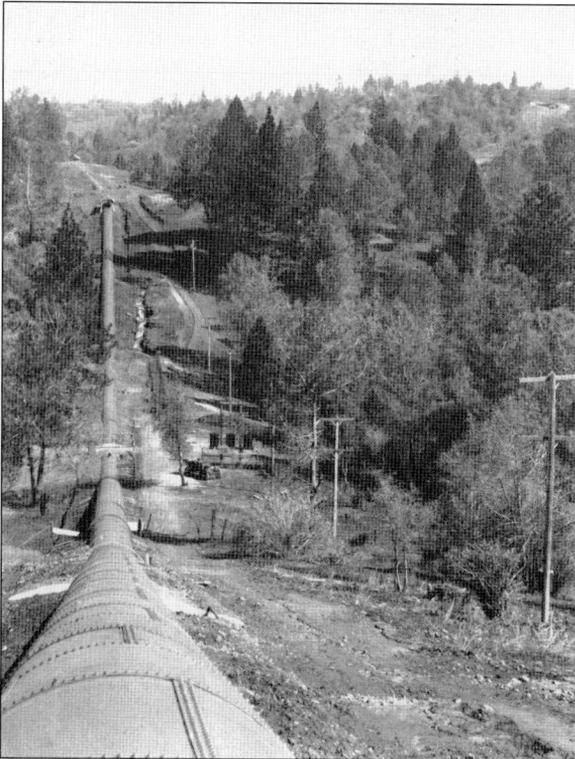

The Wise penstock, pictured here in Auburn, was eventually buried in the farmland, although other sections are still visible. It appears to be constructed in the old method, whereby sections were hauled to the construction site and riveted together in the field.

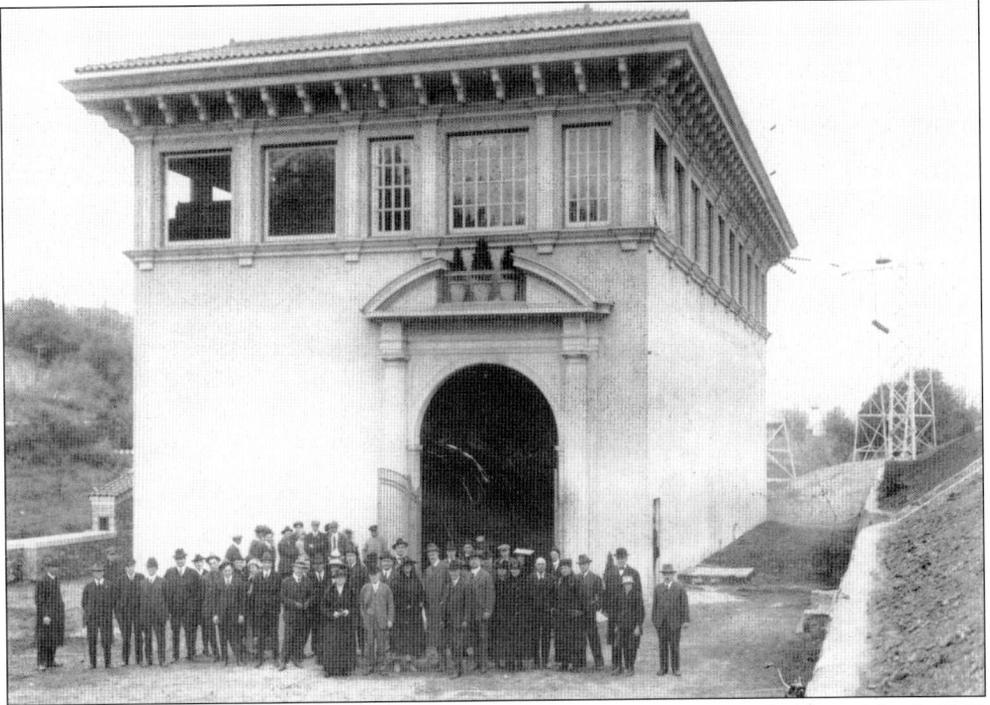

This photograph documents the dedication ceremony for the Wise Powerhouse in March 1917. The powerhouse is easily accessible from Interstate 80.

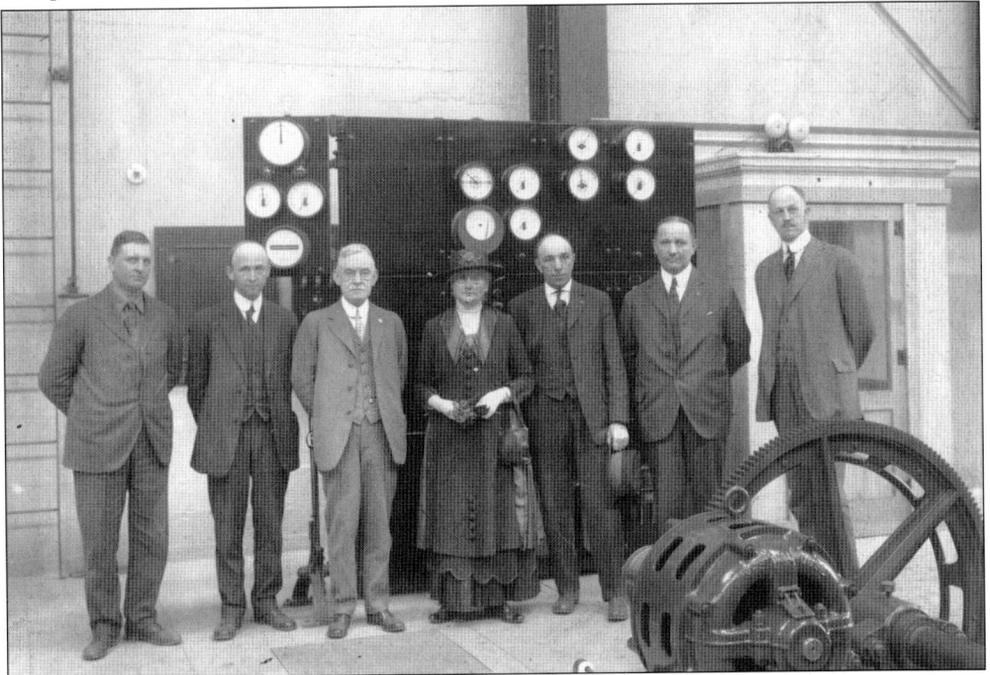

The powerhouse was named for James Wise, a well-regarded PG&E engineer who died in 1912. In this photograph, his widow stands with J. A. Britton (to her right), for whom Lake Britton is named. At the far right is P. G. Baum, for whom Baum Lake is named.

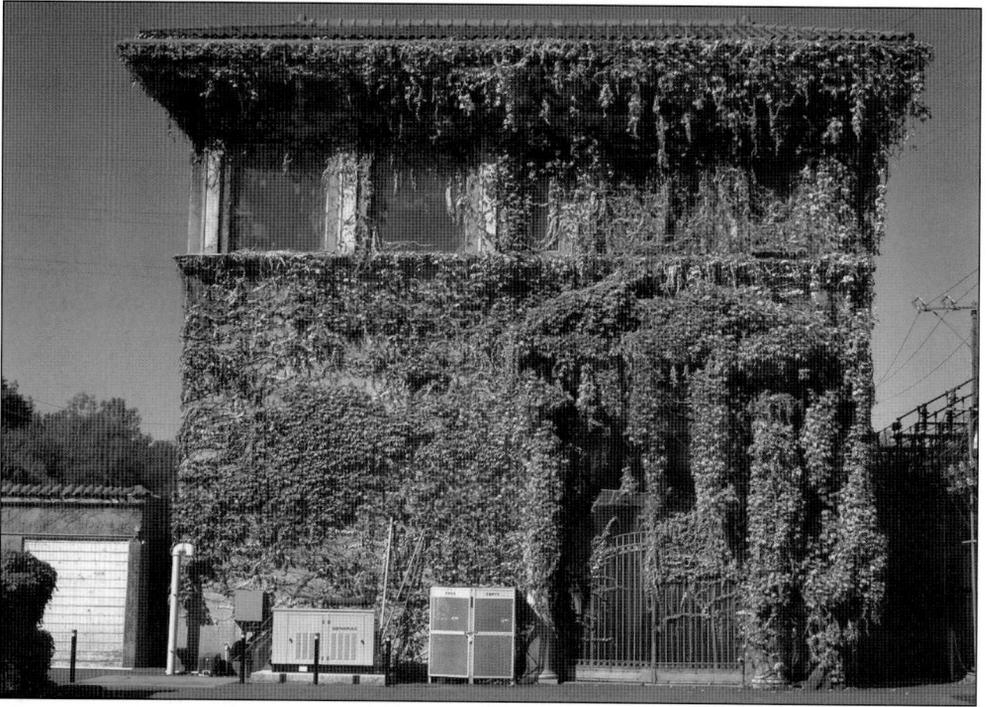

This 2004 photograph shows the extensive ivy growth that has enveloped the powerhouse since 1917. Underneath the vegetation, the building retains the grace and beauty of its Mediterranean design.

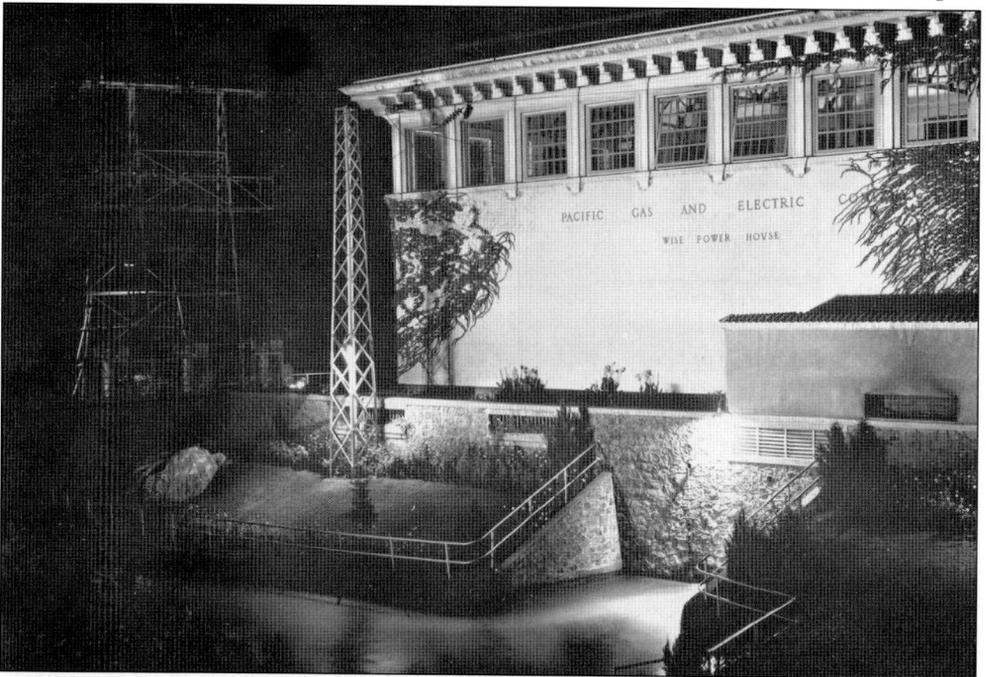

The plant was brilliantly lit at night, and the photographer captured a unique view of the new powerhouse. Because of subsequent growth of trees, this view has become obscured and can no longer be seen.

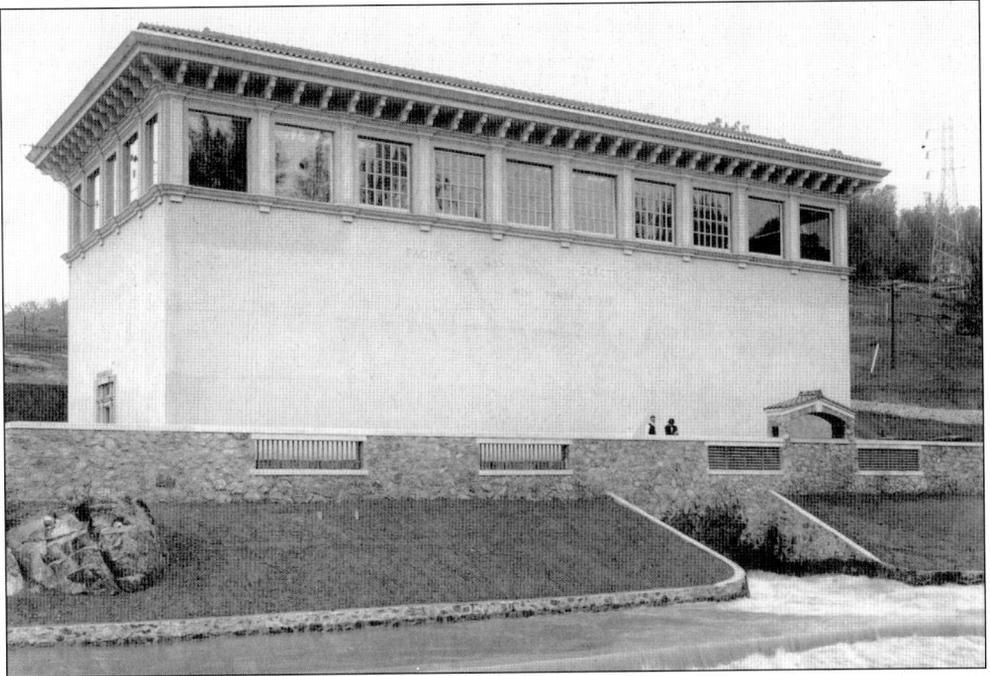

The architect of Wise designed a building with classic lines that was at the same time functional. The stone base features openings that provide architectural detail, while the curving walls of the outlet shape the discharged water into a pleasant foothill creek.

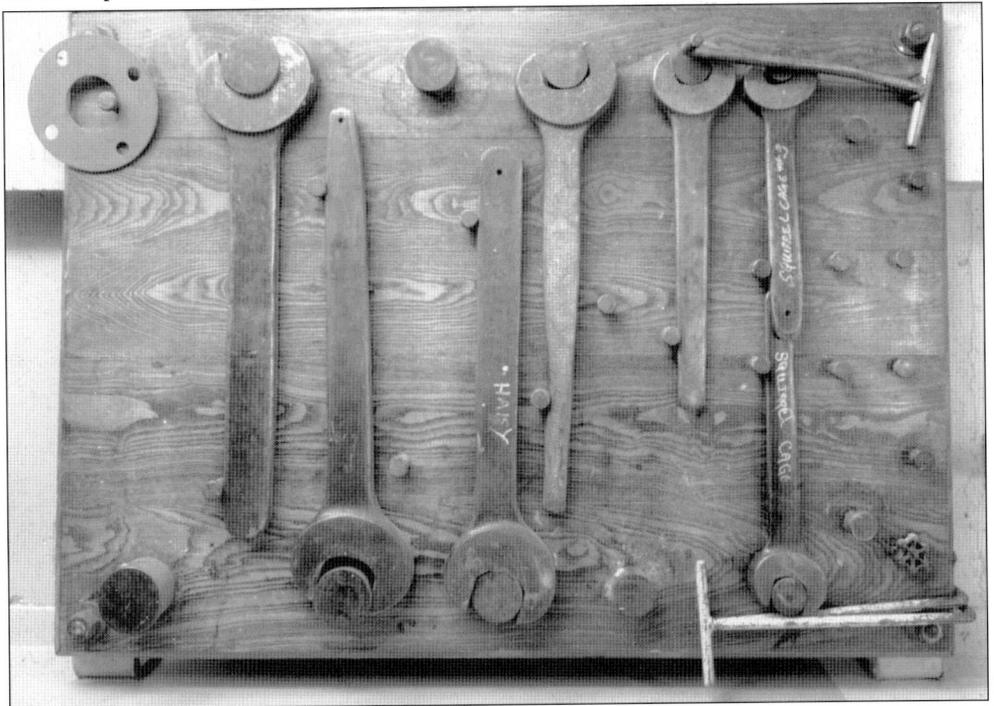

The tools on the rack in this contemporary photograph have been used at Halsey and Wise for nearly 100 years. The wrenches on the right look like they are unique fits for two "squirrel cages."

An architectural detail of the Wise Powerhouse, this is the staircase at the right of the building. Note the convex grout joints in the rock wall. The rock work on several powerhouses was done by Sicilian immigrants, who apparently used an old-world technique.

Seven

THE BEAR RIVER SYSTEM

The Bear River system includes several sites on the Bear River drainage in the central Sierra Nevada region. The river flows from its origin near Castle Peak, about 200 miles to its confluence with the Sacramento River north of Marysville.

The first site developed for hydroelectric generation was Lake Spaulding, which was originally created by a pioneer dam built in 1892. In 1912, PG&E Corporation began construction of a new concrete dam and an adjacent power plant. They also built a 4,400-foot tunnel and eight-mile canal to channel discharged water to another powerhouse, Drum, located further down the Bear River drainage.

The generating capacity of the Bear River system, which included the Alta, Dutch Flats, Halsey, and Wise powerhouses in addition to those listed above, was increased to 118,000 kilowatts by 1952.

There are three powerhouses at Spaulding Lake. The two below the dam were built on niches chiseled into the granite walls of the Bear River canyon and are visible only by climbing the ridge above the river to the west. The other is accessible by boat or trail around the lake. The area is near a major highway, Interstate 80. Take the Highway 20 exit and follow the signs to Spaulding Lake.

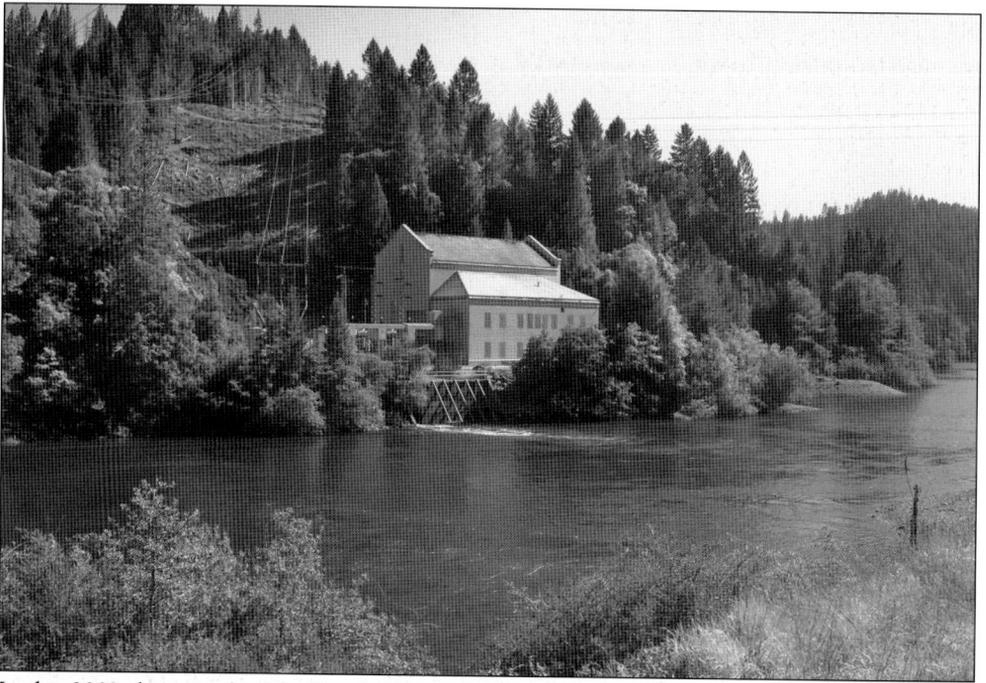

In this 2003 photograph of the Dutch Flats Powerhouse, 70 years of vegetation growth is evident. Trees underneath the high-voltage transmission line are cleared annually for fire protection.

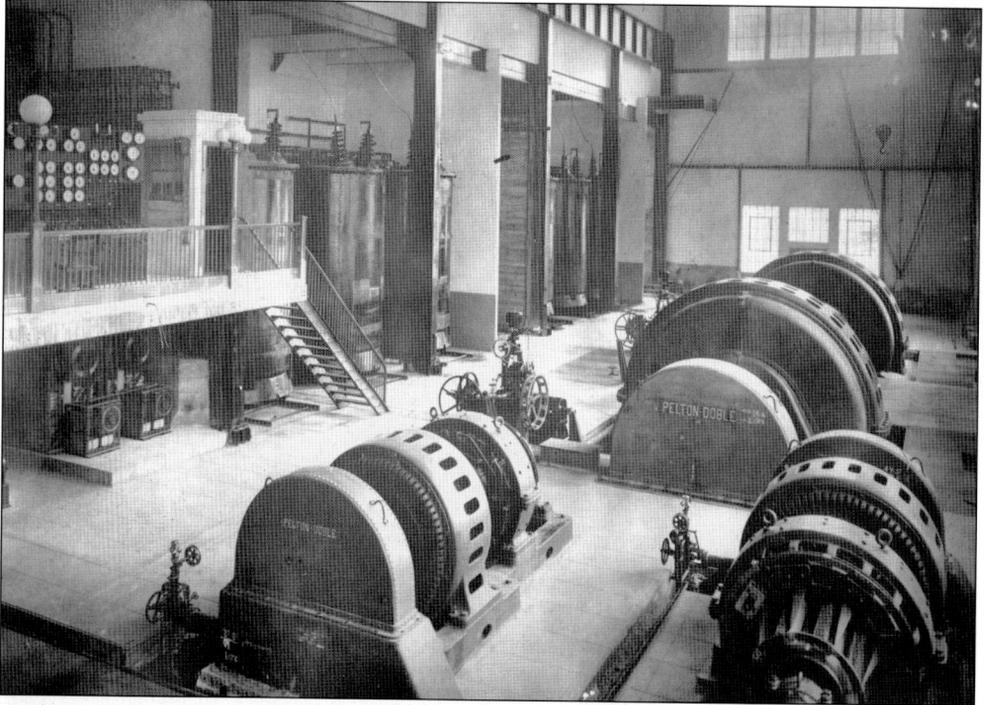

By the time this photograph was taken in 1913, the Pelton and Doble waterwheel companies had merged. One small wheel drives a generator, while another larger unit in the background powers one, or perhaps two, generators.

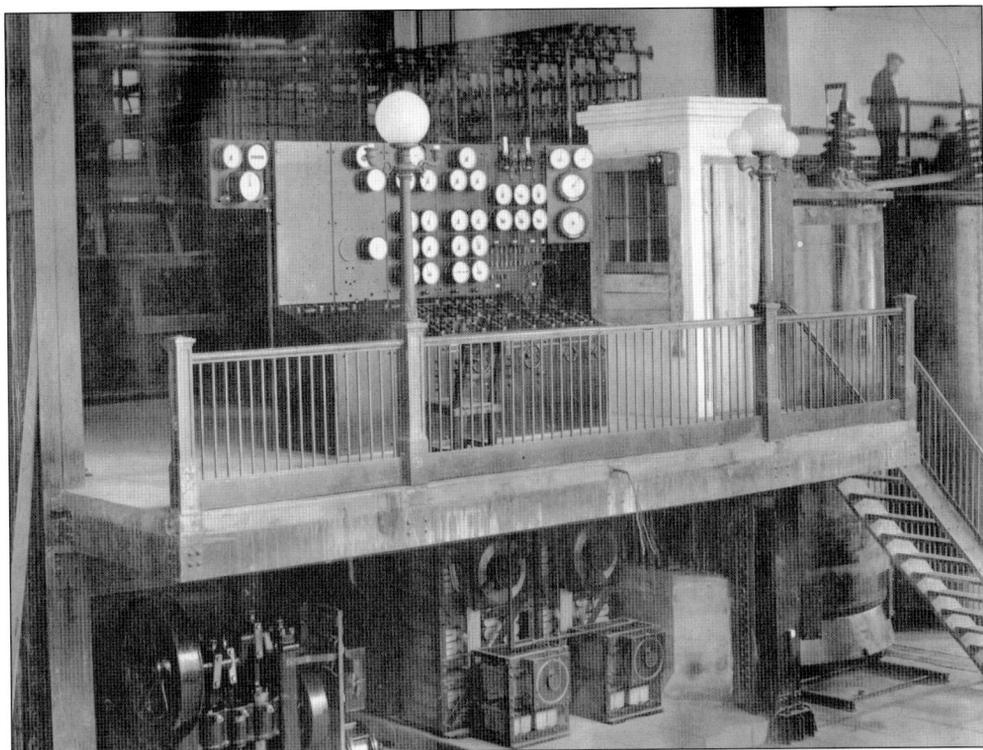

The control apparatus for the Drum generators is pictured here. Rheostats on the ground floor control voltage, while the meters on the second floor monitor the power being fed to the distribution grid. Note the streetlights for illumination.

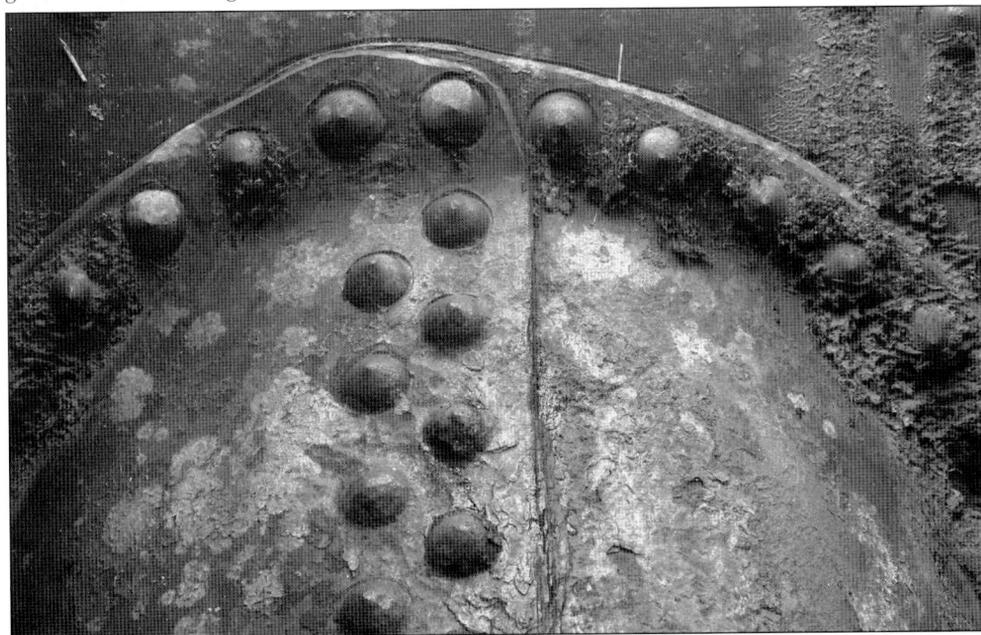

Before welding was feasible, metal was fastened with rivets inserted into drilled holes, and the rivets were seated with hammer blows. This detail of some Alta metalwork looks almost medieval.

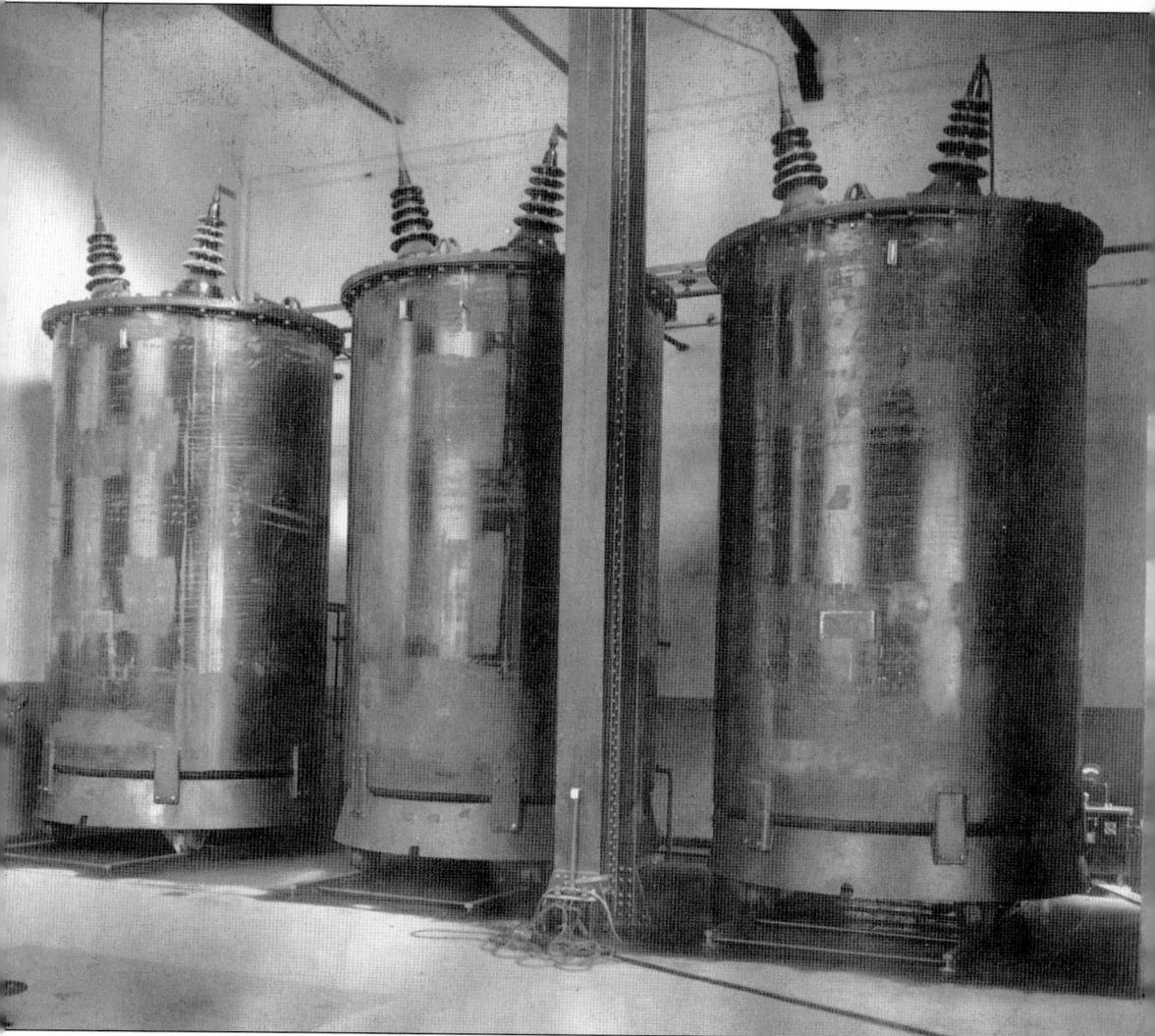

It takes a human, in this case the gentleman standing at the left of the photograph, to provide scale and show just how large the transformers at the Drum Powerhouse were. These devices stepped up the electrical voltage from 6.6 kilovolts to 115 kilovolts for efficient transmission to San Francisco.

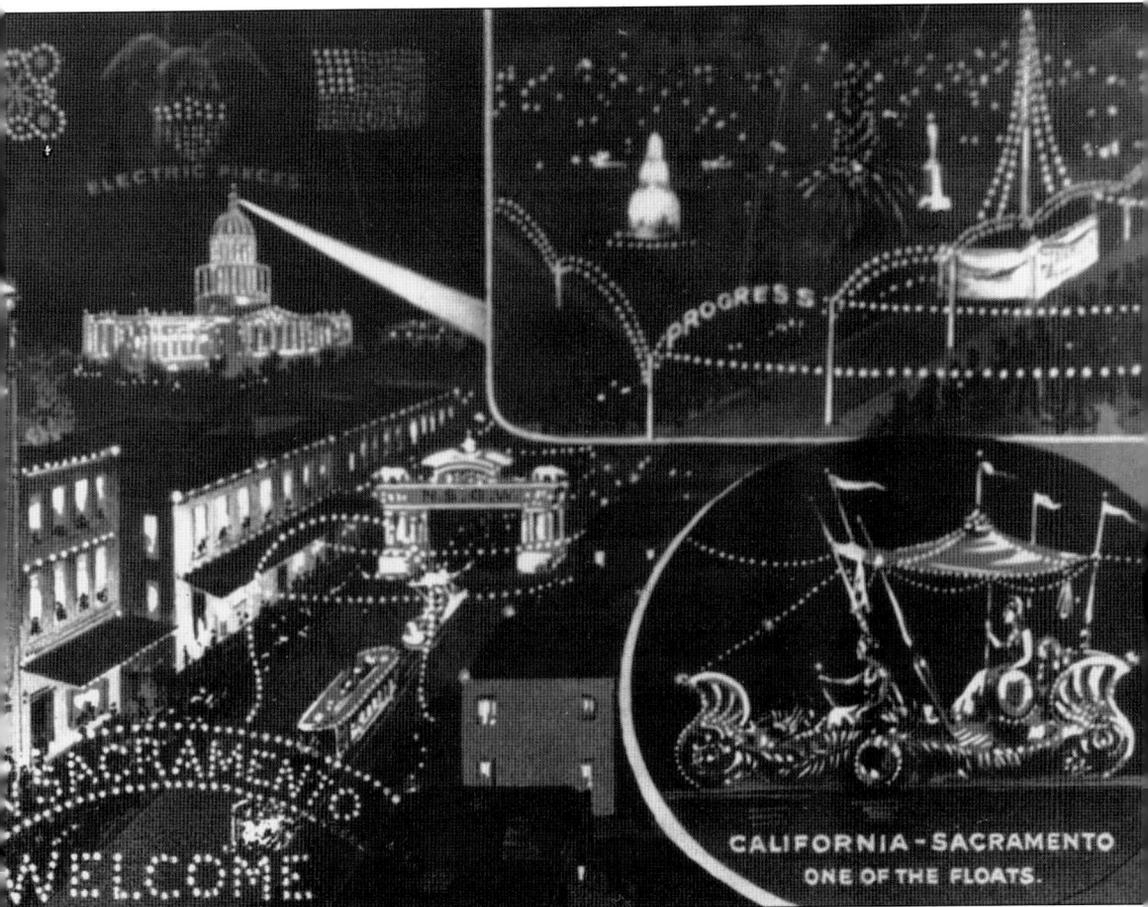

ELECTRIC POWER

PROGRESS

SACRAMENTO
WELCOME

CALIFORNIA - SACRAMENTO
ONE OF THE FLOATS.

When electric power from the Folsom Plant reached Sacramento in 1895, the city staged an extravagant nighttime celebration, complete with illuminated floats. A spotlight on the capitol dome signaled the arrival of electricity to the state capital.

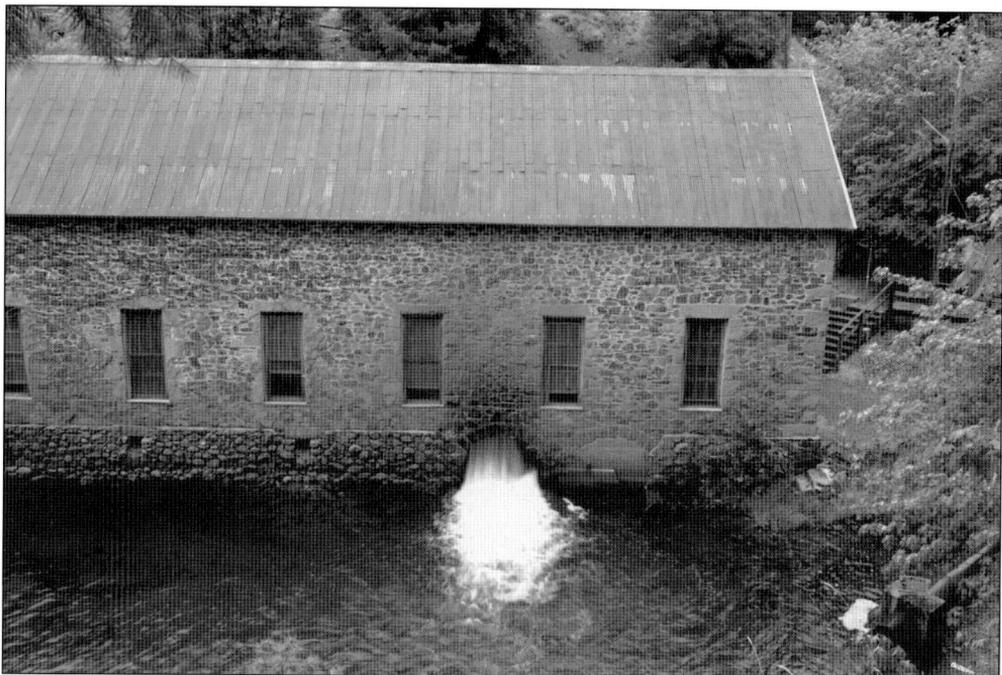

When this photograph was taken in 2004, the Alta Plant had been generating power for 100 years, and much of the original equipment, including the Pelton wheel, was still in use.

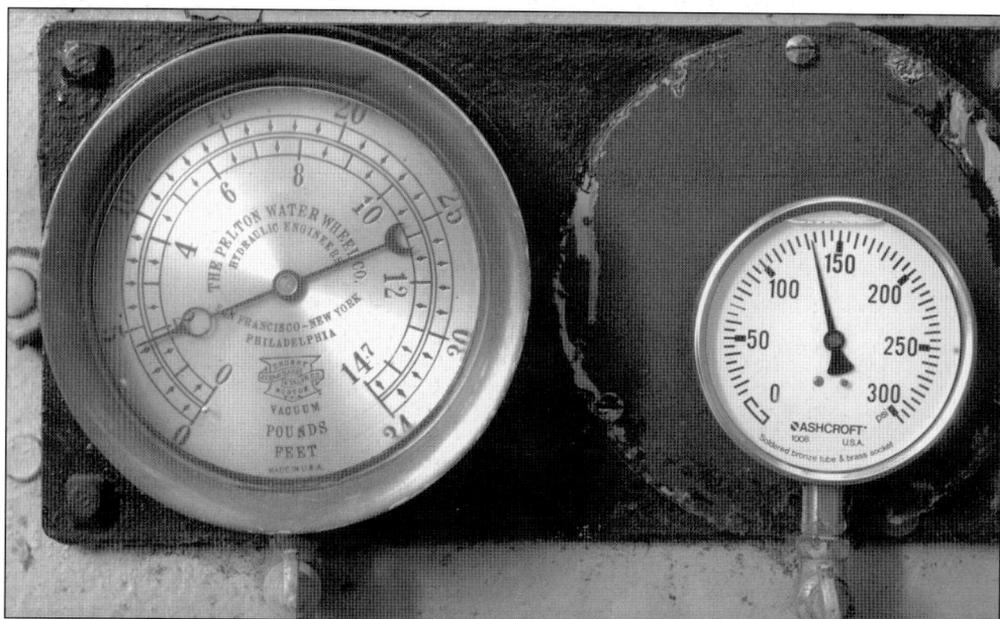

Contrasting meters measure the same parameter—water pressure—but do it in ways that reflect the industrial aesthetic of the day. Pelton's 1900 version is harder to read but prettier to look at. With the modern version, form follows function.

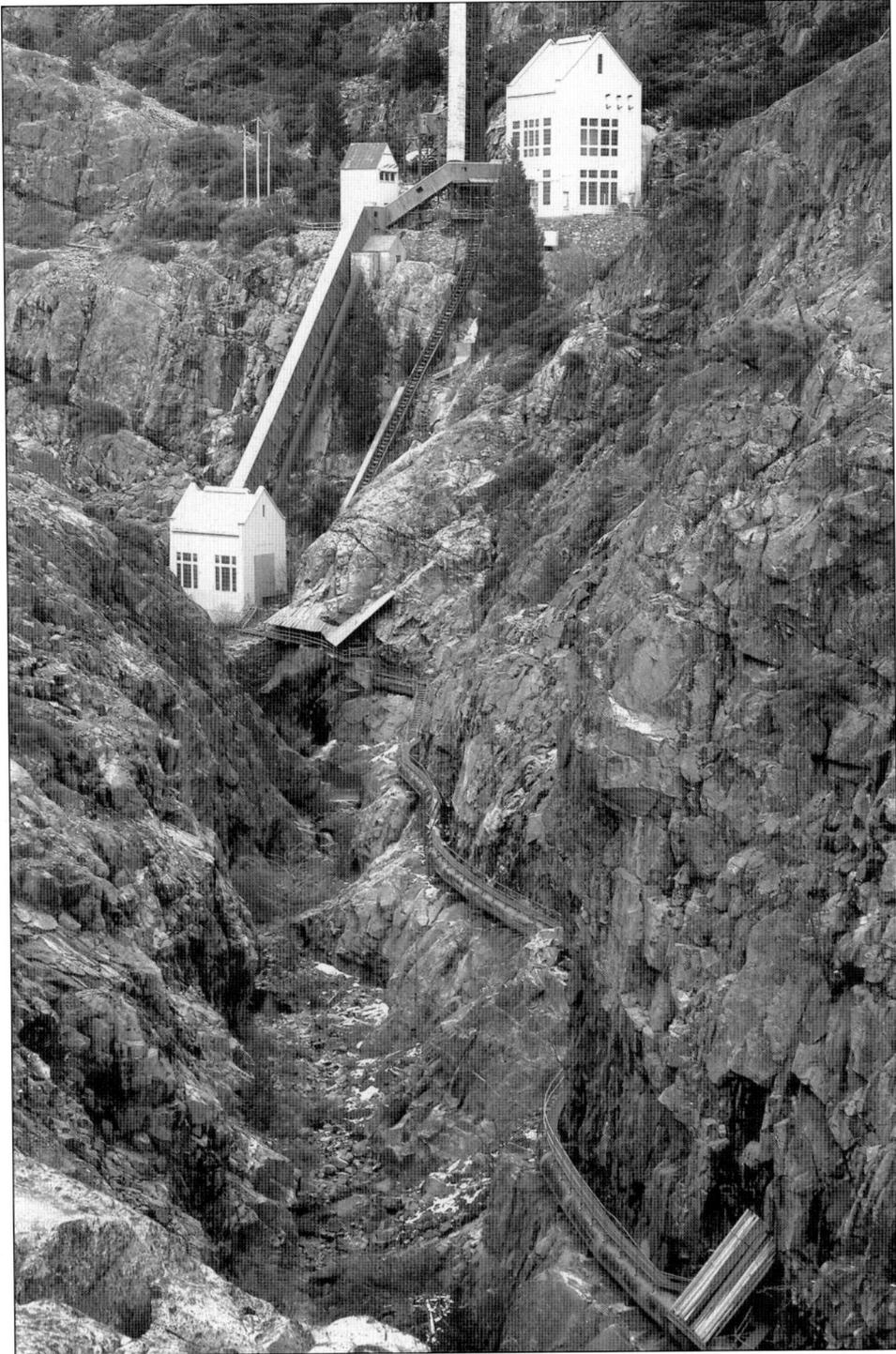

This photograph shows a contemporary view of the Spaulding Powerhouses, built on niches chiseled from the granite cliff face. No less impressive is the flume snaking its way downstream at the bottom of the canyon.

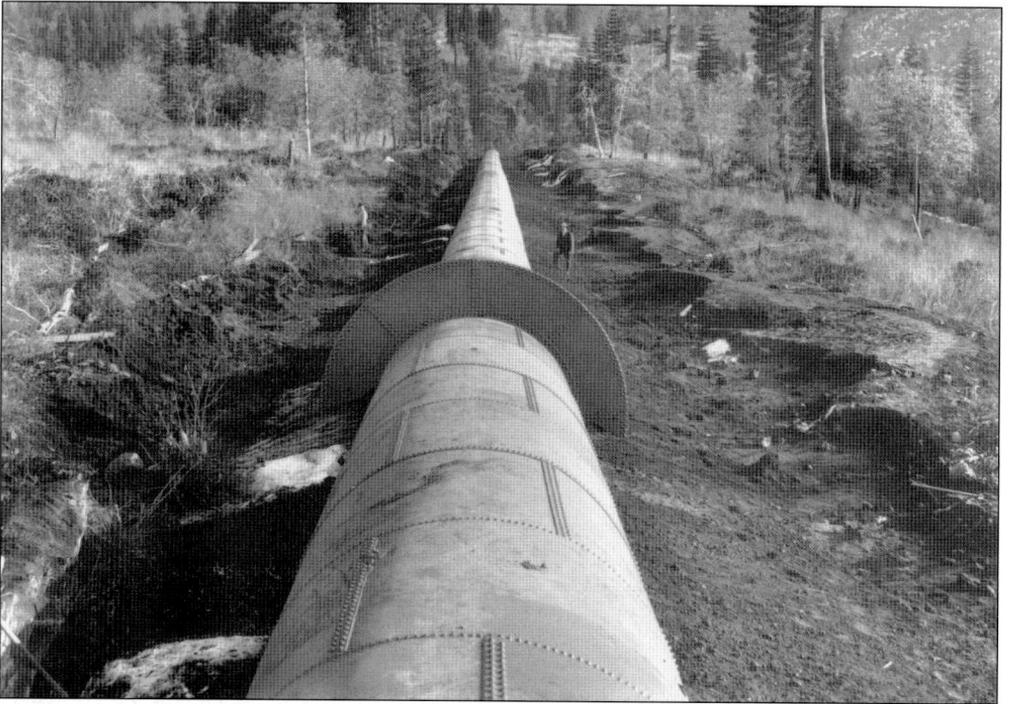

Constructed in short sections and riveted together in the field, this penstock leads from the Drum forebay to the powerhouse. The circular metal is a baffle.

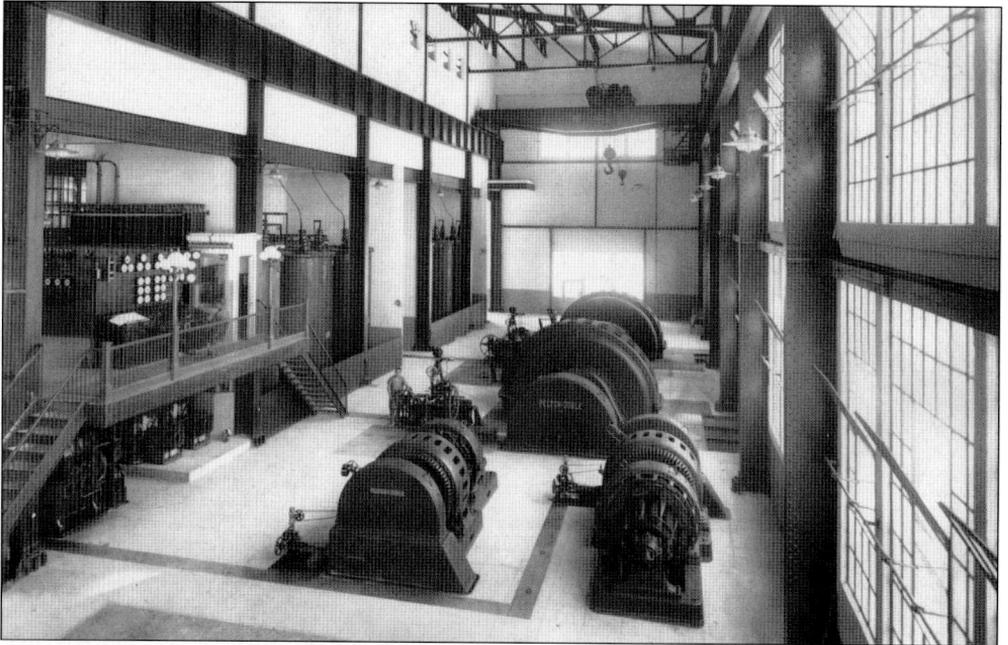

This wide view of the Drum Powerhouse, taken in May 1914, shows the traveling overhead crane that was used to move heavy generator parts and waterwheels. The high ceiling also dissipated heat. Oversize windows, used to provide light for maintenance work, were also opened for ventilation.

112

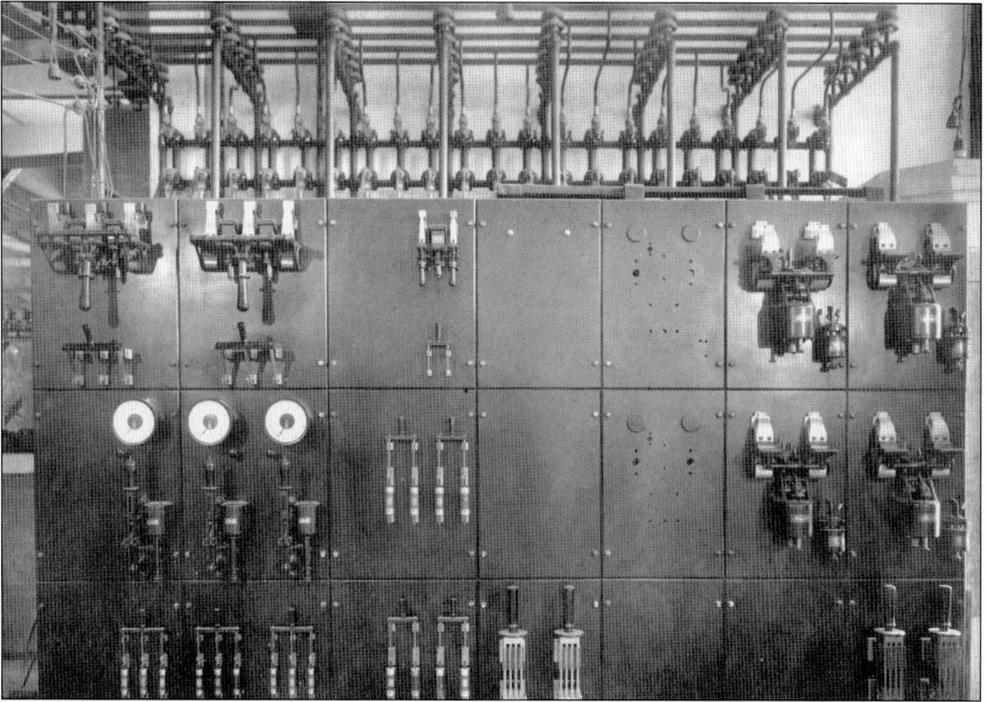

The switchboard at Drum is photographed here in 1923. At this panel, power could be diverted to different transmission systems.

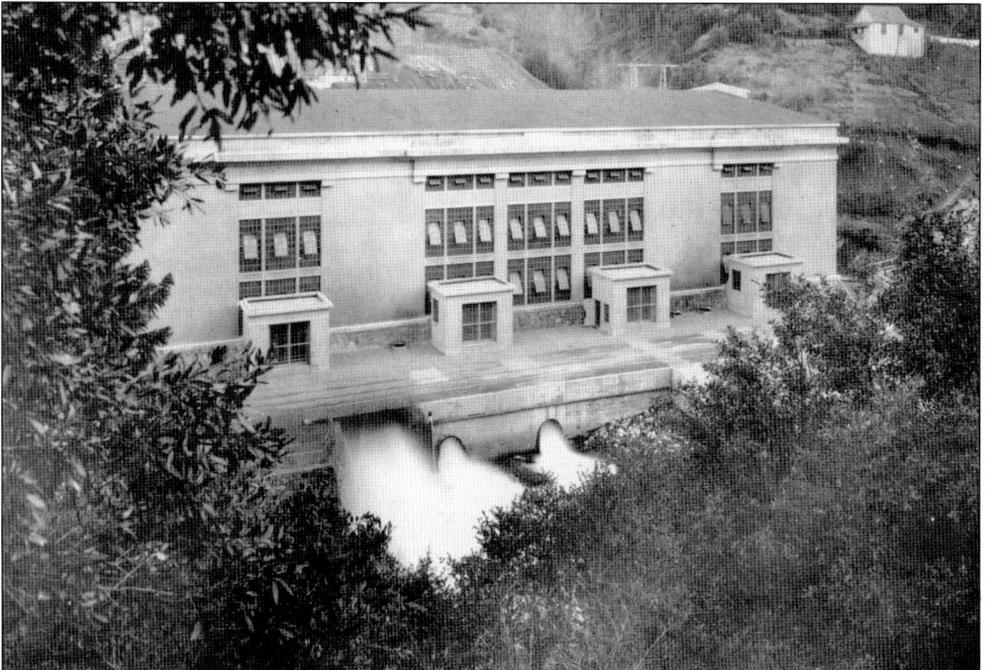

In January 1930, just months after the October 1929 stock-market crash, the Drum Powerhouse was busy making electricity. Capital costs of the plants were funded in part by bonds issued by the power companies. This facility may have just made the cut.

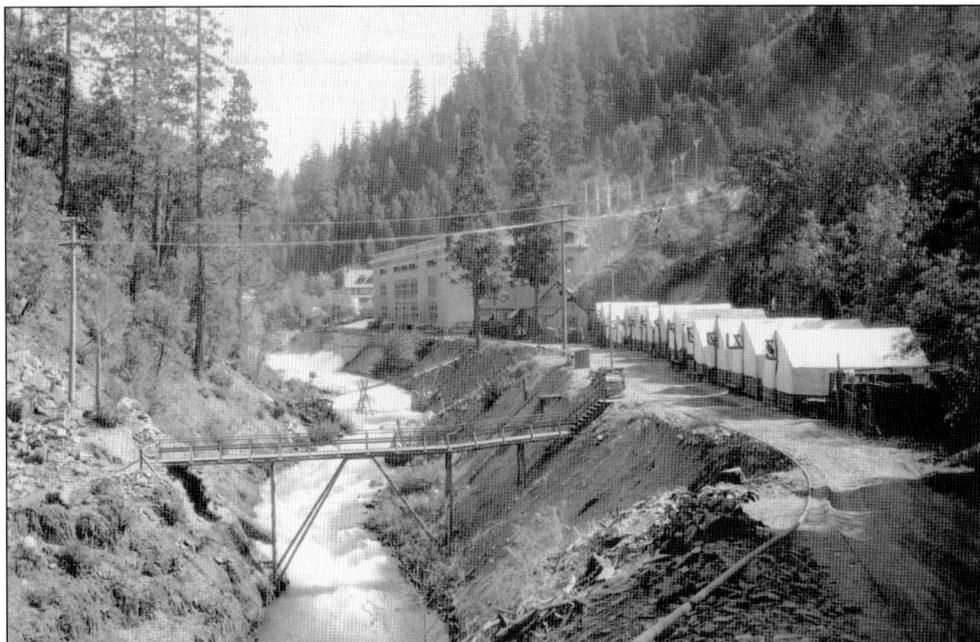

An undated photograph shows the construction camp for the Drum Powerhouse, although, at this point, construction seemed to be complete. The buildings in the foreground were subsequently removed, but the building on the other side of the powerhouse remained for the residential operator.

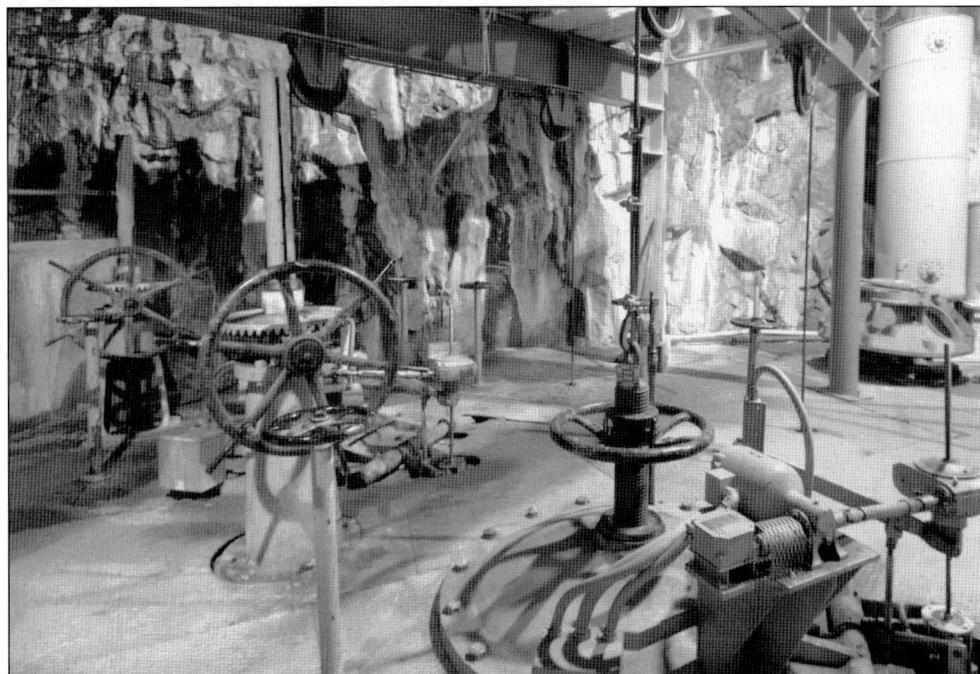

The lower Spaulding Powerhouses were literally built into the cliff, as this interior photograph shows. Water leakage through cracks in the rocks varies in intensity with the water level of the lake, located just a few hundred yards upstream.

114

This 2003 view of the Bear River Canyon and the Drum Powerhouse shows how the vegetation has grown during five decades of operation.

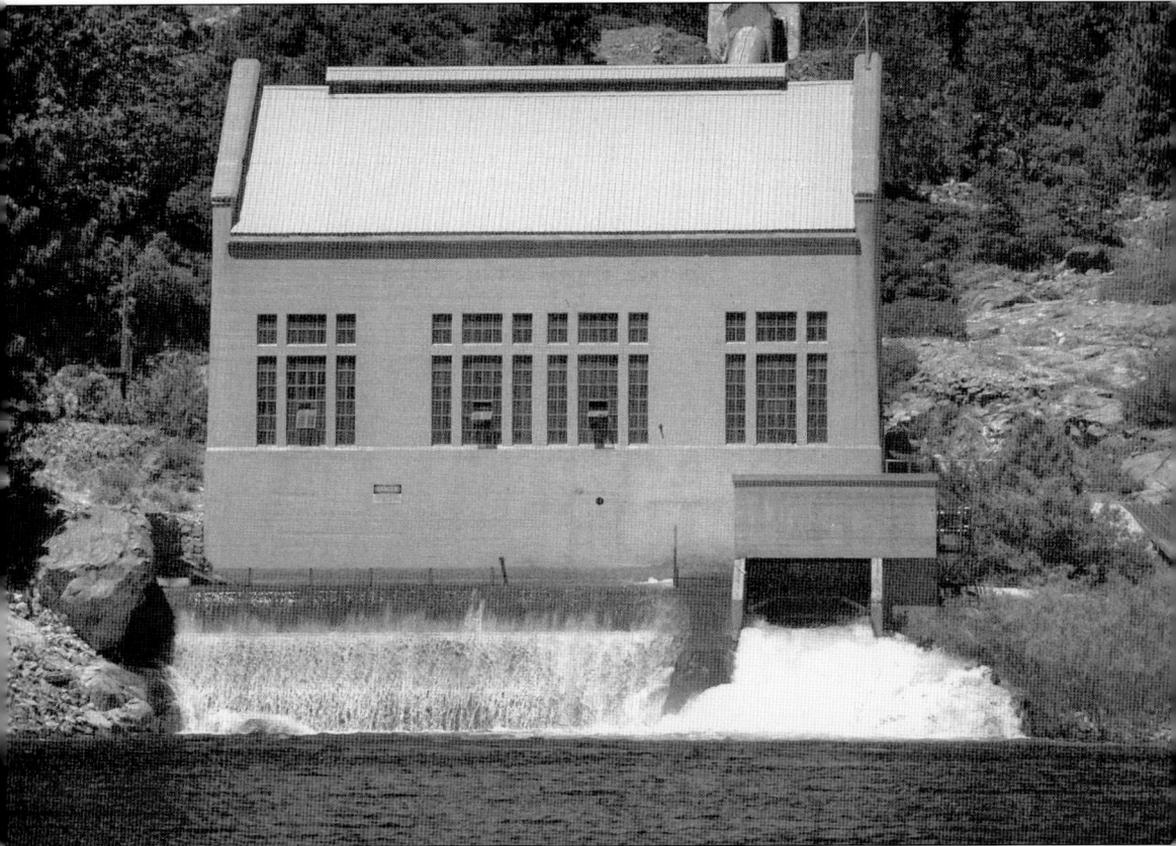

The Drum No. 4 Powerhouse is pictured here in a 2004 photograph taken from Spaulding Lake. The site is accessible from the lake or from a hiking trail around the lake's perimeter.

Eight

THE LONELY LIFE OF A DITCH TENDER

Flumes were ditches or wooden structures that conveyed water between hydroelectric sites. From the earliest day, they required constant maintenance, and ditch tenders were assigned to this task. In the autumn, leaves clogged the ditches, making them susceptible to debris dams and subsequent overflowing. Occasionally a flume would "blow out," or suffer an extreme failure, causing local floods. The ditch tender's job was to ensure such disasters did not occur by taking personal responsibility for the operation of several miles of a ditch. As the photographs show, early ditch tenders lived close their work—sometimes in cabins built astride the ditch. They patrolled constantly, cleaning the ditch, looking for leaks, and dealing with water thieves who tapped into the line without signing up for the service.

Winters were an especially challenging time because ice needed to be broken up and dissipated to the keep the water flowing.

This unique job continues into modern times. Equipped with pickup trucks instead of horses, these workers continue patrolling the waterways of the Sierra Nevada, and some are still called by the time-honored title of ditch tender.

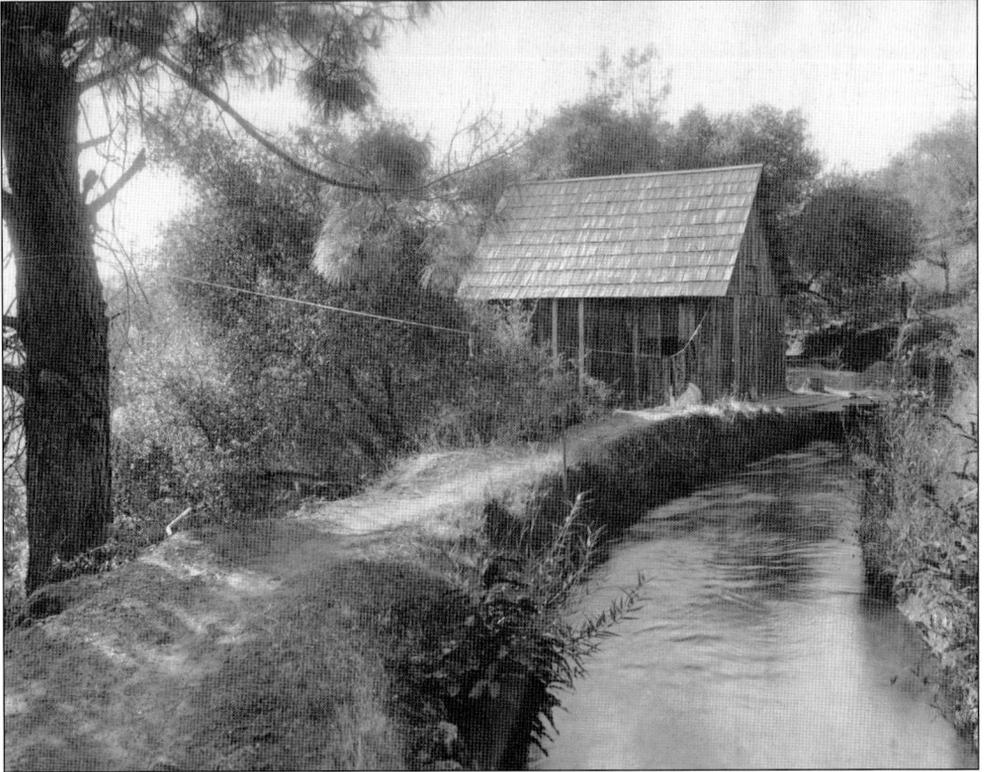

The ditch tender's company-provided residence would often be a tidy cabin beside a pleasant stream.

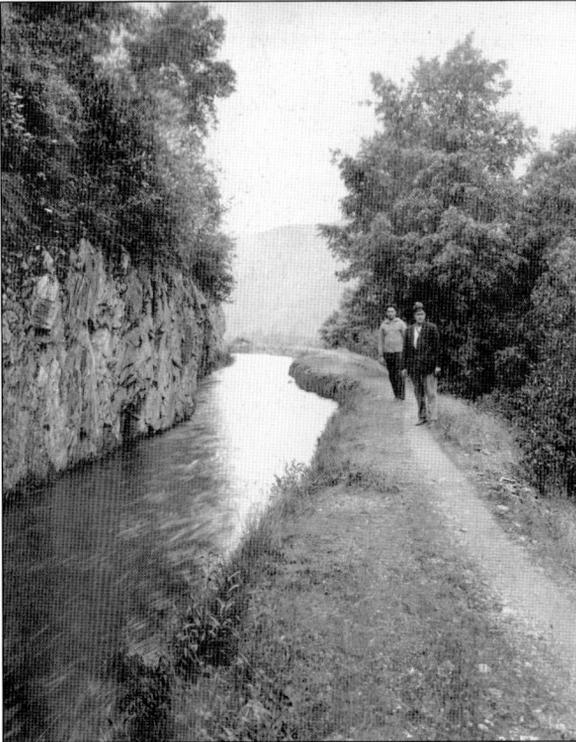

In 1917, PG&E personnel walked along the Centerville Canal. Initially, they were called ditches, but later the name was changed to canals. Note the well-worn path and the vegetation that has regrown around the canal.

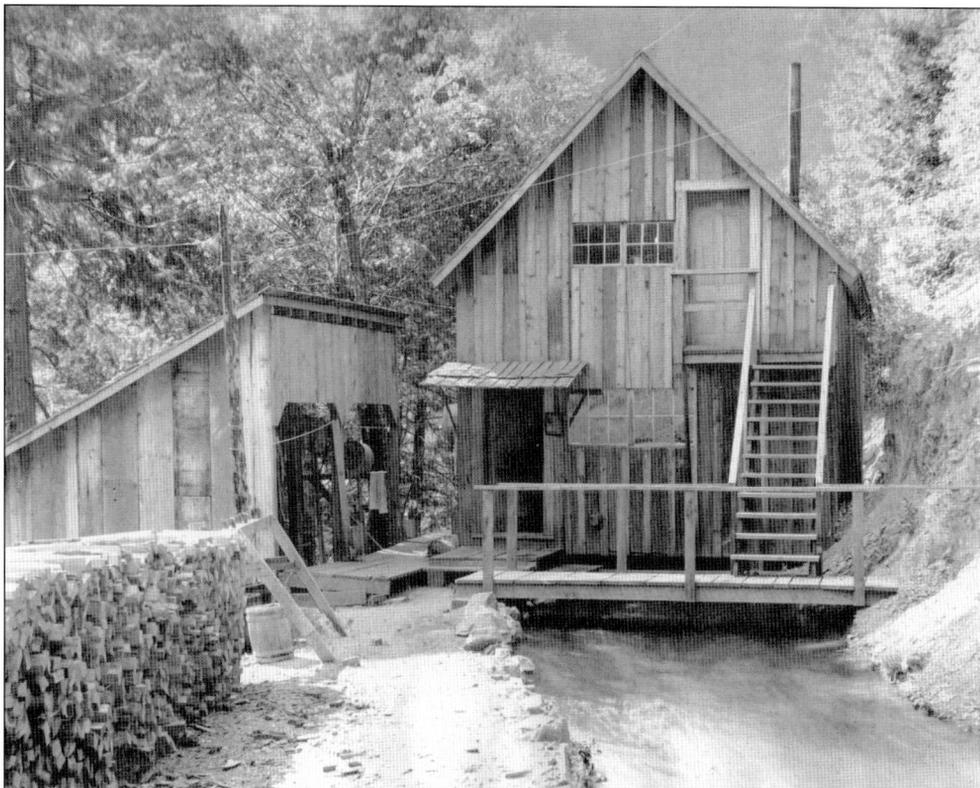

This ditch tender's residence sits astride the canal he maintains. Note the neatly piled wood stack and the dual entrances to the building.

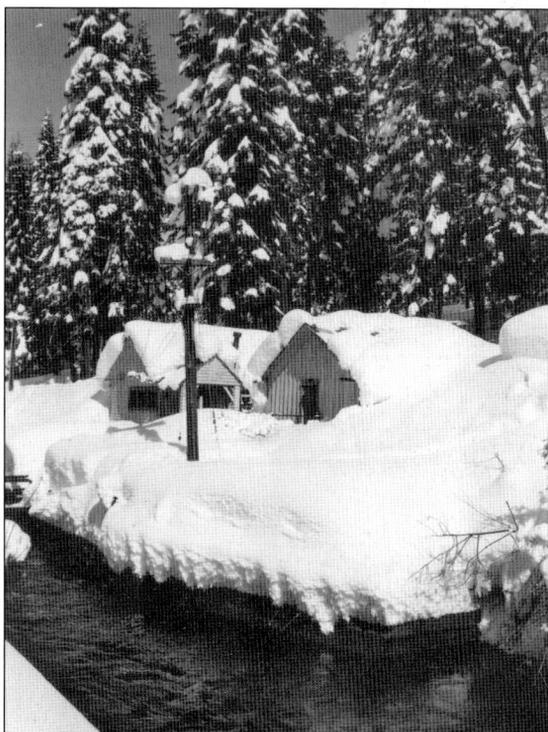

The higher-elevation canals received significant snowfall, as pictured in this photograph of the ditch tender's cabin on the Drum Canal. The waterways had to be kept free of snow and ice.

Sometimes the flumes could be used as transportation routes for freight delivery. In this case, a PG&E employee pushes a hand wagon with freight for delivery along his eight-mile stretch of the Colgate flume.

Flumes had to be carefully engineered because a failure could be catastrophic, interrupting power and flooding the countryside. This flume was designed to deliver 450 cubic feet of water per second.

Here is an established flume in a forest that appears to have a healthy stand of second-growth trees. It shows the Cascade Ditch between the Deer Creek facility and Nevada City.

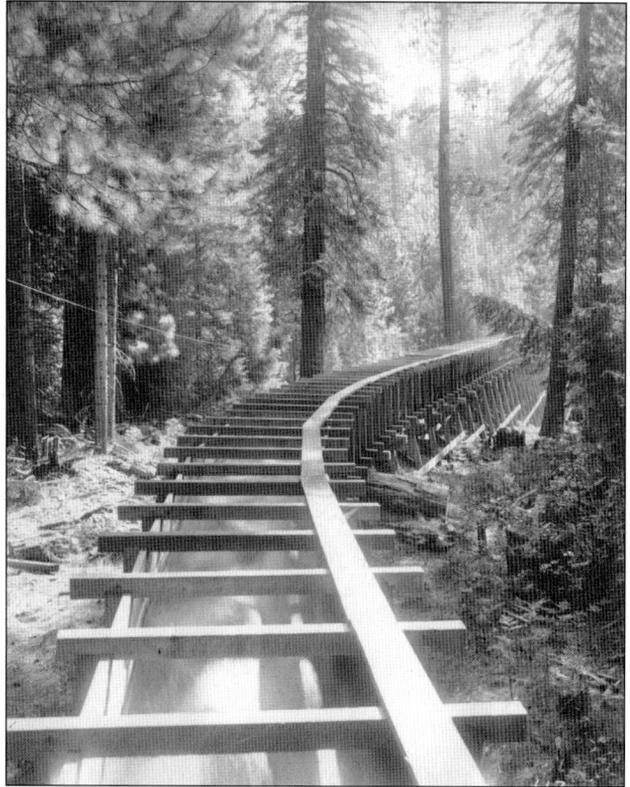

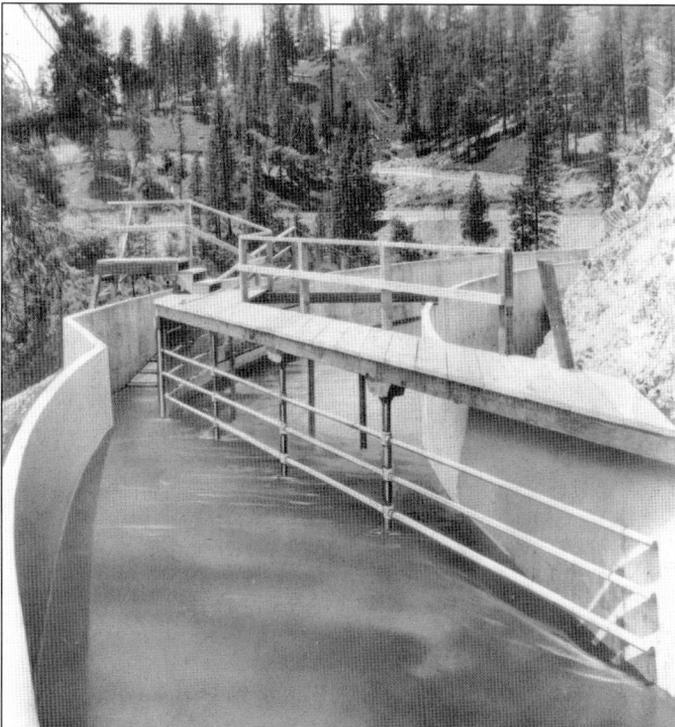

Safety measures were built into the flumes, as seen in this photograph of an "animal release." Deer that fell in the flume would be carried downstream to this device, where they could climb out on a ramp.

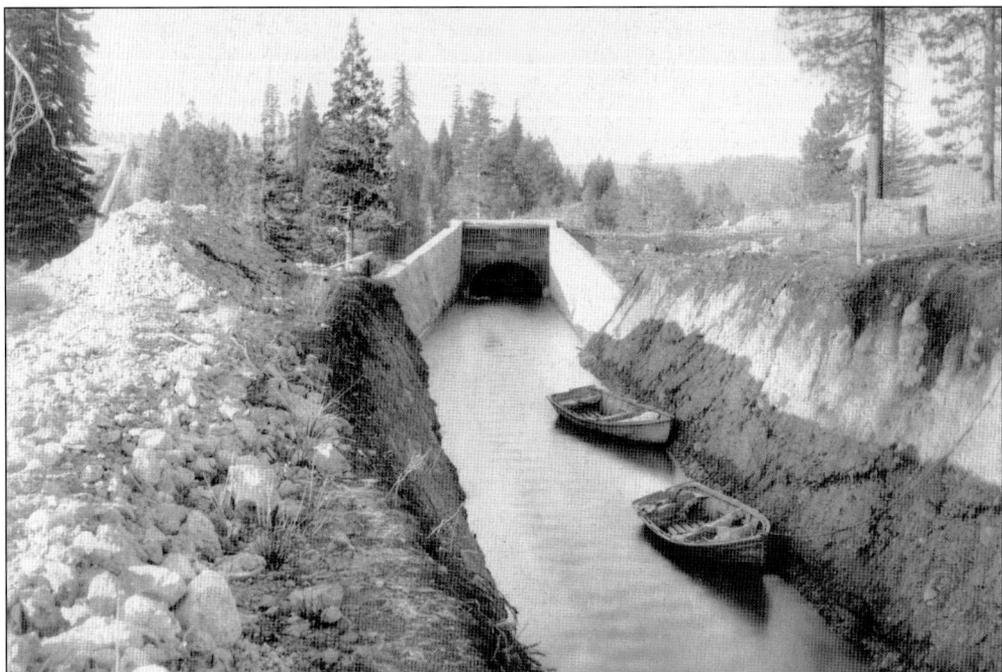

Boats are moored in the Drum Canal in 1912. How these boats were propelled up the swift current in the canal is unclear; no oars are in sight. Their purpose is also puzzling. Perhaps they served as work platforms for cleaning the debris racks.

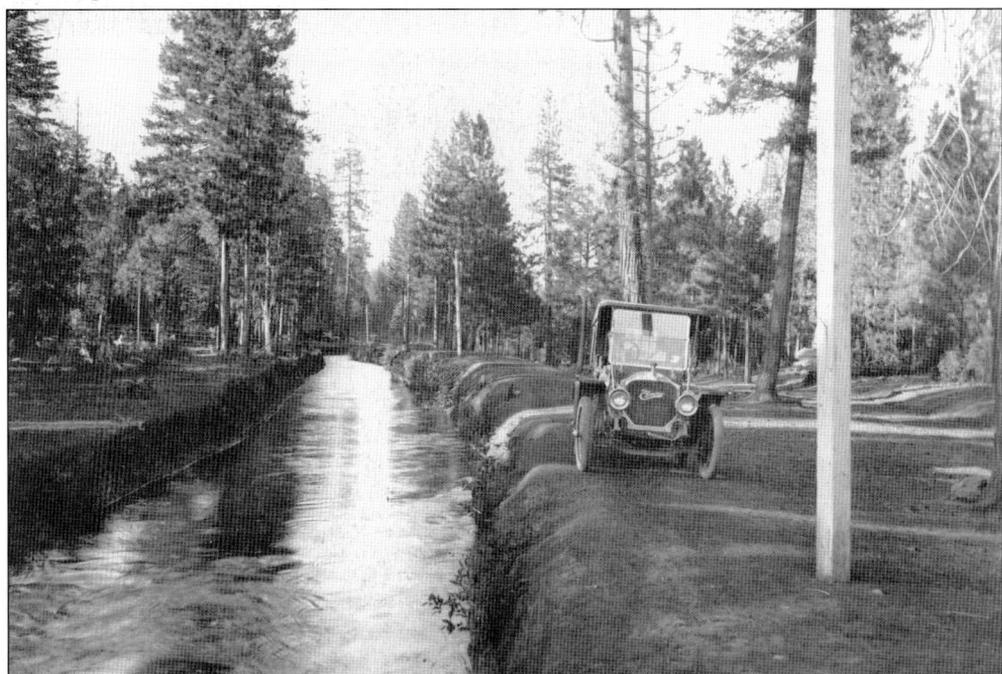

Access to the canals was not always difficult. Here an InterState motorcar allows the ditch tender to patrol his 12-mile section much quicker than his counterpart in the mountains, who had to ride a mule or walk the section he was responsible for.

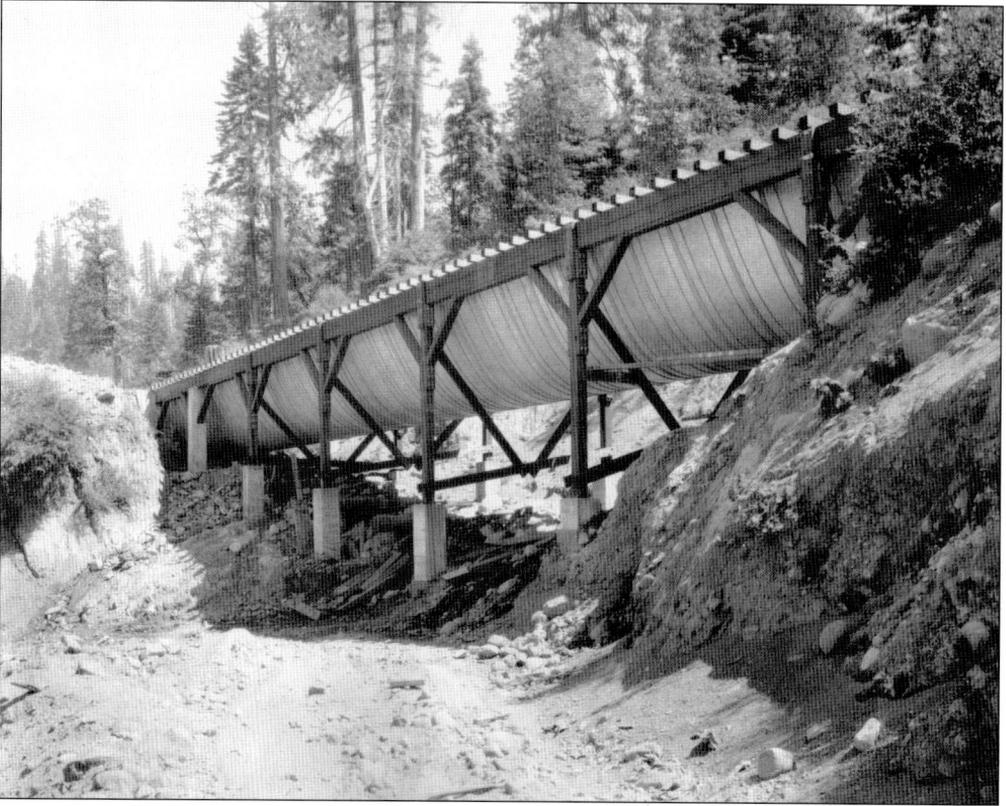

Washouts, or blowouts in the terminology of the ditch tender, were the worst disaster to contend with. This 1927 view of the Drum Canal shows where a washout in a gully occurred and an elevated metal flume had to be installed.

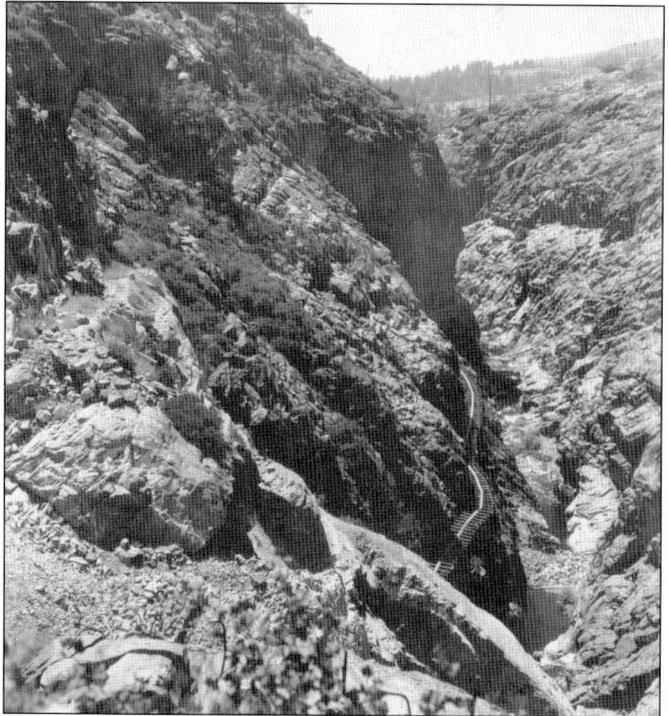

One of the most difficult canals to construct was directly downstream from the Spaulding Dam. Here the canal is literally hanging on the edge of a cliff. This area can be accessed from the Bowman Lake road.

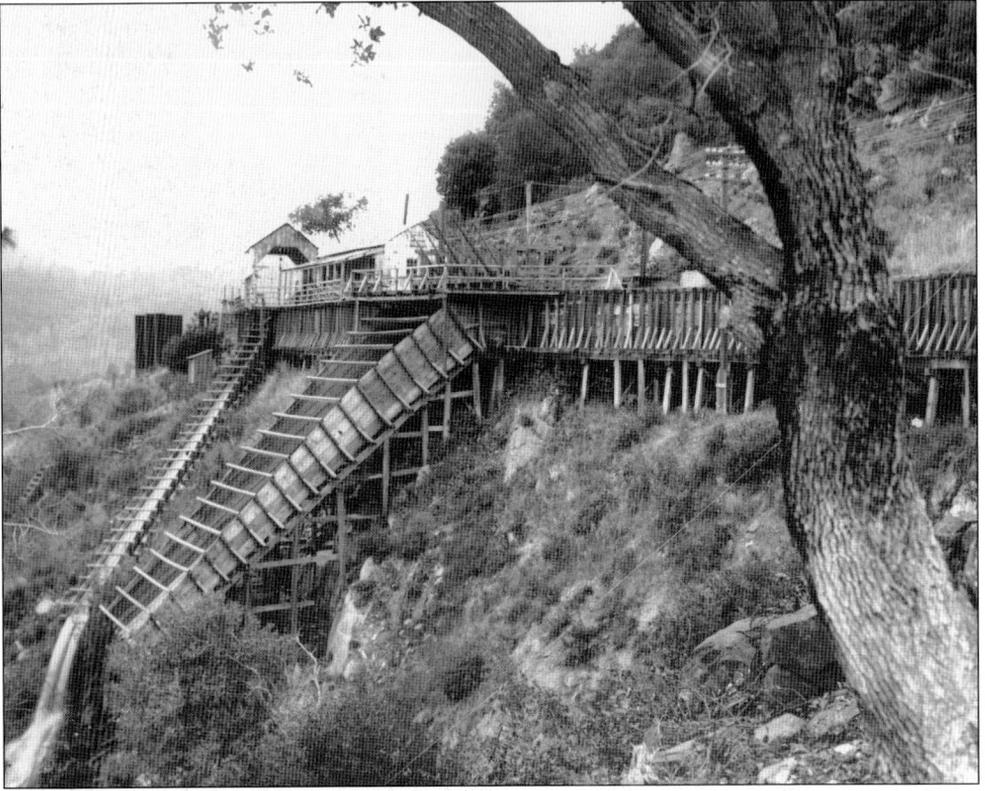

This flume features two diversion spillways that have a debatable function. Did they divert water to another facility down the ridge, or were they for releasing excessive water during floods? Present-day hydro engineers can't explain it.

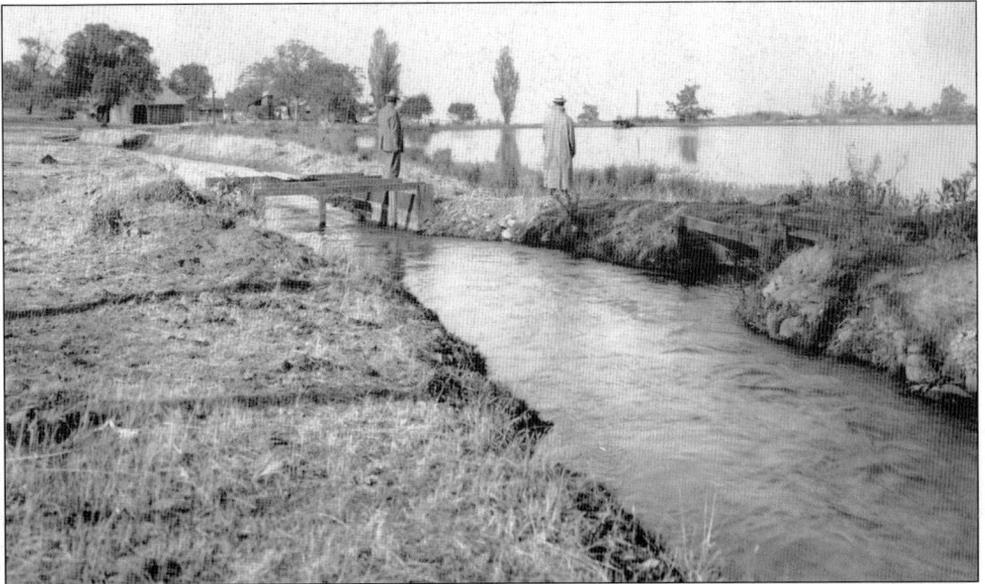

Eventually the water passed through the powerhouses and emerged onto the Sacramento Valley floor, where it irrigated thousands of acres.

Wintertime was an especially high-maintenance period for the linemen and the ditch tenders. Here a repair party heads out from Drum Powerhouse on skis, carrying insulators, wire, and tools on their backs.

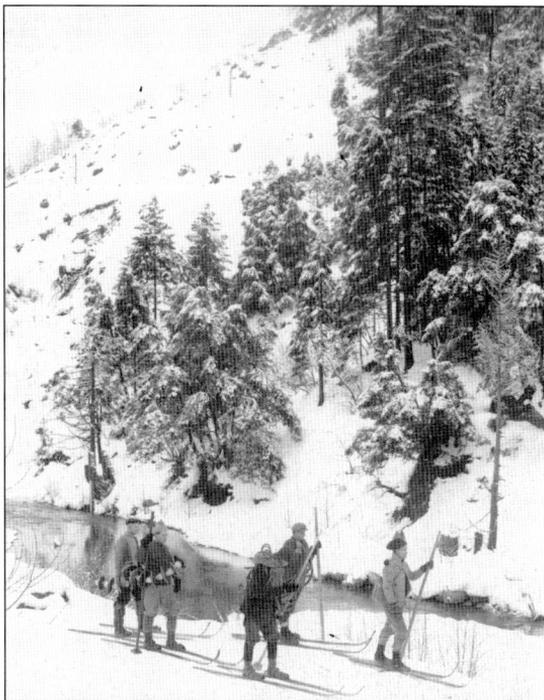

Sometimes there was no alternative for removing ice except to tie on a safety rope, grab an axe, and climb down into the canal. Here a worker in 1949 chops away at ice accumulation in the Eldorado Canal on the American River.

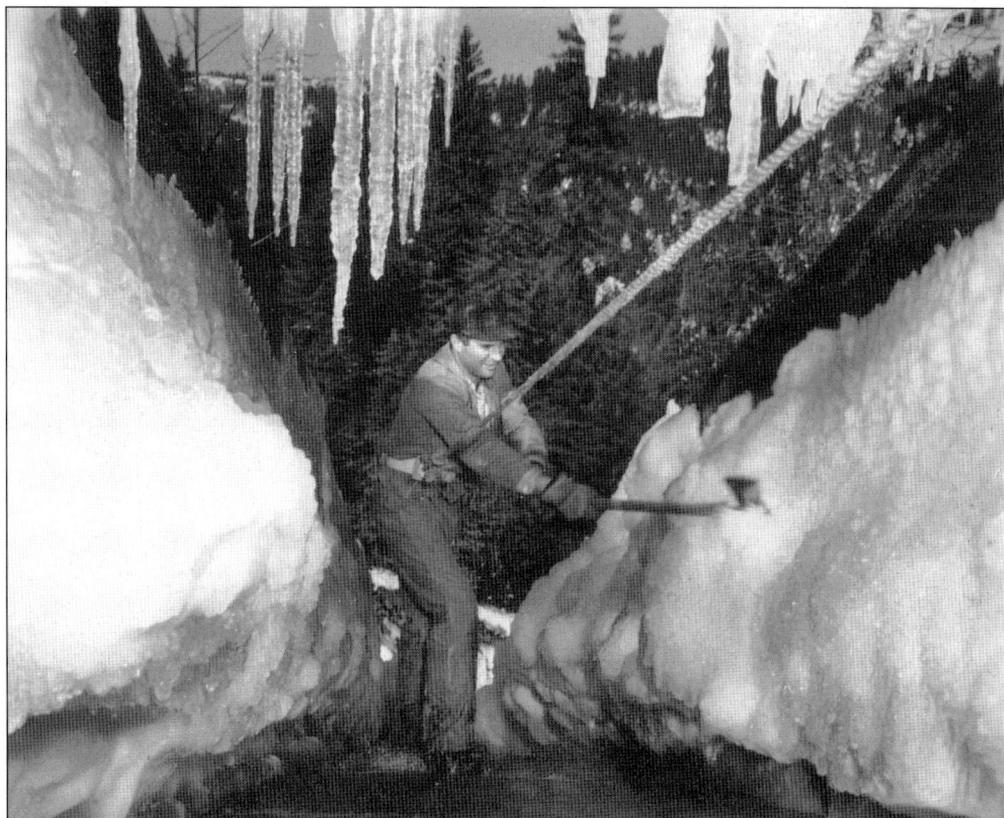

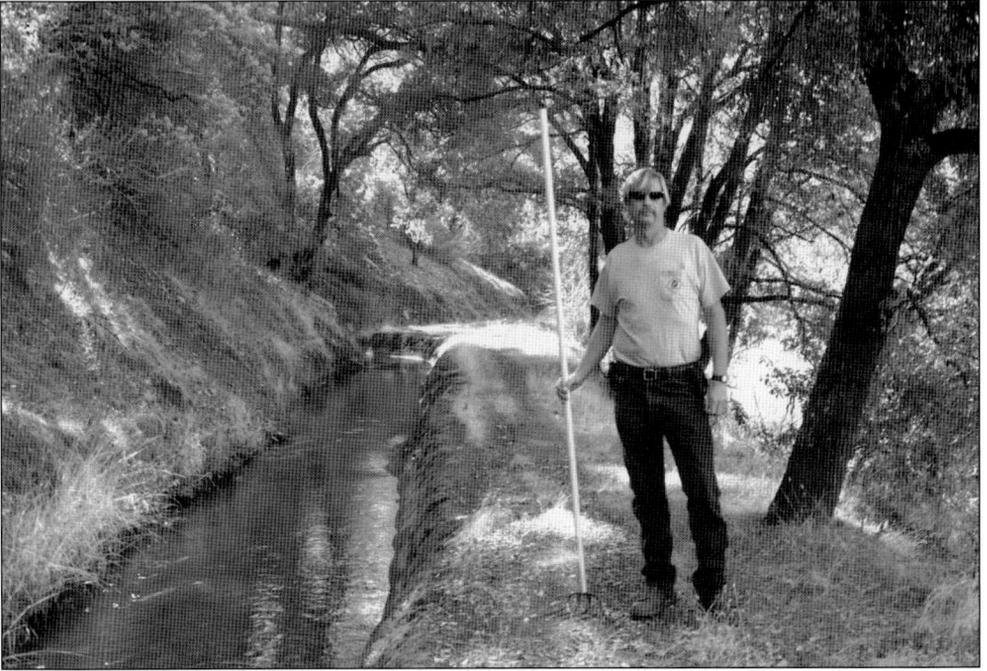

Maintaining the canals is an endless task, still carried on by the ditch tender's modern counterpart, the canal operator. Steve Kedinger, seen in this contemporary photograph, maintains the Boardman Canal for the Placer County Water Agency.

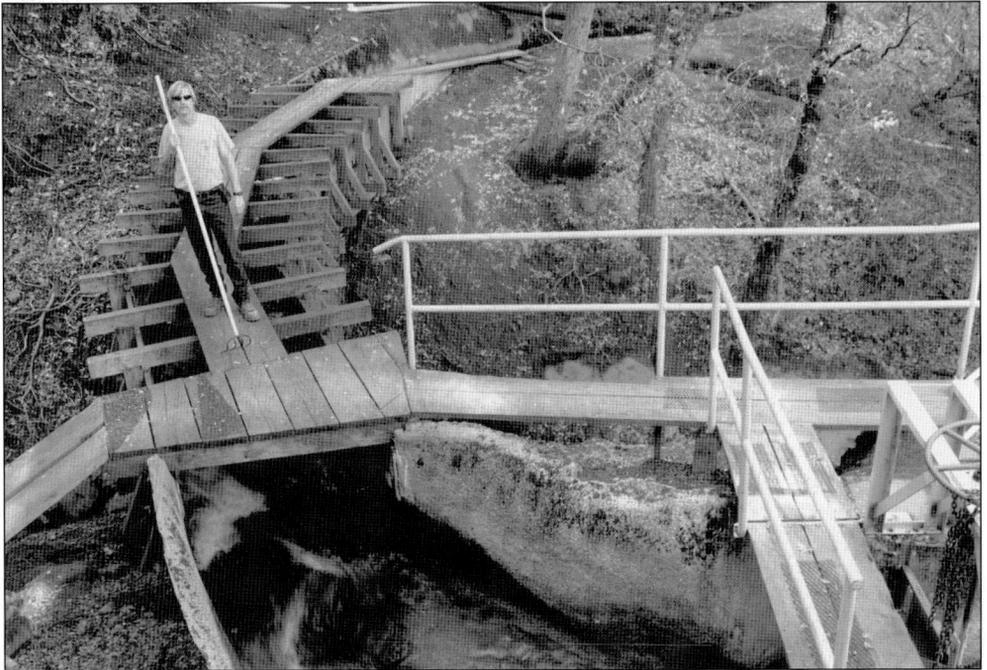

Although mules have been replaced by pickup trucks, the task for Kedinger is essentially the same his forbearers faced: keep the canal free of debris and obstructions and keep the water flowing.

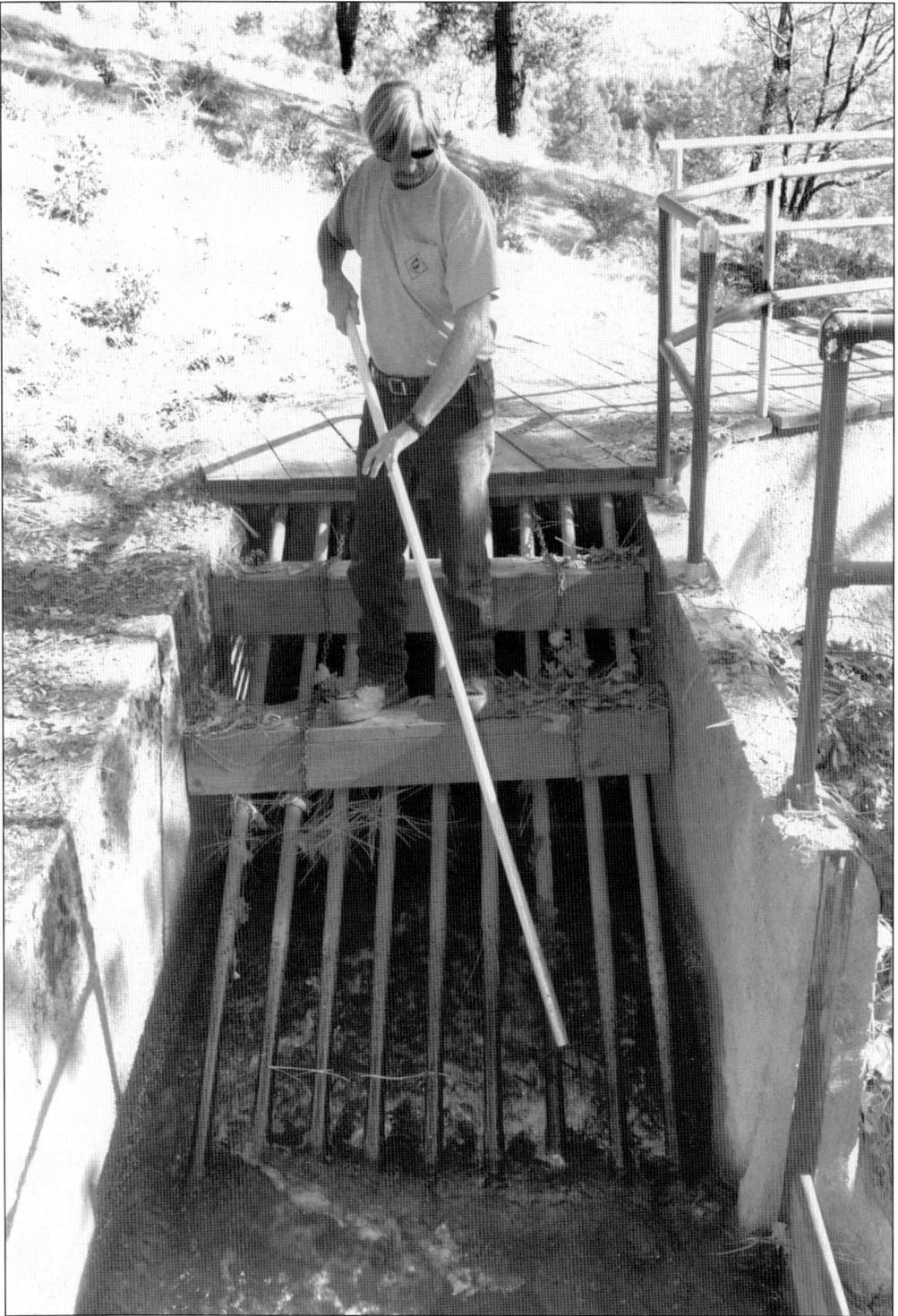

The worst time of the year for canal operators is the fall, when oak leaves clog the racks. The operators use a "potato hook" to pick out the leaves.

ACROSS AMERICA, PEOPLE ARE DISCOVERING SOMETHING WONDERFUL. THEIR HERITAGE.

Arcadia Publishing is the leading local history publisher in the United States. With more than 3,000 titles in print and hundreds of new titles released every year, Arcadia has extensive specialized experience chronicling the history of communities and celebrating America's hidden stories, bringing to life the people, places, and events from the past. To discover the history of other communities across the nation, please visit:

www.arcadiapublishing.com

Customized search tools allow you to find regional history books about the town where you grew up, the cities where your friends and family live, the town where your parents met, or even that retirement spot you've been dreaming about.